Fractal Cosmos

The Art of Mathematical Design

Lifesmith Classic Fractals
Amber Lotus

Revised edition 1998
First published 1994

For information, write to Amber Lotus, P.O. Box 31538, San Francisco CA 94131.

Website address www.amberlotus.com.

Printed in USA on recycled paper.

ISBN 1-56937-064-8

I would like to dedicate this book to my parents,
Alvin and Rochelle Berkowitz.
My mother's artistic sensitivity has been inestimable and
her support has been unconditional.
My father's business acumen, advice, and support
when no one else believed in me
has been invaluable to my success.

TABLE OF CONTENTS

PREFACE

From the earliest times of man's civilization, he has endeavored to describe his surroundings and his experiences with whatever medium was available. Be it charred oak from a primeval forest fire, the purple ink from a south Pacific sea squid or carefully mined, refined and combined titanium oxide, man learned how to express himself and derive some kind of meaning for his existence in the natural world. To this day man's artistic exploration continues within an expanded comprehension of his world, and his tools have become more complicated and numerous. What is presented in this book is merely another step along this aesthetic foray into descriptive expression.

As a child I was taught about the fundamental nature of numbers, that everything was quantifiable. I was instantly attracted to mathematics, not necessarily because of this quantifiability in Nature, but because of the clear boundary between correctness and error. Acute curiosity often motivated me to explore puzzles in mathematics and logic and I sought all the best books covering these topics. I read all of Isaac Asimov's books that our local library had on its shelves. I was always interested in new or different methods to do mundane arithmetic calculations and learned the Trachtenberg system of speed mathematics while in the sixth grade. These and many other tricks became my stock in trade as a high school teacher of science and mathematics.

After teaching for about ten years, I discovered my need to further my own education and went back to the university to earn a master's degree in physics. Again curiosity was as much a driving factor in my education as the urge to further my career and enhance my earnings. I learned a deeper understanding of Planck's quantum, a finite (though incredibly small) building block of energy and how natural phenomena were once again fully and comfortably quantifiable. My comfort was short-lived as it became more and more difficult to numerically describe concepts such as consciousness, truth, beauty and the like. I do believe consciousness is ultimately quantifiable and that it must be incorporated within our physical laws before a comprehensive Grand Unified Theory of everything (physical and non-physical) can be realized. But that is another story. Indeed, there are still many important mysteries within physics, some extremely esoteric and others exceedingly common. Science does not have all the answers yet.

Recently, methods have been uncovered which allow us to approximate seemingly natural forms using manipulations of pure numbers. In 1988, during my graduate work at California State University, Northridge, a classmate brought a black-and-white printout of a crab-like object to physics class and told me that it was a fractal. He had produced the crude drawing on his home PC and told me that the method was fairly simple. In fact he described the mathematical procedure to me in ten minutes time. The elegant detail of that fractal object made a profound impression on me.

Later that week I discovered the new Advanced Function Workstation Lab at the university which featured a couple dozen of networked Sun workstation computers all running

the UNIX operating system with compilers for C and Fortran languages. As physicists, we are obliged to do most of our calculations by computer (little is done by hand anymore). I had a good background with computers going all the way back to the terminal we had at our junior high in 1968 with its acoustic modem and IBM card reader. Again my curiosity, coupled with the practicality of the educational experience, enticed me to get involved with these advanced computers. I had some programming experience with Fortran and none with C, so I decided to learn how to program in C using this new (to me) operating system. The technicians in the lab were all very helpful and encouraging and I owe them all a debt of gratitude.

Within a week I had written a rudimentary program for generating full-color Julia set fractals and began to explore the subject, both in the library and within the computer. Fellow lab users inspired me to continue to explore and experiment with various equations and methods. The colors, the forms, the beauty of pure mathematics was as intoxicating as any drug or experience I had known. I found myself staying up all night on numerous occasions, not to do my intricate physics homework, but to explore the realm of fractals. I read all the books and articles I could find on the subject but nothing I read was as interesting as the images themselves.

During the past eight years, my program has grown to about seven thousand lines of computer code. It encompasses five hundred complex equations, each representing a different family of images. I even learned how to use purely numerical methods to color the designs. Since 1988, I have produced roughly 250,000 interesting two-dimensional fractal images to this date. About five years ago, I began to render these fractal images as three-dimensional objects, objects available for lighting, shading and shadowing. Included in this book is a collection of some of my work through 1994 with data available to those of you who are computer-literate which will enable you to reproduce some of the images on your own computer system provided you have the appropriate software. Notice that I chose not to place a "descriptive" title on any of my images as I do not want to channel the observer into seeing what I see; I hope the viewer will enjoy and interpret each in his or her own way without any outside influence.

Recently, I have constructed an extensive website, http://www.lifesmith.com, which includes many of the images from this volume plus much of my work from the years 1995 to the present. There you will find many fascinating images and features for you to explore and experience.

For me, doing this work has quite a bit of spiritual importance. An important point I like to make is the fact that, if we are now able to construct natural objects like mountains, hills, trees, planets, etc., using our truly simple computational tools, imagine what Divine Presence is able to accomplish with his/her/their tools. The incredible depth of the orchestration of life in the universe is truly awesome and overwhelming. And if we can be creators of whatever reality we choose, do we not then share that divinity with The Creator?

My purpose for this book is to uncover for the viewer the beauty that is inherent in pure mathematics. I do not wish to do a treatise on chaos theory, bifurcation, self-similarities, or Hausdorff dimensionalities. There are much finer mathematicians than I that have covered those subjects. I have listed many of the more readily obtainable texts in Appendix B should you wish to do your own educational research.

How fascinating it is that what was once an attraction to mathematics for the bipolar simplicity of correctness versus error has become a more profound appreciation for the juxtaposition of order and chaos within these mathematical forms. After eight plus years of 24-hours-a-day research, I am still enthused and fascinated by the surprises I get to uncover within the world of mathematics. Yes, man's artistic attempt to describe his place in the universe ever continues; only his tools change.

viii

Jeff Berkowitz, M.S.
January 21, 1994, revised October 25, 1997

ACKNOWLEDGMENTS

I would like to thank the following people
for their contributions and support for this book:

The entire staff at Amber Lotus for taking the risk of publishing my
work in this book as well as calendars, cards, and stationery;

Charles Hansen, Jim Schmidt II, and Judy Riedel of Stuart Hall
Company, Inc. for granting me the commercial success that enabled me
to continue my research as a full-time fractalier;

Edward Maros, Steve Acheson, and Kevin Kaufman whose friendly
technical support since my days at CSU Northridge has bailed me out
of more than a few messes with hardware and software;

California State University, Northridge professors in the physics and
mathematics departments for my technical education and support.

Thanks to the many great mathematicians and scientists who have laid
the foundations for this work and that to follow.

Oh, and thanks to Steve Larson for showing me that first fractal.

CHAPTER ONE

Introduction to Fractals

As we intend the focus of this book to concentrate on the intrinsic beauty of the art of fractal mathematics, we only offer a superficial presentation on the history and development of chaos theory and its relation to fractal geometry. We urge that readers with further interest consult the books and important papers listed in Appendix B.

Let us begin our look at order and chaos with man's initial theories about the Earth and the solar system. The geocentric theory, credited to Ptolemy, Roman governor of Egypt, stated that all of the heavenly bodies revolved around the Earth. Astronomers from that time until the time of Galileo and Copernicus, careful not to step on powerful ecclesiastical toes, were wise to explain away minor perturbations and outright conflicts with geocentricity by the use of orbital "epicycles" and other geometrical tricks. After all, God had dominion over an ordered world, one not filled with unpredictability and random chance. Galileo himself was shunned and even supposedly imprisoned because he publicly espoused Copernicus's heliocentric theory. Though astronomy was already a developed science in the Middle East (hence most of our stars have Arabic names), the western world only began to seriously and scientifically explore the universe during the first part of the sixteenth century.

Later in that century, Johannes Kepler assembled thirty years of observational data left him by his mentor, Tycho Brahe (who had a wooden nose and died drinking), and formulated his three laws of planetary motion. These laws were intended to describe the motion of one body as it revolved around another. Kepler theorized, as did Newton, that with further mathematical manipulations and calculations, the future motion of two or more planets and one star, or one planet and two stars, etc., could be predicted as accurately as one planet and one star. But, as modern physicists know, the "three-body problem" is completely insoluble. That is, if three (or more) bodies with some type of attractive force between them are allowed to interact given some initial conditions, it is absolutely impossible to predict their position and motion after a long period of time has elapsed. Not only is this still a fundamental problem in physics, the stability of our solar system is still an unsolved area of controversy.

The Keplerian/Newtonian order was believed to be "proven" well into the nineteenth century, at least until the French physicist Henri Poincaré pointed out that the slightest adjustment to complicated systems could produce surprisingly catastrophic effects. Known as the "butterfly effect," it is said that the batting of a butterfly's wings in China could produce a hurricane in the Caribbean. One can imagine how the stability of our solar system

could be undermined by the ostensibly trivial influence of a renegade comet, let alone Nemesis, the purported dark star companion to our sun, which orbits every 26,000,000 years. Ecologically speaking, we have seen that the removal of an apparently insignificant niche of an ecosystem can result in the complete downfall of all of the elements of that delicate arrangement. The interdependence and interactivity of everything within our entire existence becomes clearer when this interesting principle is pondered.

Let us now turn our attention toward a biological system so that we may understand the complexities of order and chaos as they pertain to a simple population model. Imagine, if you will, a large field of grass and shrubs, recently populated by a single family of rabbits. Now, as everyone knows, rabbits multiply with alarming rapidity. Let's say that the rabbit population simply doubles every year until it reaches its optimal population. Call it a number P. If there are too many rabbits and not enough food, some of the rabbits would die off so that the population would then dip below P. The next year, the population increases above P and the following year it once again drops below P. This cycle turns out to be very predictable as long as the rate of increase of the rabbit population is below 100%. If the rate is just a few percent (e.g., 3%), the growth of the rabbit population is said to be linear and will double in about twenty-five years. It has been shown that a rate of 80% growth will cause the population to approach the optimal value P and then maintain itself there. As rates grow higher, predictable up and down cycles become apparent, as mentioned before. But a very curious thing happens when the growth rate reaches about 157%. It turns out that the population of rabbits becomes totally unpredictable from year to year—the system is out of control and chaos reigns. The idea of bifurcation theory stems from this intriguing situation.

It was in 1845 that F. P. Verhulst first formulated his population modeling law, which takes into account a particular growth rate and the fact that a certain biological niche can only support an optimal number of organisms before its population begins to wane. In 1963, well over 100 years later, a meteorologist from MIT named Edward Lorenz discovered that Verhulst's law described not only population models but certain models of complicated and turbulent atmospheric gas and fluid flows as well. It was Lorenz's work that really opened the doors to a new field called Nonlinear Dynamics.

If we examine bifurcation carefully, especially as the growth rate goes to 130%, 150%, 155%, 156%, 156.5%, and so on, we can begin to understand how cyclical order and predictability can turn into random chaos. Within this exploration, a very interesting numerical phenomenon appears that deals with the ratio of intervals of growth rate versus the doubling of the number of up and down cycles characteristic of that rate. These intervals are reduced (for each number of cycles doubling) by a *universal* factor of 4.669201660910... This number, first presented by Großman and Thomae, is called the Feigenbaum number, in honor of Mitchell Feigenbaum, a scientist at Los Alamos who discovered the universality of this number. Imagine how he must have felt to discover a constant of Nature as important to these phenomena as π is to circular geometry!

Sometime during the late 1970s, following up on the pioneering work of Gaston Julia, one of his professors, an IBM scientist named Benoit Mandelbrot made an intriguing leap of reason. Up until then, all of the studies of Verhulst processes and bifurcation theory had dealt with values within the real number set. He proposed that analogs to these ideas existed within the complex number set. Within a short time, on what is now archaic computer equipment, Mandelbrot first produced a picture of the famous set that bears his name. When he first printed the lobular Mandelbrot set, there were very small "dirt" marks on

the printout that were initially dismissed as printer glitches caused by an unclean roller and ribbon. Imagine his surprise to find that these "dirt" marks were actually miniature versions of the same set strewn symmetrically around the large central lobes. With the help of Adrien Douady and John Hubbard, Mandelbrot made a careful and thorough inspection of this set and the related Julia sets, Cantor sets, Fatou dusts, and Siegel disks. An incredible wealth of beauty and knowledge spilled forth as a result of their efforts. The work in this book is just the latest child to be born of these forefathers' efforts.

The most notable feature of these fractal objects is one of self-similarity. That is, if one were to enlarge certain portions of a Julia set, for example, one would find objects that are identical to the original Julia set from which they sprang. This pattern repeats over and over ad infinitum. In fact, because of this endless self-imaging and depth, the Mandelbrot set has been called the most complicated object ever discovered. For one particular client, I produced a Julia set fractal at a magnification of one trillion (10^{12}) and the magnified picture was essentially no different than the original. An abbreviated series of these images can be found in Chapter 6. Later I was able to continue this exploration of depth to a magnification of 169 quintillion (1 quintillion = 10^{18}) and still the fractal picture remained very much unchanged.

The emergence of affordable high-powered number crunchers now enables us to produce these fractal art pictures at a comfortable rate. Consider that the average fractal picture of 1800 by 1800 pixels at 150 iterations for each point comes to nearly 500,000,000 (half a billion!) calculations at a precision of 15 decimal places! I read somewhere that the first Julia set was calculated on paper by hand at a size of 100 points by 100 points and took nearly eighteen months to complete. At that rate it would take a man about five lifetimes and then some to do what a high-speed workstation can complete in fifteen minutes!

Since Mandelbrot's initial discovery, other researchers have made contributions to the field. A team of scientists from the University of Bremen, headed by H. O. Peitgen, is responsible for the most comprehensive work in the field to date, including *The Science of Fractal Images*, *The Beauty of Fractals*, and *Chaos and Fractals*. They explore many types of fractals with varying degrees of technical rigor, and are helpful in introducing algorithms that are easy to follow, should readers wish to produce the images on their own. Their three-dimensional fractals encouraged and inspired me to seek out ways to carry mathematical creativity to the new vistas of expression you see pictured in this volume.

Another important contributor is Dr. Michael Barnsley, then of the Georgia Institute of Technology, who formulated what he calls "iterated function systems," a way to generate self-similar objects using affine transformations (manipulation by matrices). He has shown how ferns, trees, brick walls, and other seemingly realistic objects can be generated using pure numbers. His first fractal book, *Fractals Everywhere,* is the first textbook on the subject actually intended for classroom learning, complete with projects and exercises. It is well-structured and rigorous, yet entertaining and insightful.

Both the late Aristide Lindemeyer and Przemyslaw Prusinkiewicz have contributed to mathematical constructions with their explorations into L-systems, a hybrid between turtle graphics and matrix manipulation. Their methods produce astonishingly realistic plants and flowers from a very small set of numerical parameters and instructions.

Another relatively early and important text is Becker and Dörfler's *Dynamical Systems and Fractals: Computer Graphics Experiments in Pascal.* This book, done in black and white, is full of instructive illustrations, algorithms, program fragments and examples, and is a most useful study from an experimental and programming point of view.

The works of Richard Voss of IBM, Loren Carpenter of Pixar, and F. Kenton Musgrave are impressive, as they are some of the earliest pioneers in rendering fractals as three-dimensional objects in scenes. Voss has done extensive work in bringing various types of 1/f noise to the fore, presenting them as realistically appearing landscapes and mountain ranges. Carpenter, besides penning some of the important early papers in computer graphics and ray-tracing, has had a hand in producing some of the wonderful fractal effects seen in the *Star Trek* movies. Musgrave is a very talented fractal artist whose otherworldly scenes are chilling in their realistic detail and artistic feel.

And then there are those in the field who have helped popularize fractals, enlightening the public as to the beauty and wonder of fractal mathematics. Mathematician A. K. Dewdney has written a number of enjoyable and entertaining articles for *Scientific American* that have inspired thousands of people. James Gleick, the author of the best-selling *Chaos: Making a New Science*, has introduced virtually millions of people to the ever-broadening field of chaos theory and fractals in an easily palatable and entertaining way. Mathematician/scientist Clifford Pickover is one of the most creative fractal artists and authors around. His books, *Computers and the Imagination, Mazes for the Mind,* and *Computers, Patterns, Chaos, and Beauty: Graphics from an Unseen World,* are informative, illustrative, fascinating, and just plain fun. Homer Smith, of Art Matrix, has used the supercomputer complex at Cornell University to produce probably the earliest collection of fractal slides and products available. Even the recent smash movie hit, *Jurassic Park,* contains a scene in which a mathematician is explaining chaos theory to another scientist on their way to view the dinosaurs.

Truly there have been many late contributors to the field. At last count there were about fifty different books and nearly 1,000 papers and articles written about chaos theory, fractals, and their applications. Scientists are using fractal methods for a very wide variety of applications. Besides population modeling, biological growth modeling, and fluid flow modeling mentioned earlier, other types of modeling are now being done: crystal growth, particle aggregation, and superconductivity. I recently read papers about modeling the fluctuations in the stock market as well as a new technique for compressing computer graphic images using fractal methods. The entire field is expanding so quickly, both in scope and the number of people getting involved, that I am sure there are still quite a few surprises awaiting us just around that next fractal curve.

CHAPTER TWO

Mandelbrot/Julia Set Fractals of the Equation $f(z) = z^2 + c$

This chapter is devoted entirely to the simplest and most popular of equations that generate Mandelbrot/Julia set fractals, $f(z) = z^2 + c$. There are a number of reasons for its popularity. First, this is the original expression to which Benoit Mandelbrot applied his leap of faith into complex iterations to produce his now famous Mandelbrot set. It and the corresponding infinite family of Julia sets are heir to an incredible wealth of mathemetical beauty and discovery. Second, being the simplest of expressions, it takes the shortest amount of time to render two hundred million calculations of it on a computer. Compare this equation with an equation such as $f(z) = z^2\sin x + cyz + z^2\cos x + cz \sin y + c$, and you'll see what I mean. Third, being the simplest and quickest of fractal-generating expressions, it has been popularized by many, many companies in a growing number of commercial products that require the high-tech visual punch and presentation these images offer. Furthermore, it is the expression that teachers generally use in the classroom to explain the basic principles of Mandelbrot and Julia set generation.

Many of the images in this chapter exhibit symmetry about the origin. This is because the function itself is what is called an "even" function. Technically, we say that an even function is one where $f(z) = f(-z)$. Other common even functions include $f(z) = z^4 + c$ and the cosine function. In all of these images, try to observe the number of symmetrical "arms" that are present. I have observed images with 29-fold, 37-fold, and even 43-fold symmetry, features not known to be ostensibly present in biological or other natural systems.

Some regions within these sets are totally self-similar; that is, the deeper and more magnified you go, the more the picture remains the same. Other regions produce deep wells of stability (black regions), seahorse-like extensions, and whirling vortices.

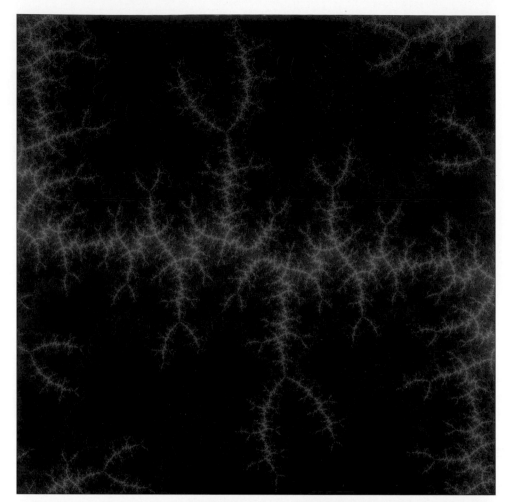

$f(z) = z^2 + c$

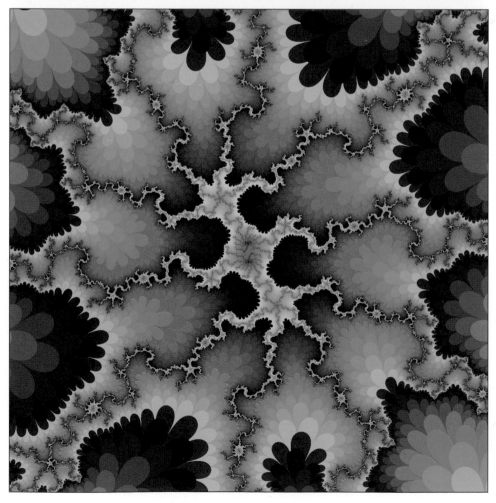

2-2

$f(z) = z^2 + c$

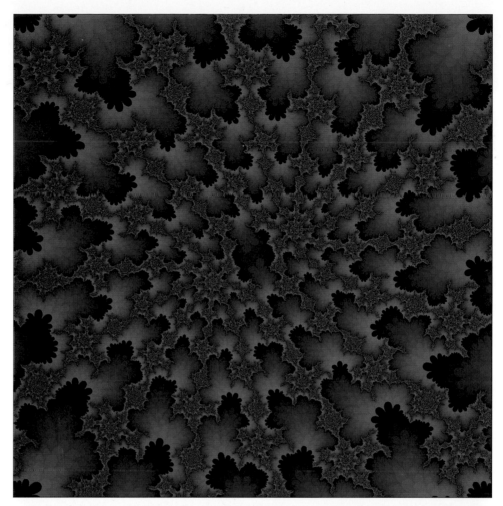

$f(z) = z^2 + c$

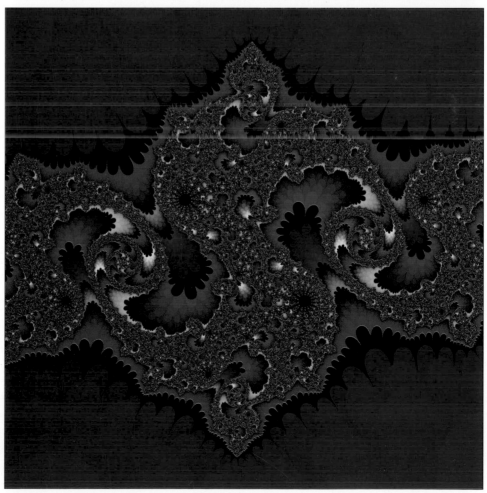

$f(z) = z^2 + c$

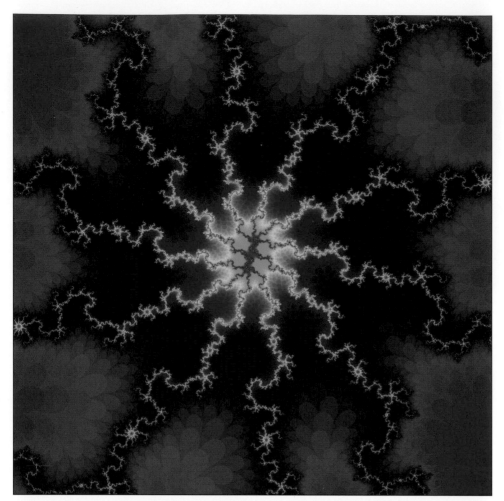

$f(z) = z^2 + c$

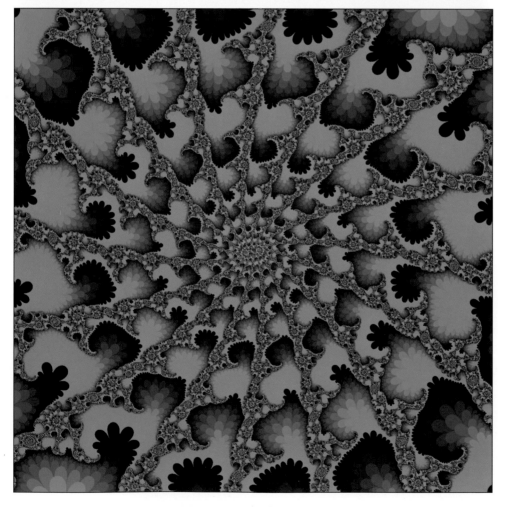

2-4

$f(z) = z^2 + c$

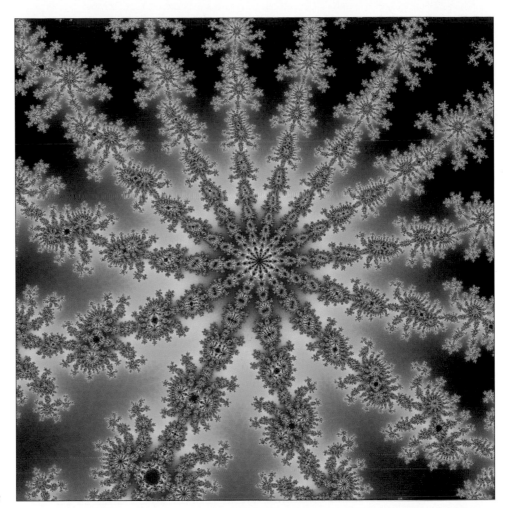

$f(z) = z^2 + c$

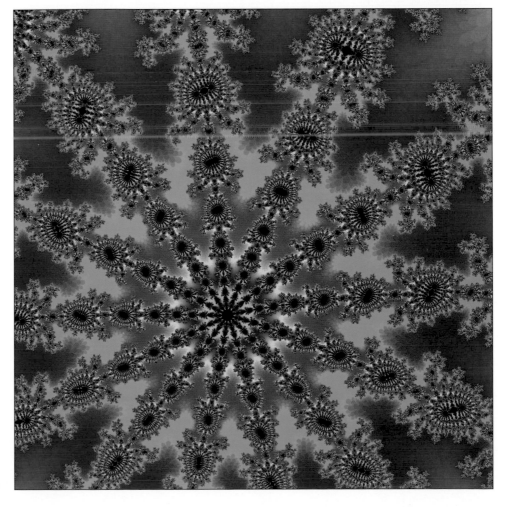

$f(z) = z^2 + c$

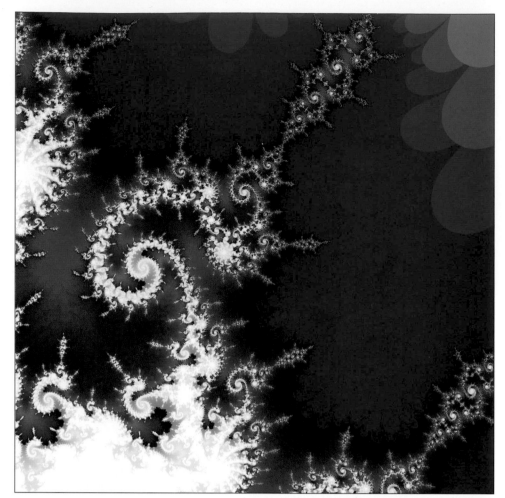

$f(z) = z^2 + c$

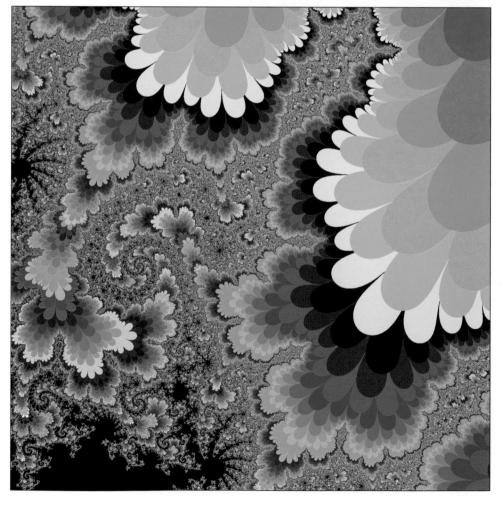

$f(z) = z^2 + c$

$f(z) = z^2 + c$

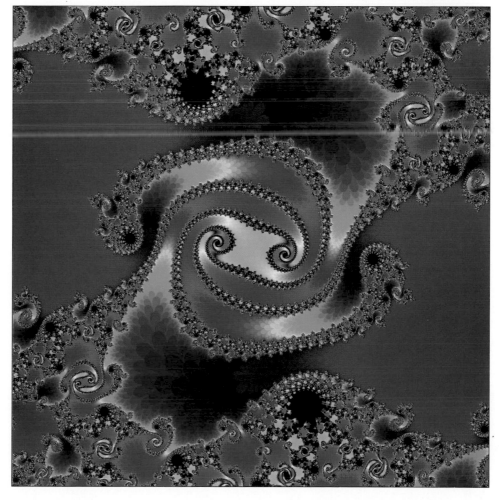

$f(z) = z^2 + c$

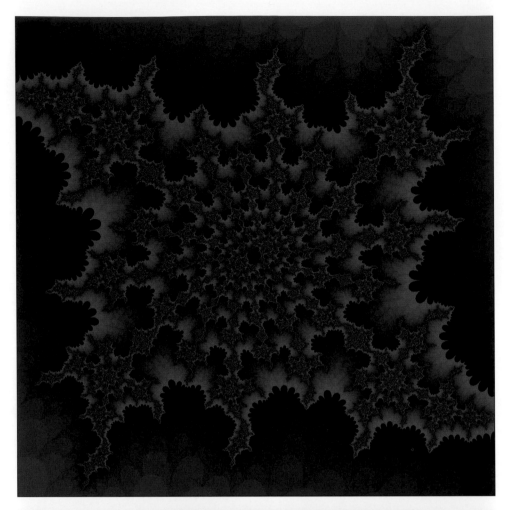

$f(z) = z^2 + c$

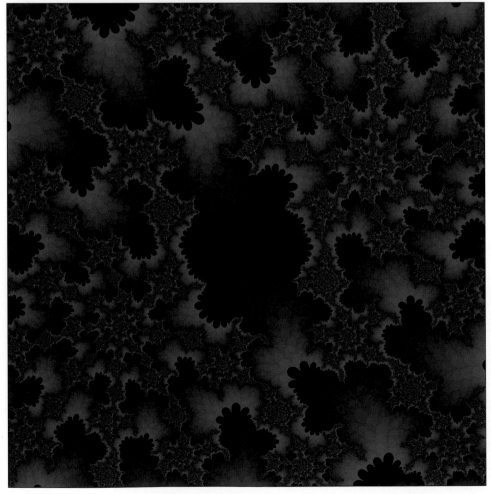

$f(z) = z^2 + c$

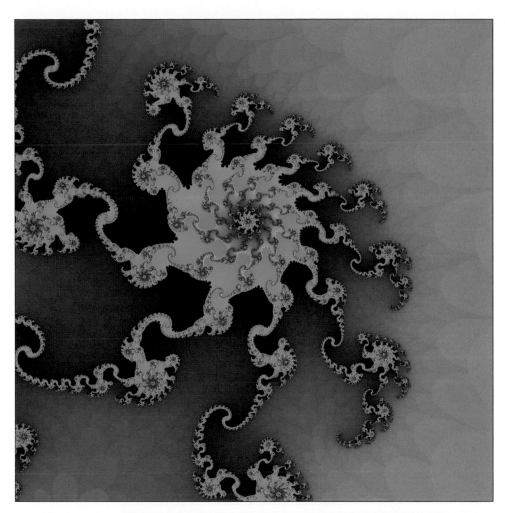

$f(z) = z^2 + c$

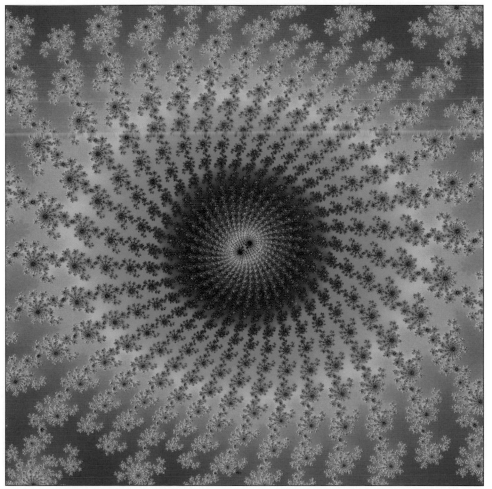

$f(z) = z^2 + c$

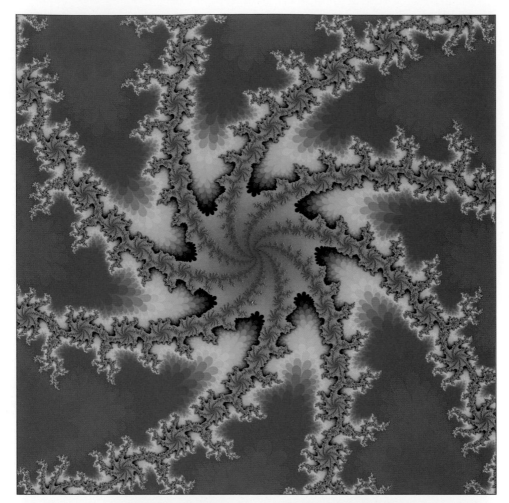

$f(z) = z^2 + c$

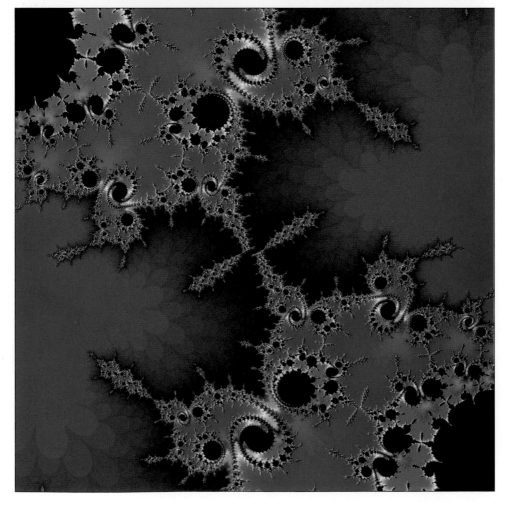

$f(z) = z^2 + c$

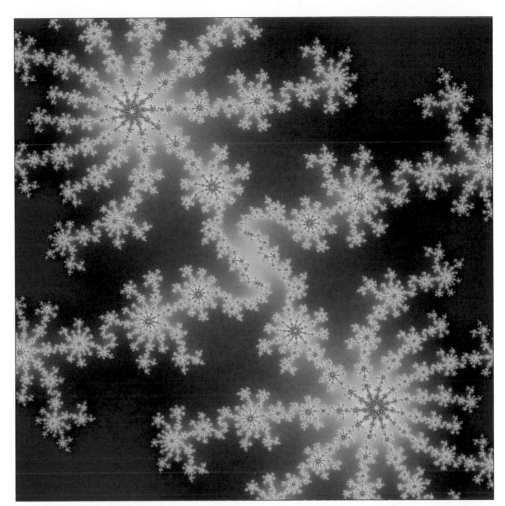

$f(z) = z^2 + c$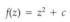

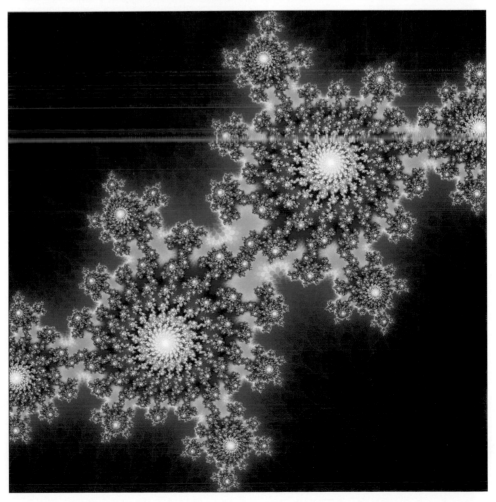

$f(z) = z^2 + c$

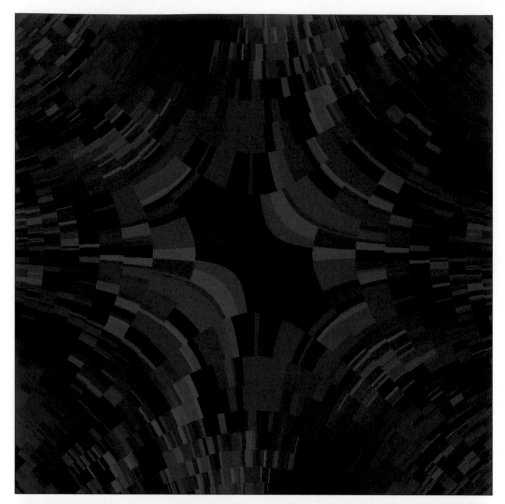

$f(z) = z^2 + c$

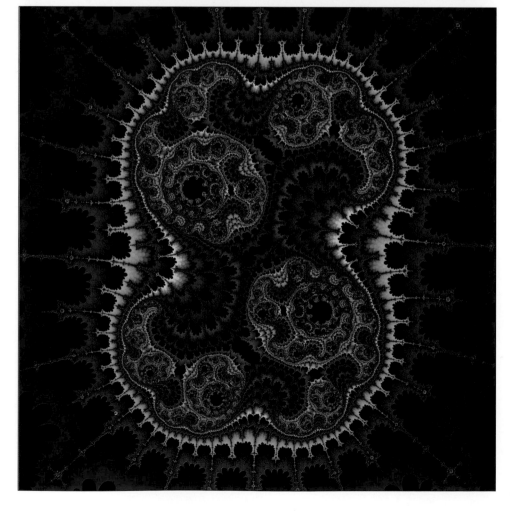

$f(z) = z^2 + c$

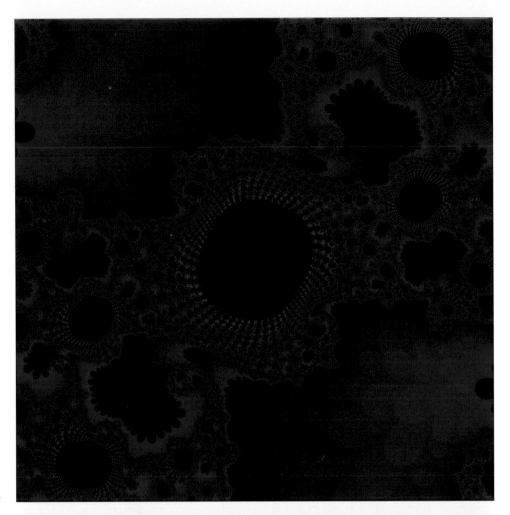

$f(z) = z^2 + c$

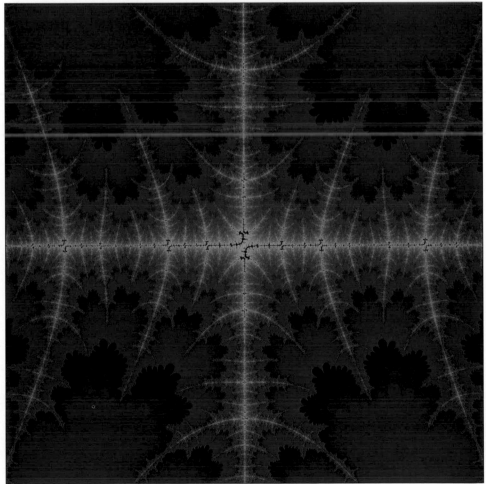

$f(z) = z^2 + c$

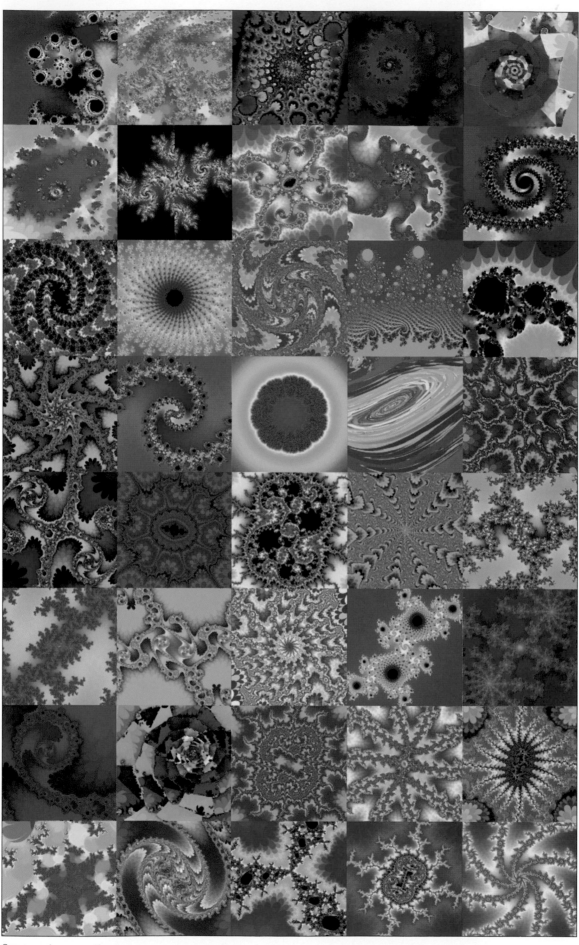

2-14 Seven various equations

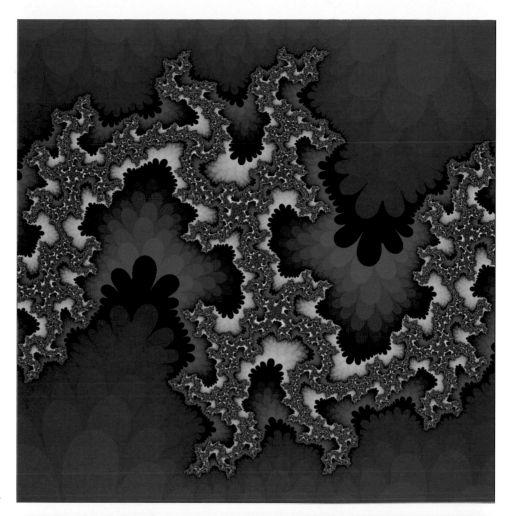

$f(z) = z^2 + c$

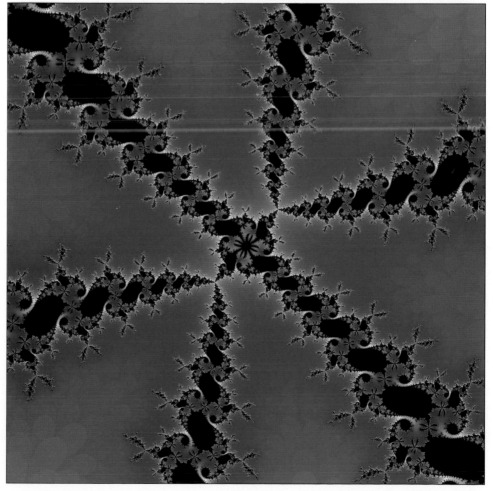

$f(z) = z^2 + c$

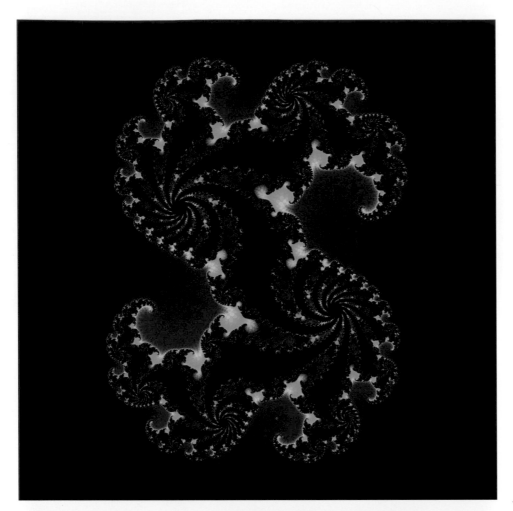

$f(z) = z^2 + c$

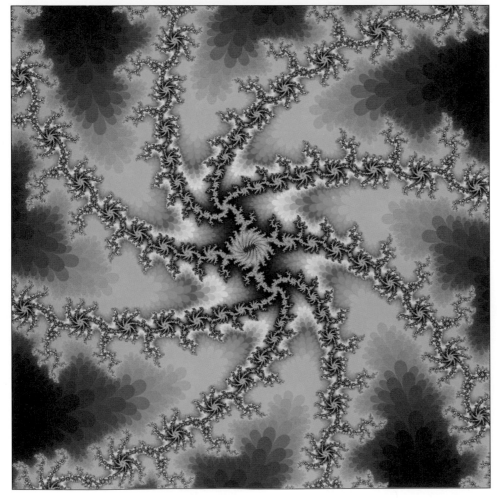

2-16

$f(z) = z^2 + c$

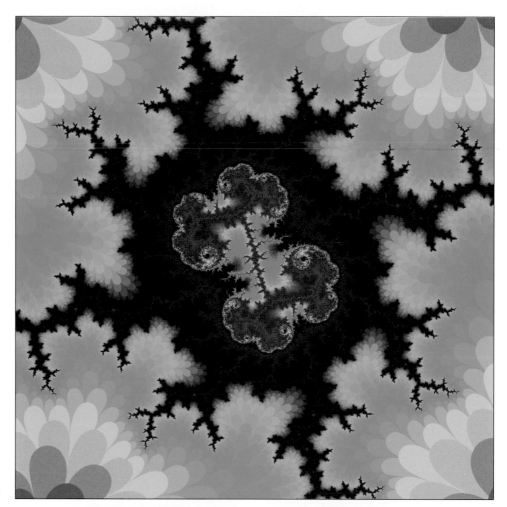

$f(z) = z^2 + c$

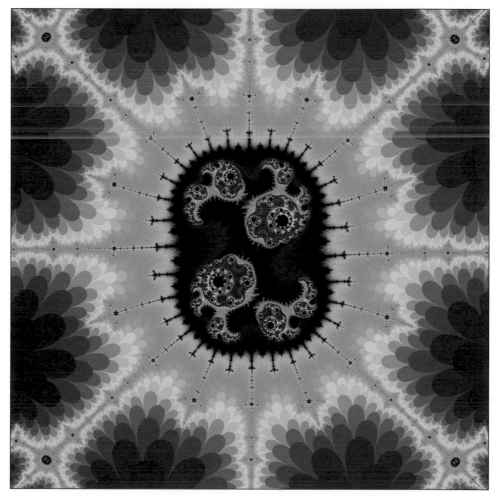

$f(z) = z^2 + c$

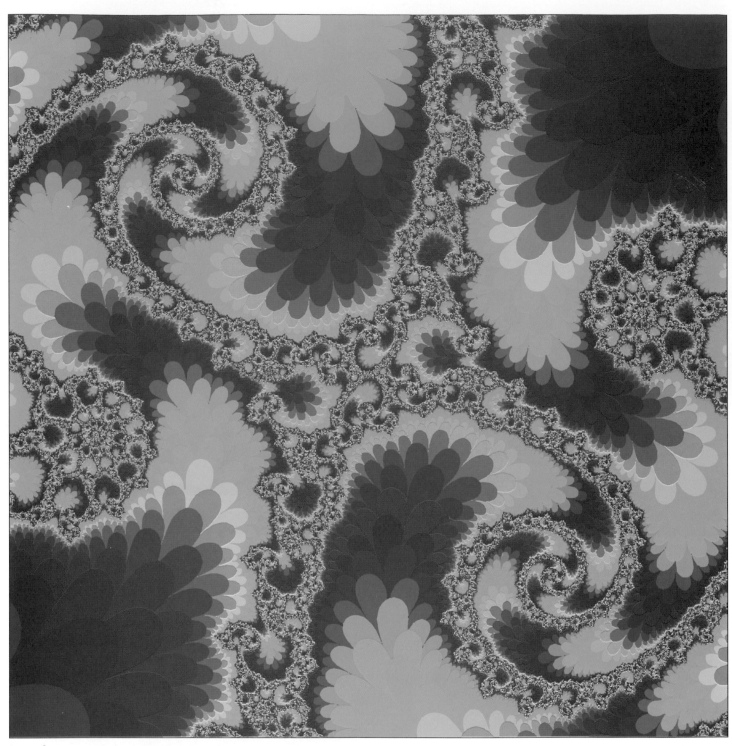

$f(z) = z^2 + c$

2-18

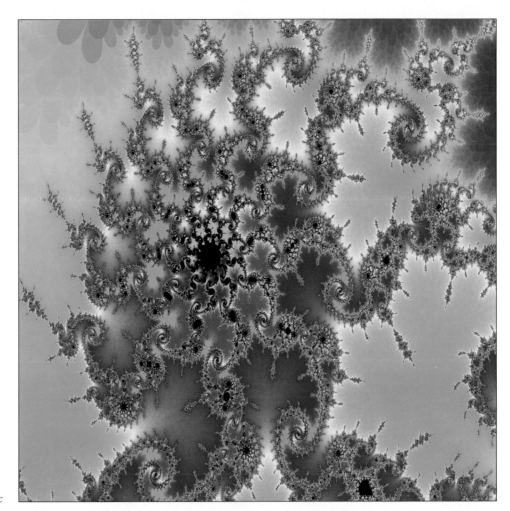

$f(z) = z^2 + c$

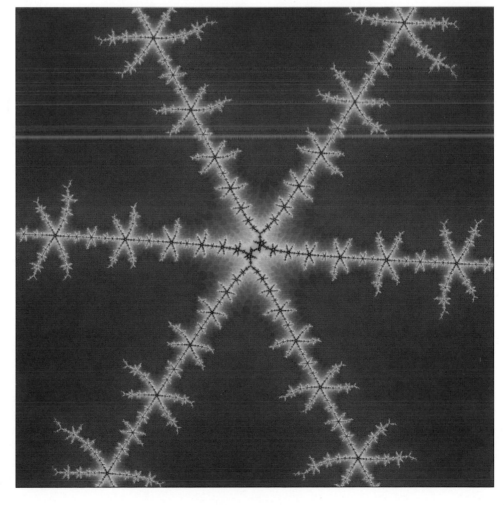

$f(z) = z^2 + c$

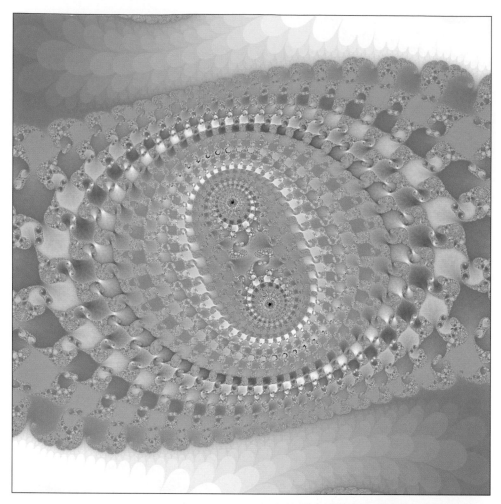

$f(z) = z^2 + c$

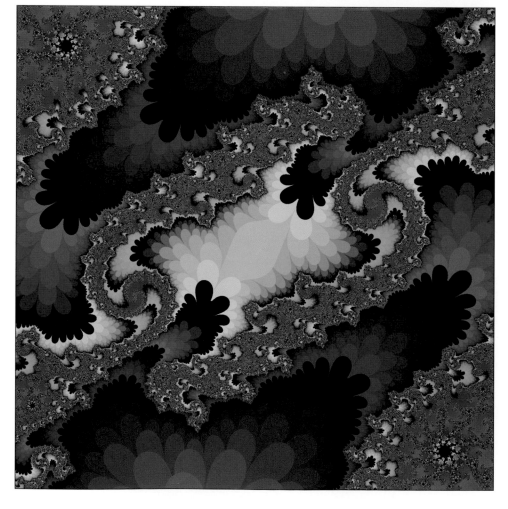

$f(z) = z^2 + c$

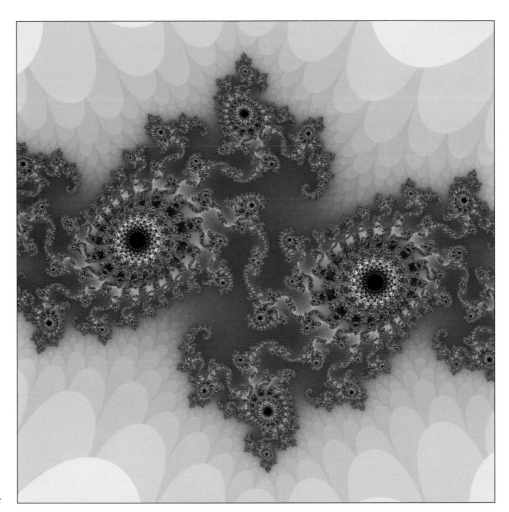

$f(z) = z^2 + c$

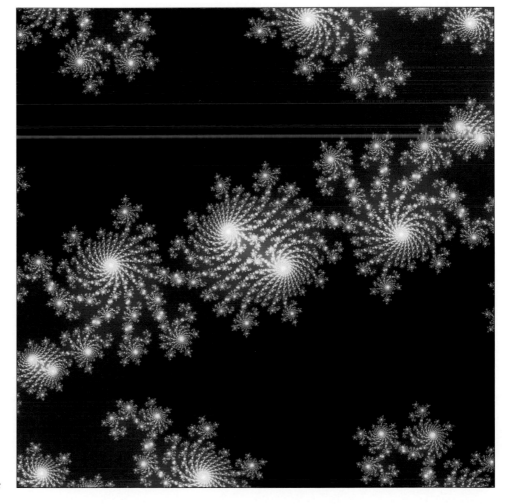

$f(z) = z^2 + c$

2-21

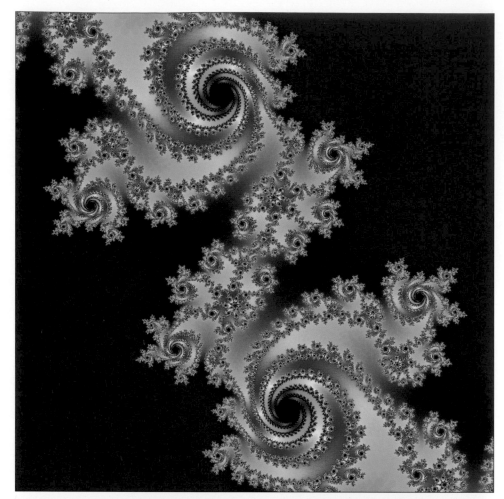

$f(z) = z^2 + c$

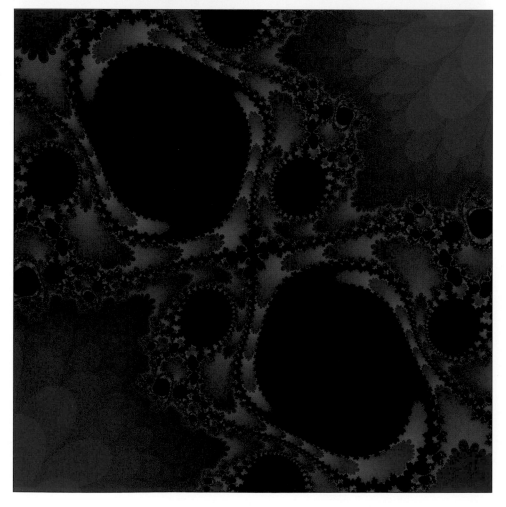

2-22

$f(z) = z^2 + c$

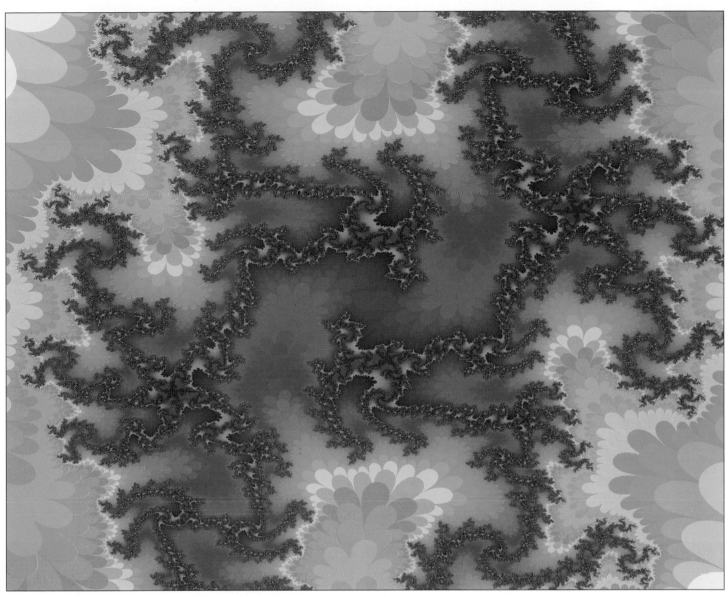

$f(z) = z^2 + c$

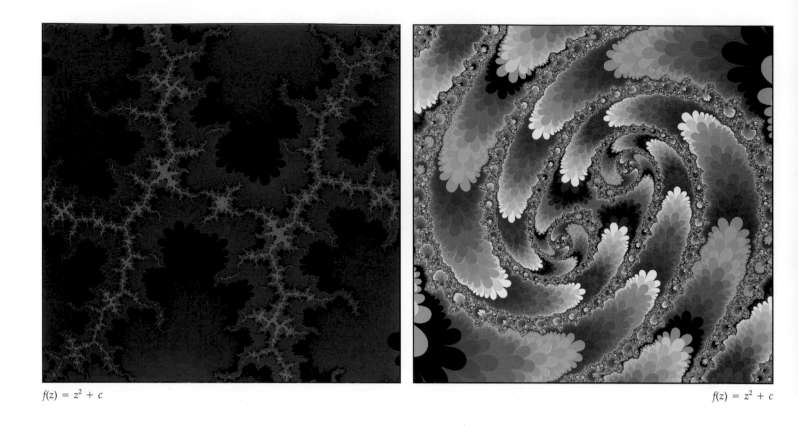

$f(z) = z^2 + c$

$f(z) = z^2 + c$

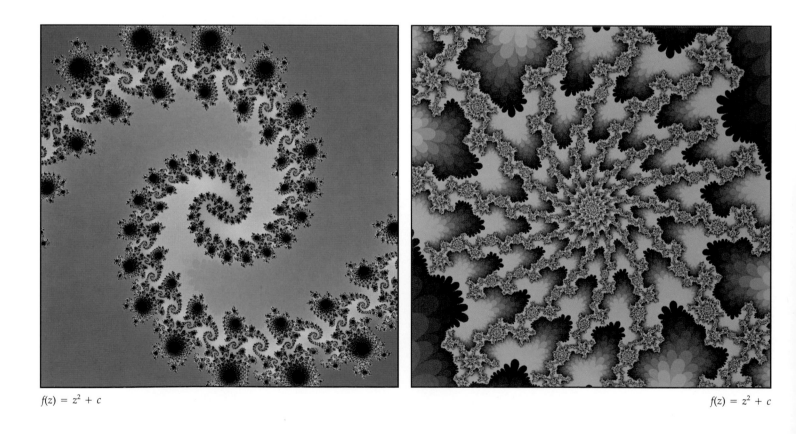

$f(z) = z^2 + c$

$f(z) = z^2 + c$

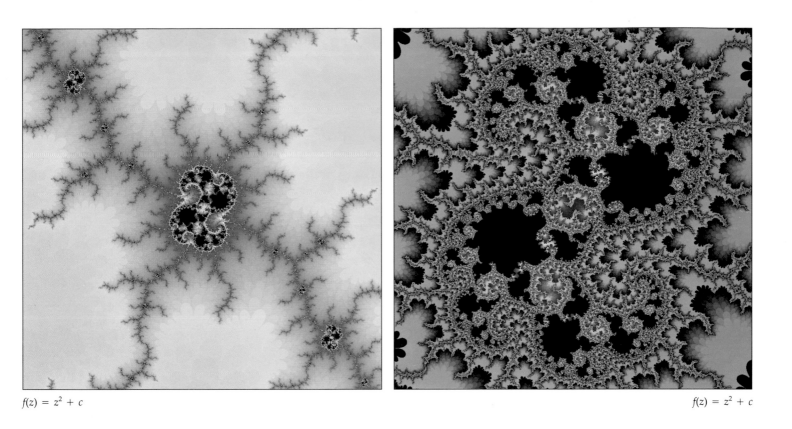

$f(z) = z^2 + c$

$f(z) = z^2 + c$

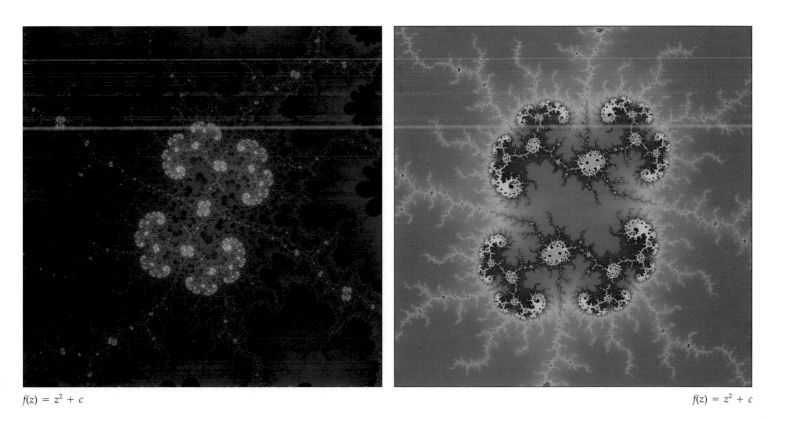

$f(z) = z^2 + c$

$f(z) = z^2 + c$

2-25

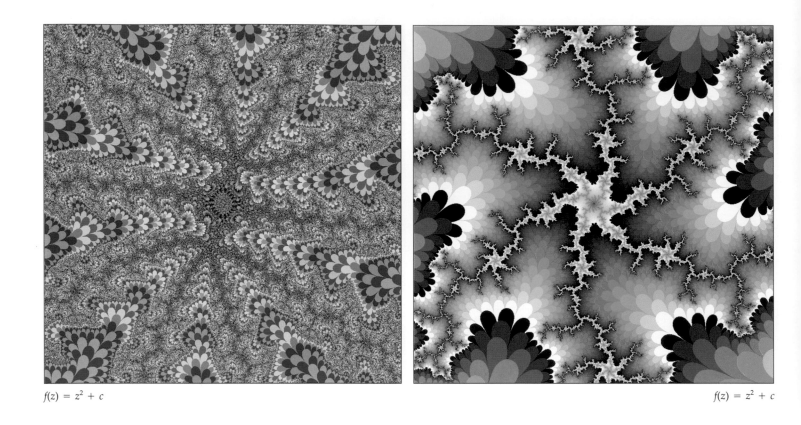

$f(z) = z^2 + c$

$f(z) = z^2 + c$

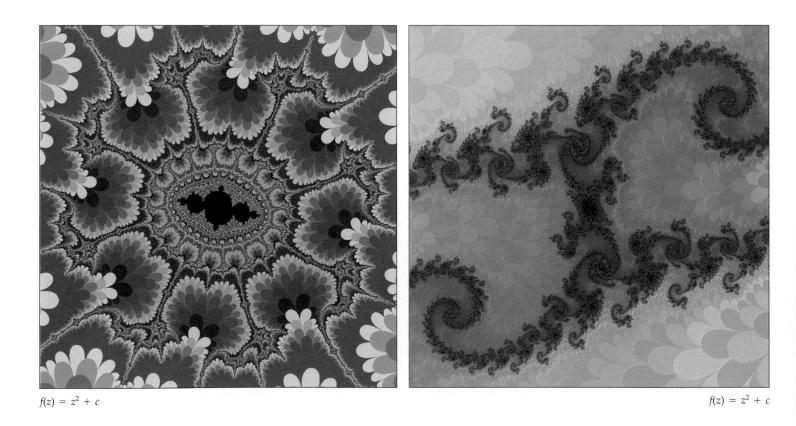

$f(z) = z^2 + c$

$f(z) = z^2 + c$

2-26

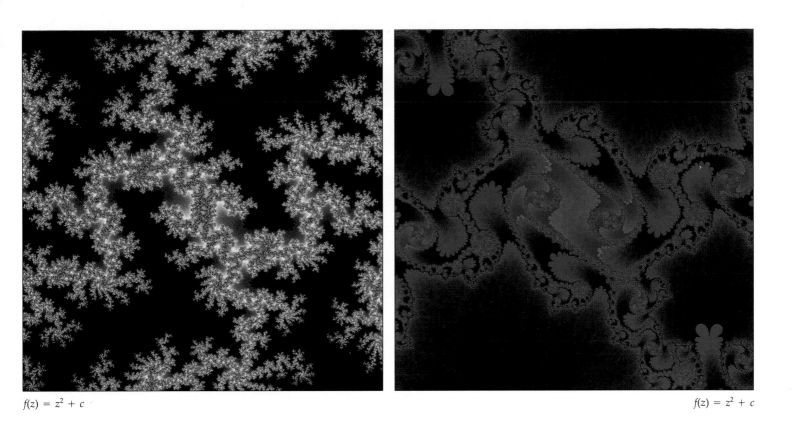

$f(z) = z^2 + c$

$f(z) = z^2 + c$

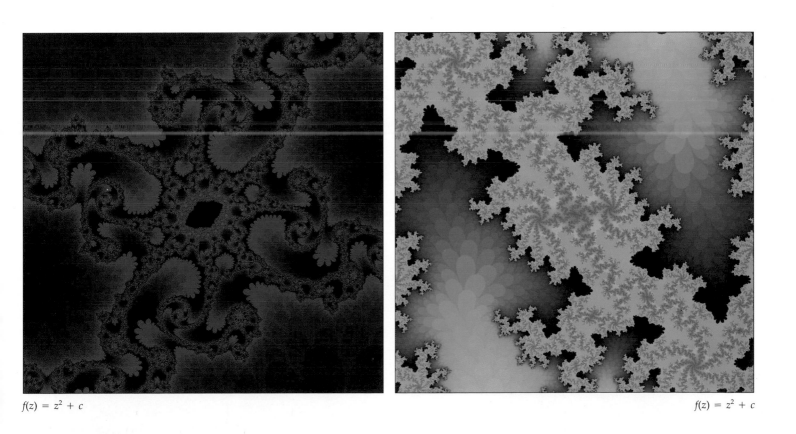

$f(z) = z^2 + c$

$f(z) = z^2 + c$

2-27

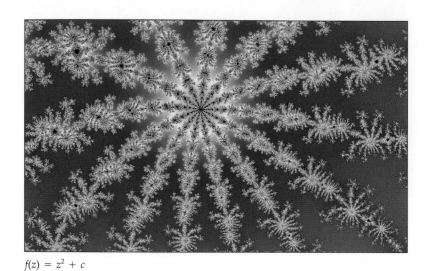

$f(z) = z^2 + c$

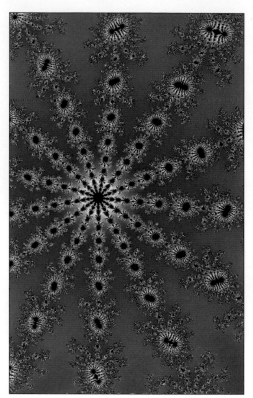

$f(z) = z^2 + c$

$f(z) = z^2 + c$

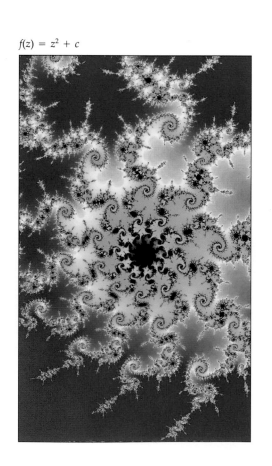

$f(z) = z^2 + c$

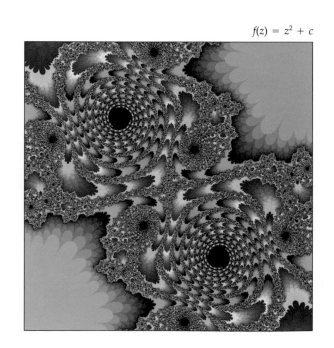

2-28

CHAPTER THREE

Mandelbrot/Julia Set Fractals of Polynomials, Powers, Roots, and Rational Expressions

This chapter begins the breaking of some new ground within the realm of fractal exploration. It is not so much that these algebraic equations are anything new or that any profound discoveries are hereby announced, but more like the situation of the famous sculptor who said that his creation was always inside the chunk of marble; all he did was uncover it. These images surely fortify the feelings of awe one gets from the beauty, majesty, and incredible detail within the orchestration of creation.

I have tried to show that, even with very high orders (z^{20} and up), the principles of symmetry and self-similarity continue to govern the behavior of these expressions and that they are really not too far removed from the simplest expression presented in Chapter 2. That is not to say that "there is nothing new under the sun." Just witness the beauty in some of the ninth-order expressions, the equations involving roots, and even some of the rational expressions. (A rational expression is one that involves the division of one algebraic expression by another—a complicated fraction.)

I should mention that whenever you see an expression with a fractional or decimal exponent such as $(z^3 + 1)^{.5}$ or $(z^5 + 1)^{(1/3)}$ or $(z^9 + c)^{.25}$, it means that we are taking the particular square root or third root or fourth root, respectively, of a particular expression.

Given the limited size of this publication, I am not able to show all of my work in this realm, but I will continue explorations into higher orders. I have calculated the complete expansions of the expressions $f(z) = z^{30} + c$ through $f(z) = z^{60} + c$ in addition to dozens of new fractal-generating equations not yet incorporated into my computer code. It is now a matter of inserting these unwieldy expressions into my fractal program and letting the computer do its thing. With the success of this book, I look forward to bold new vistas of mathematical exploration and visual expression.

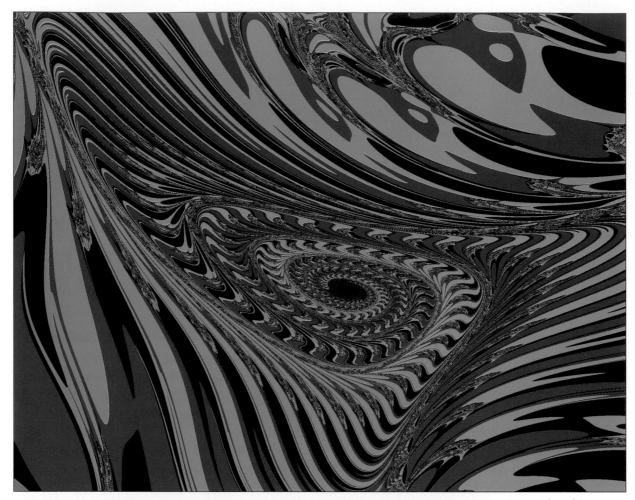

$f(z) = (z^3 + z^2 + z + c)/(z - c)$

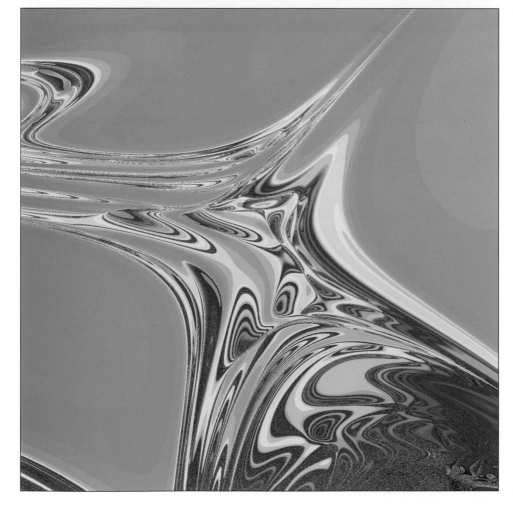

$f(z) = (z^2 + c)/(z - c)$

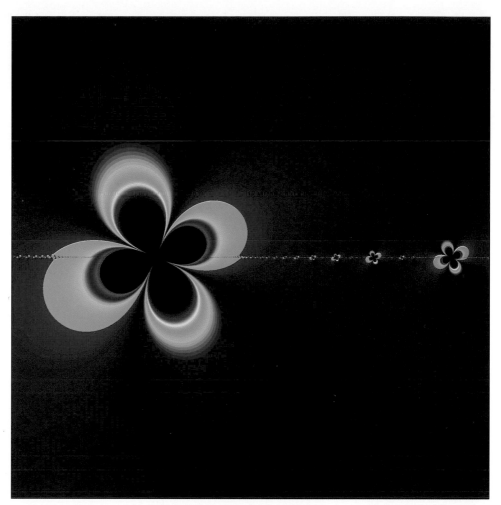

$f(z) = ((z + 1)^2 + c)/z$

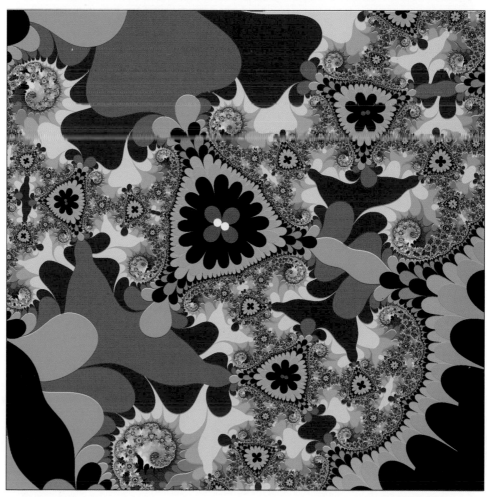

$f(z) = (z^3 + c)/z$

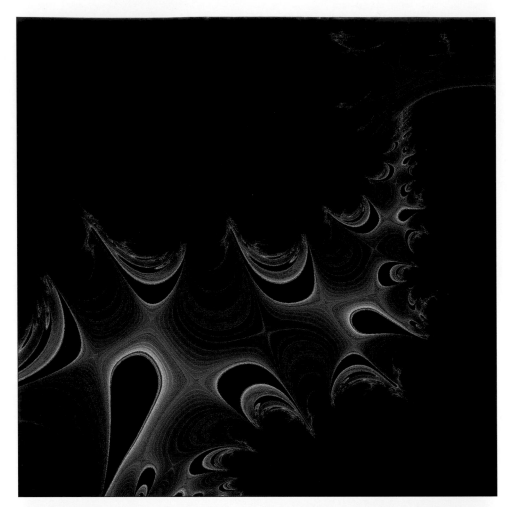

$$f(z) = (z^2 + c)^2 + z + c$$

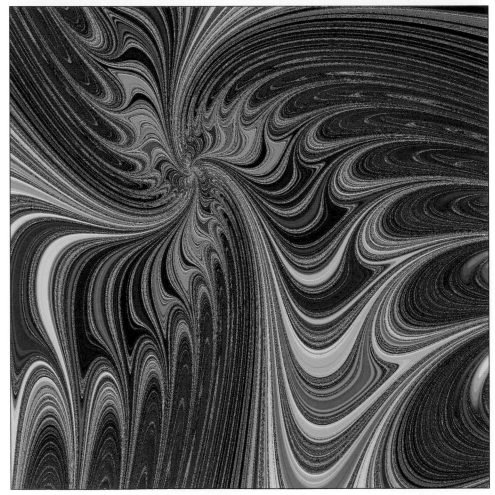

3-4

$$f(z) = z^3 + c$$

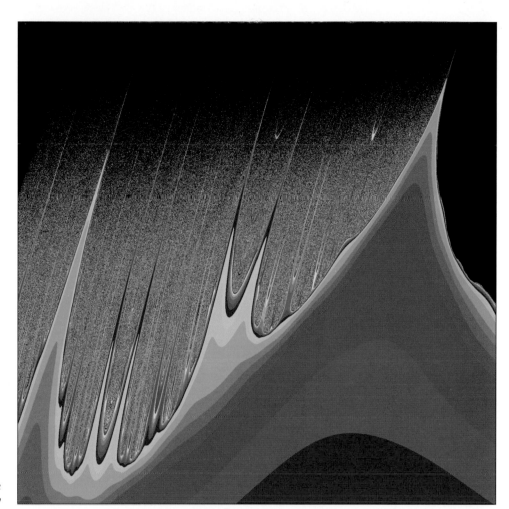

$f(x) = x^2 + xy + a$
$f(y) = y^2 - xy + b$

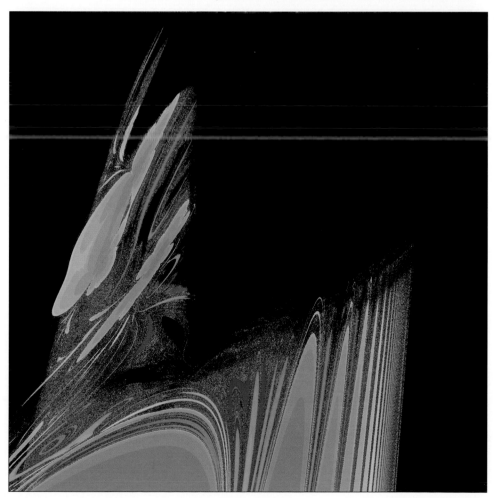

$f(z) = (z^2 + c)^2/(z - c)$

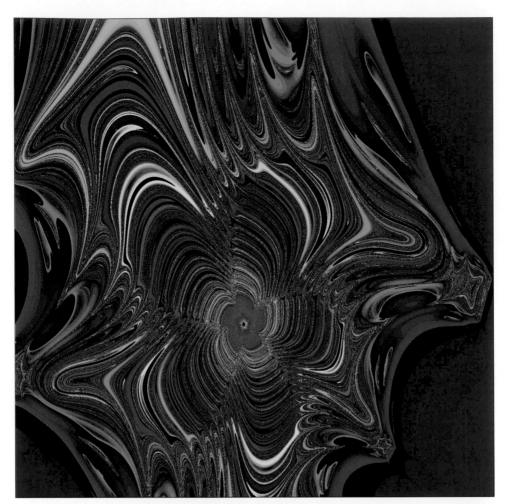

$f(z) = z^3 + c$

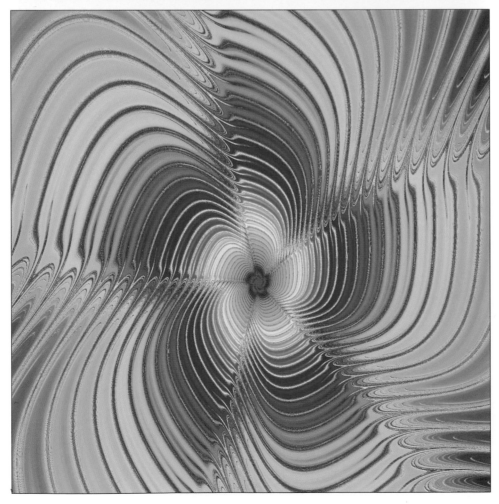

$f(z) = z^3 + c$

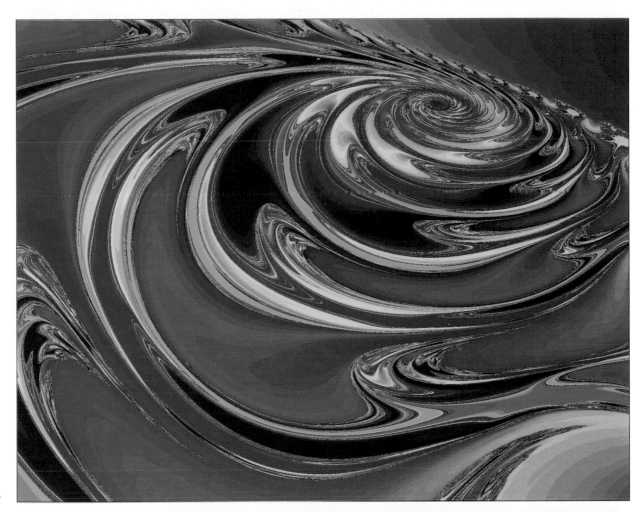

$f(z) = z^7 + c$

$f(z) = (4z^5 + c)/5z^4$

3-7

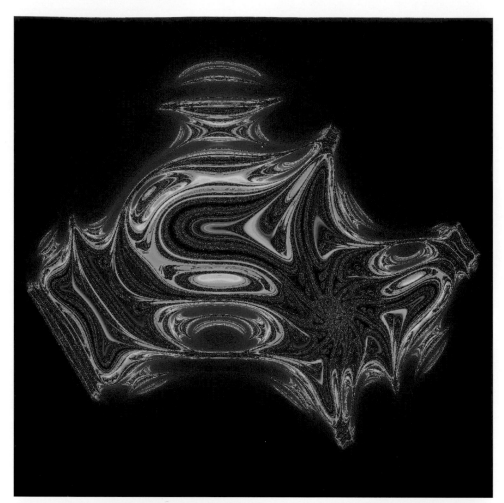

$f(z) = z^3 + c$

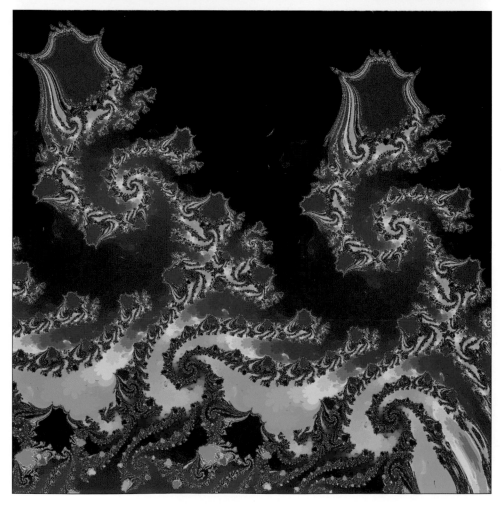

$f(z) = z^{20} + c$

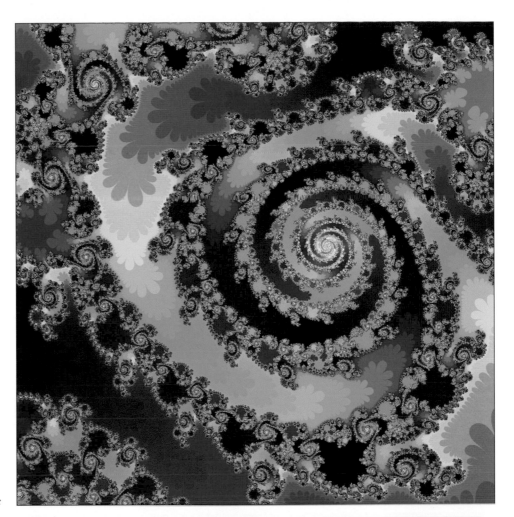

$f(z) = z^9 + c$

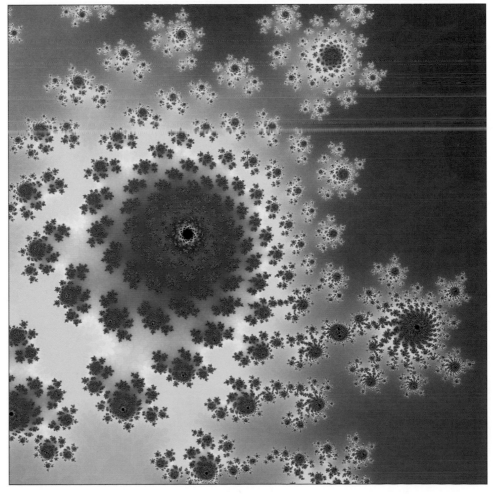

$f(z) = z^2 - z + c$

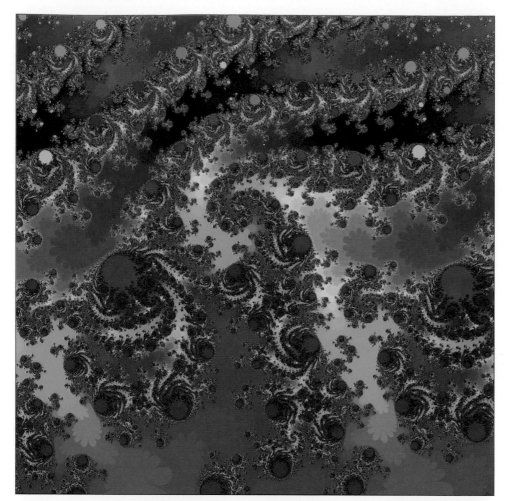

$f(z) = z^{22} + c$

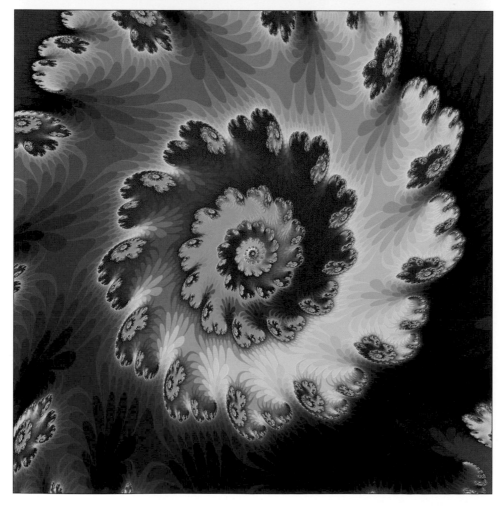

3-10

$f(z) = cz^2 + c^2z$

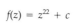

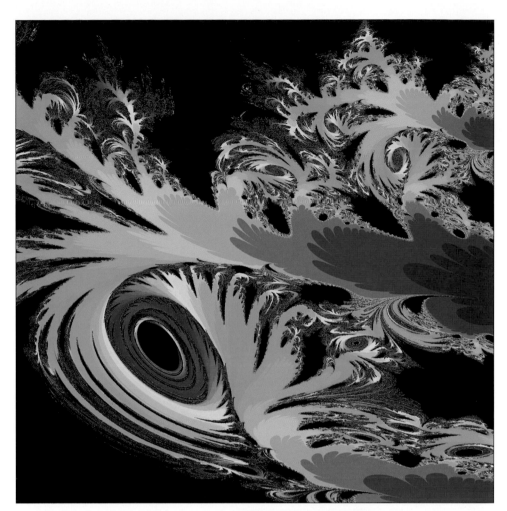

$f(z) = z^{24} + c$

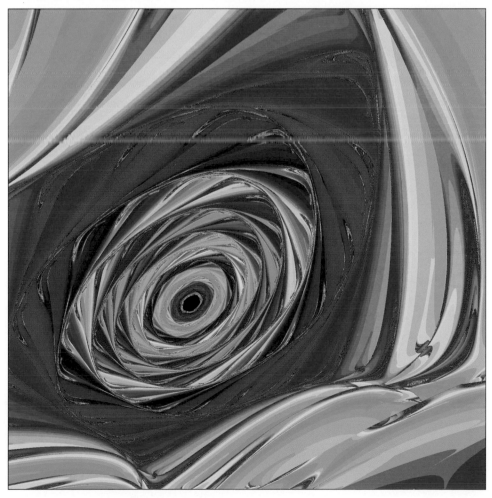

$f(z) = (z^3 + 1)^{.5} + c$

3-11

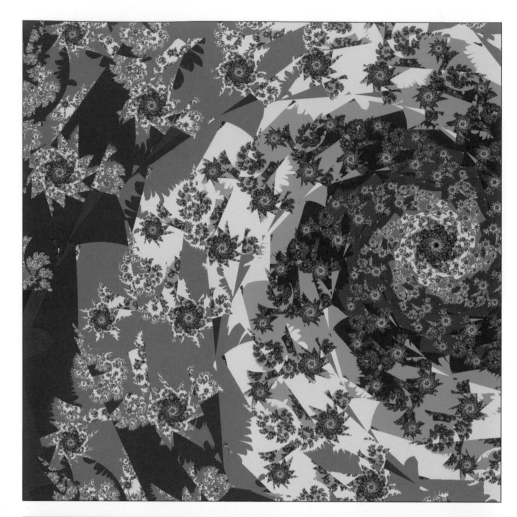

$f(z) = z^2 + z^{1.5} + c$

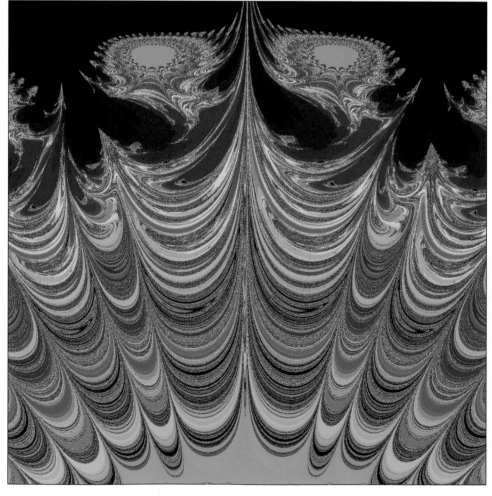

$f(z) = z^{24} + c$

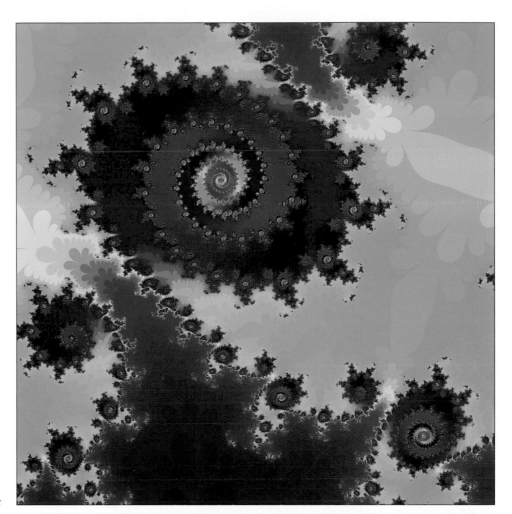

$f(z) = z^4 + z + c$

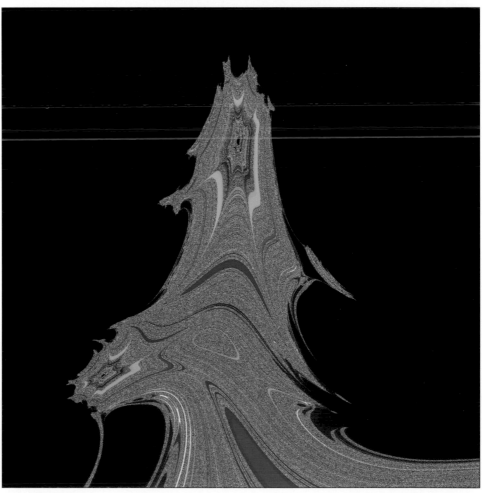

$f(z) = z^{11} + c$

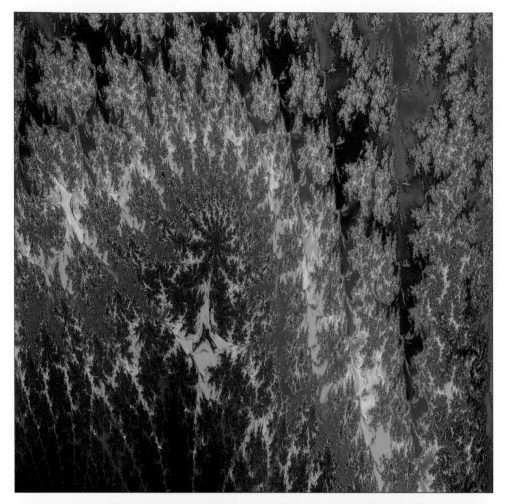

$f(z) = (z^5 + c)/(z^3 + z^2 + z + 1)$

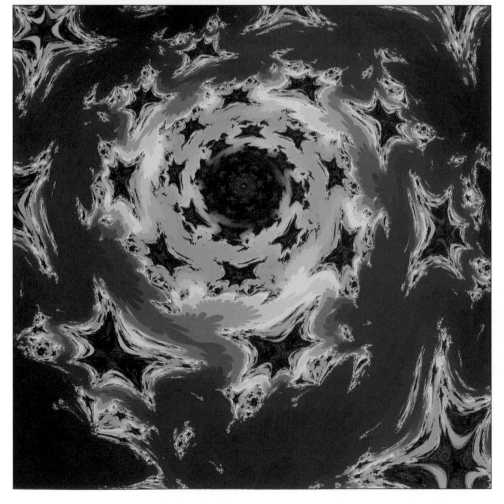

3-14

$f(z) = z^9 - cz^6 + cz^3 + c$

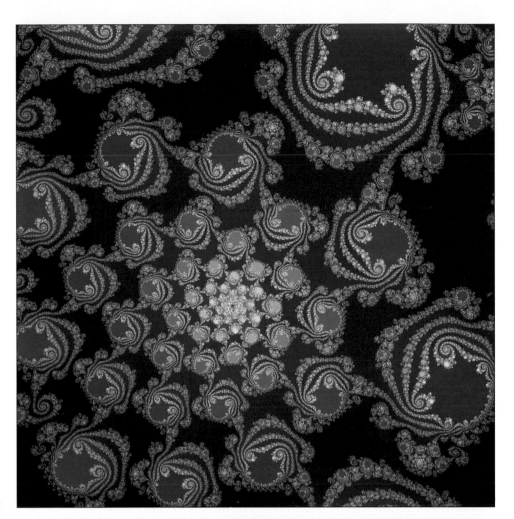

$f(z) = z^{10} + c$

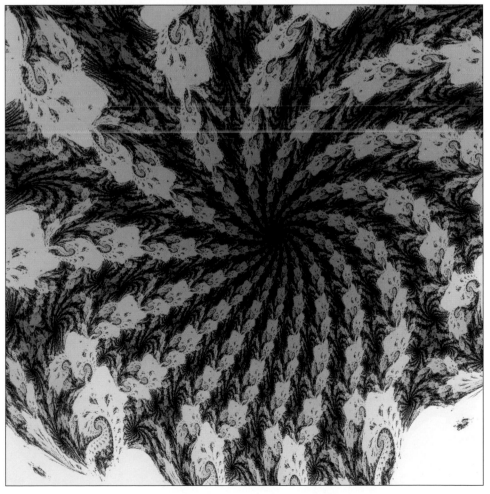

$f(z) = z^9 - cz^6 + cz^3 + c$

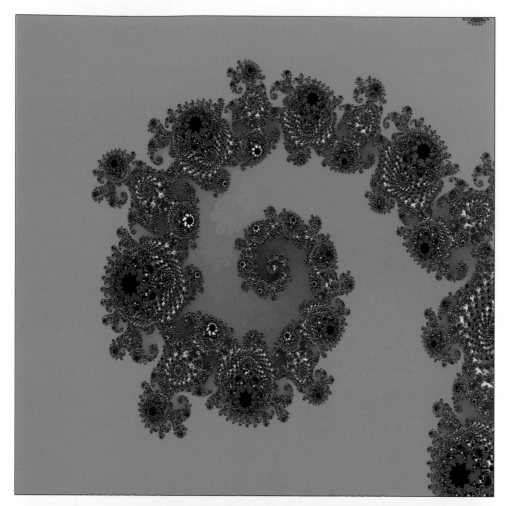

$f(z) = z^{12} - z^{11} - z^{10} + c$

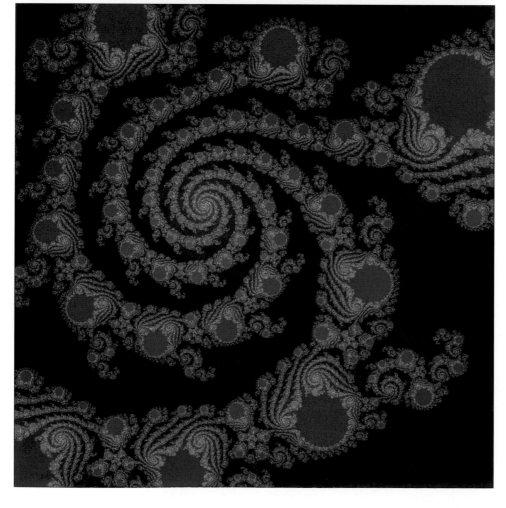

3-16

$f(z) = z^{12} + c$

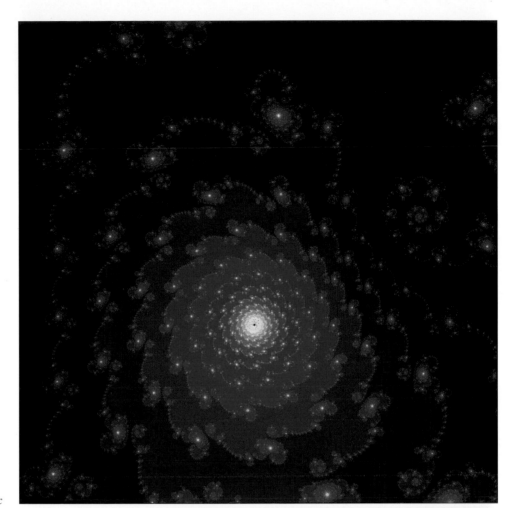

$f(z) = z^{10} + c$

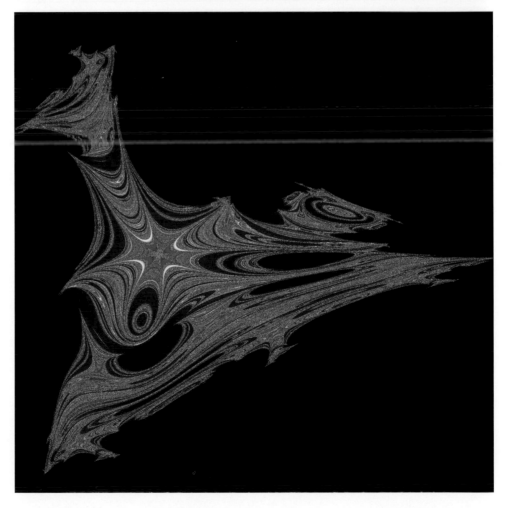

$f(z) = (z^3 - z^2)^2 + c$

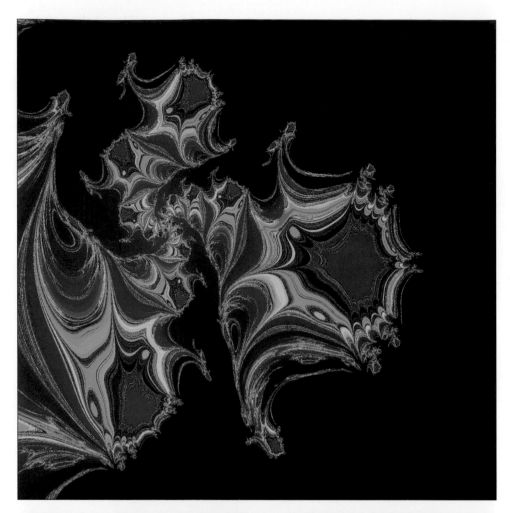

$f(z) = z^{15} + c$

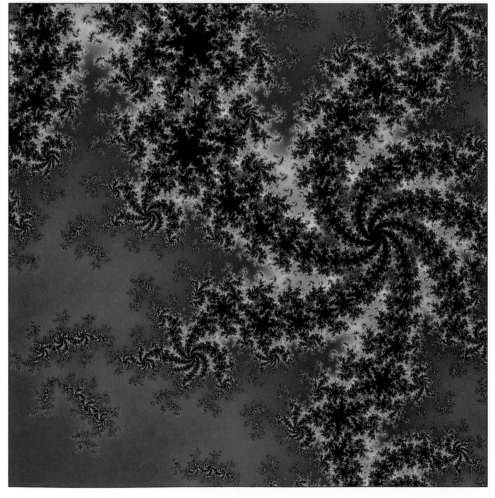

3-18

$f(z) = z^4 + cz^2 + c$

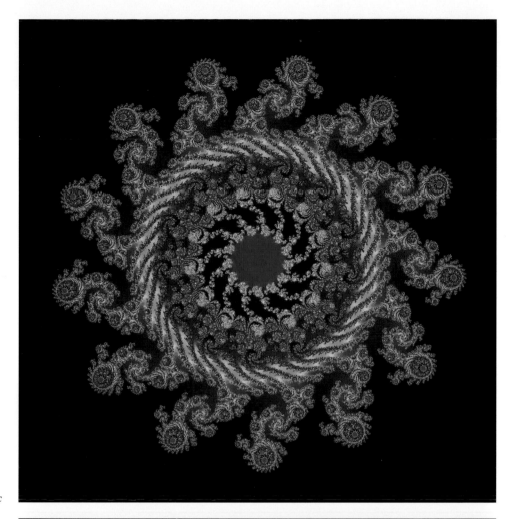

$f(z) = z^{13} + c$

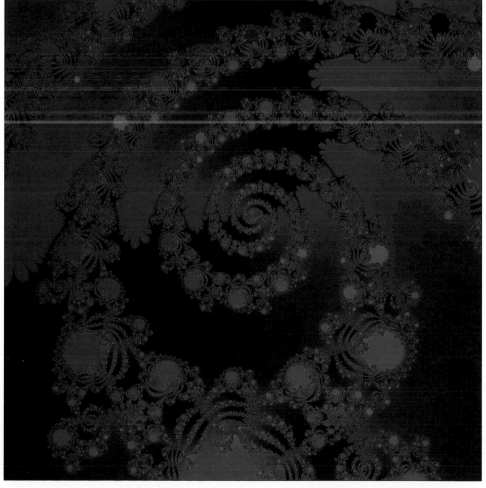

$f(z) = z^{10} + c$

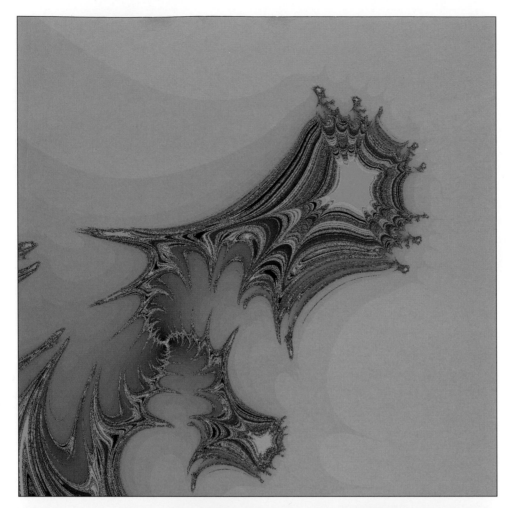

$f(z) = z^{15} + c$

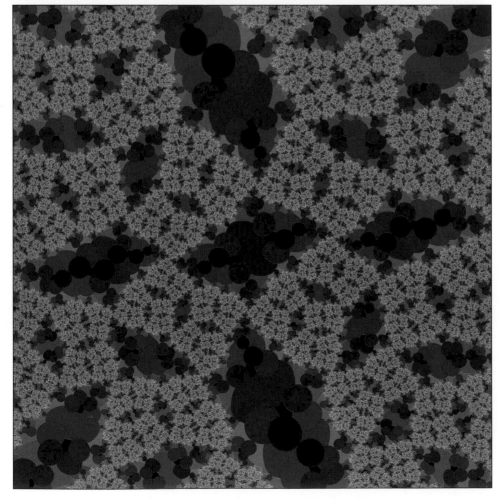

3-20

$f(z) = (z^2 + c + 1)/(z^2 - c - 1)$

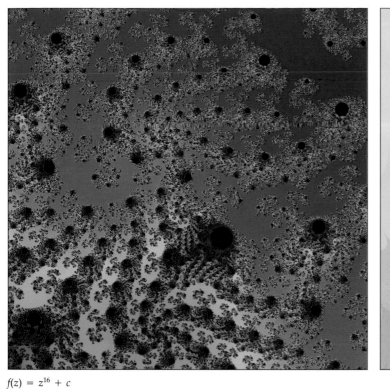

$f(z) = z^{16} + c$

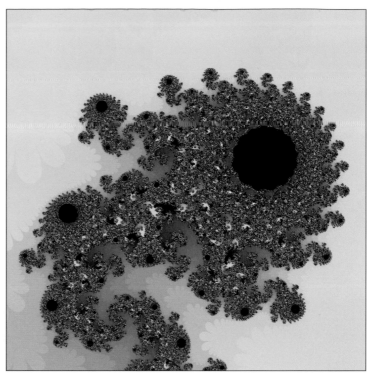

$f(z) = z^{16} \mid c$

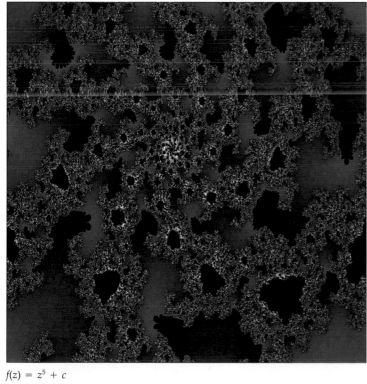

$f(z) = z^5 + c$

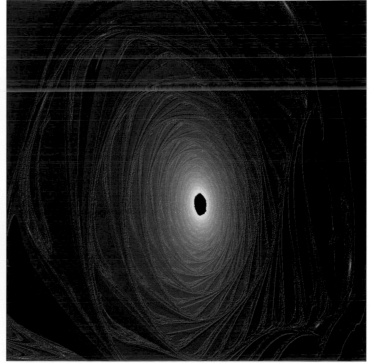

$f(z) = (z^3 + 1)^{.5} + c$

3-21

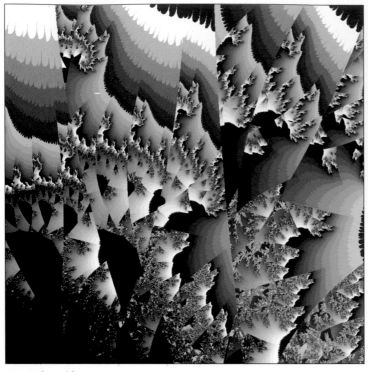

$f(z) = z^2 + z^{1.5} + c$

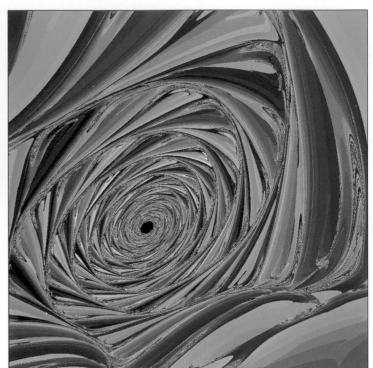

$f(z) = (z^3 + 1)^{.5} + c$

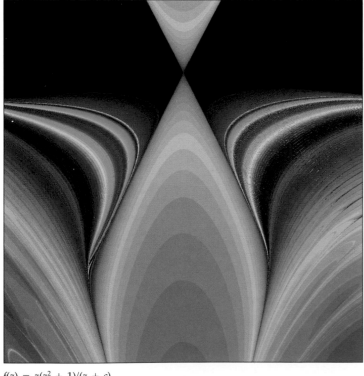

$f(z) = z(z^2 + 1)/(z + c)$

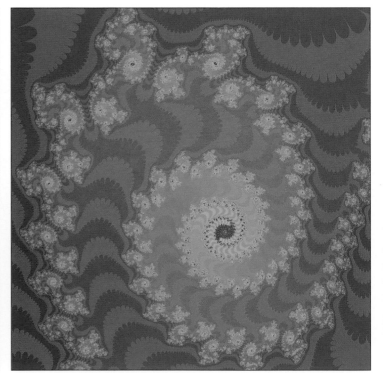

$f(z) = z^3 - z^2 + z + c$

3-22

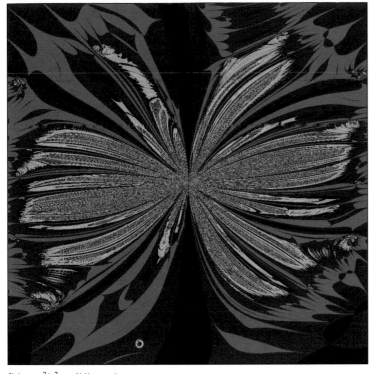

$f(z) = z^2(z^2 + 1)/(z + c)$

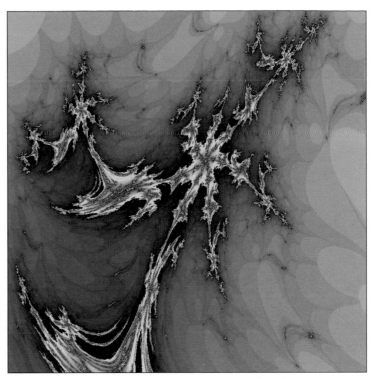

$f(z) = (z^3 + z^2 + z + c)/(z - c)$

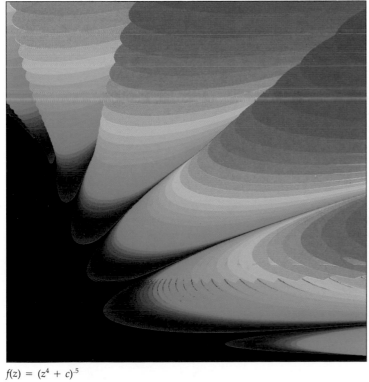

$f(z) = (z^4 + c)^{.5}$

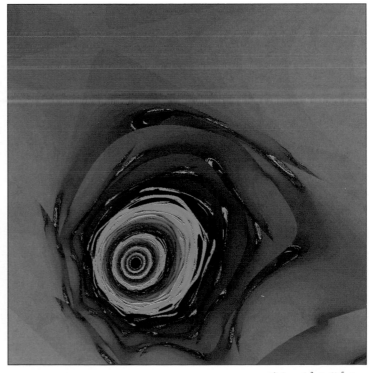

$f(z) = (z^3 + 1)^{.5} + c$

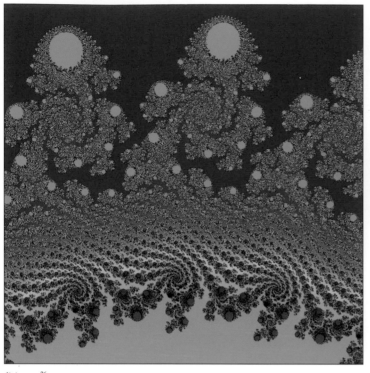

$f(z) = z^{26} + c$

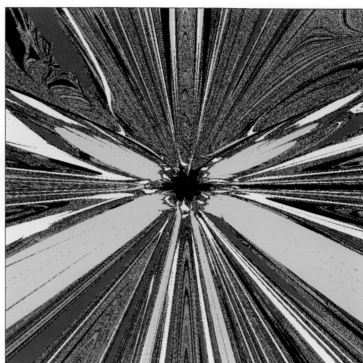

$f(z) = (6z^7 + c)/7z^6$

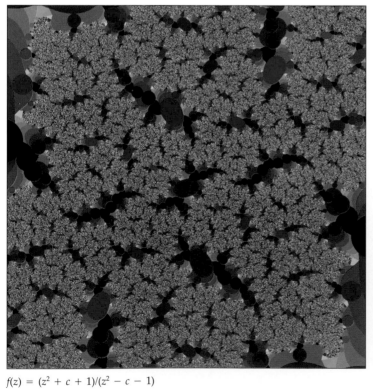

$f(z) = (z^2 + c + 1)/(z^2 - c - 1)$

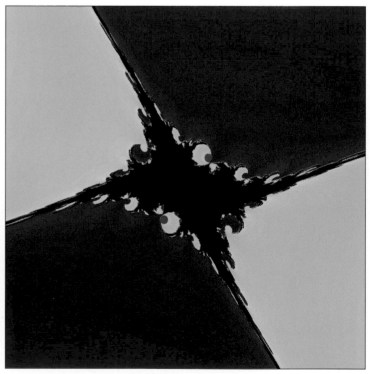

$f(z) = z^3/(1 + cz^2)$

3-24

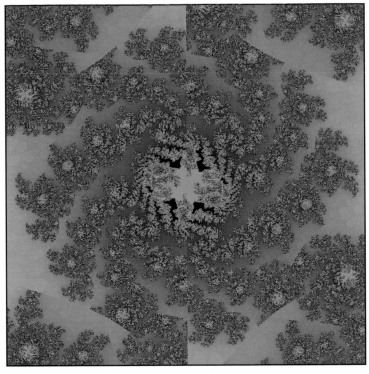

$f(z) = z^\pi + \pi^c$

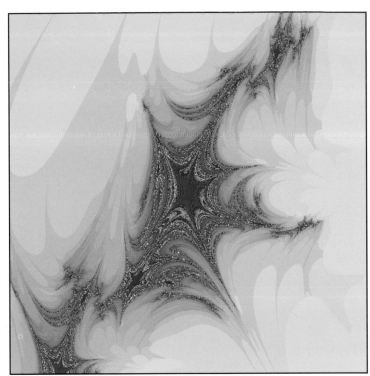

$f(z) = ((z^2(x - y^2))/(1 - z)) + c$

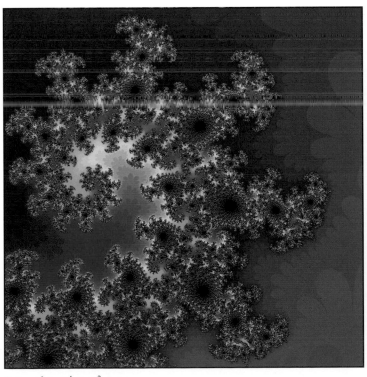

$f(z) = z^6 + cz^4 + cz^2 + c$

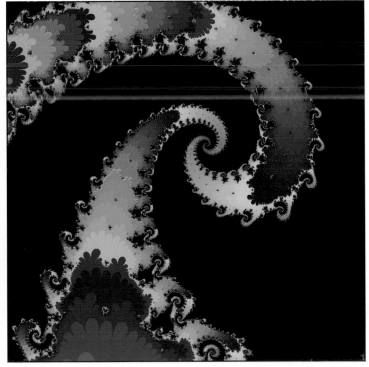

$f(z) = z^6 + cz^4 + cz^2 + c$

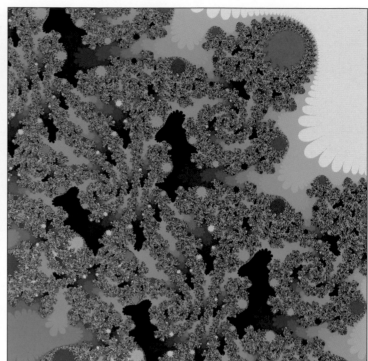

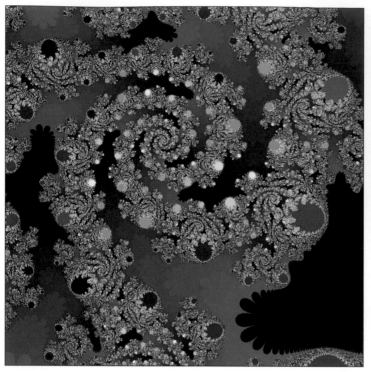

$f(z) = z^{26} + c$

$f(z) = z^{26} + c$

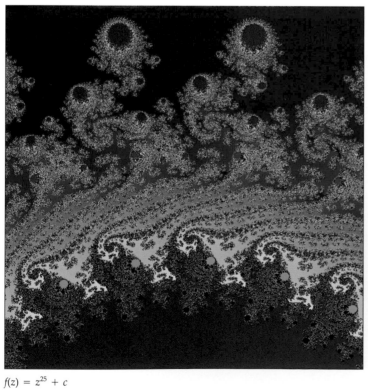

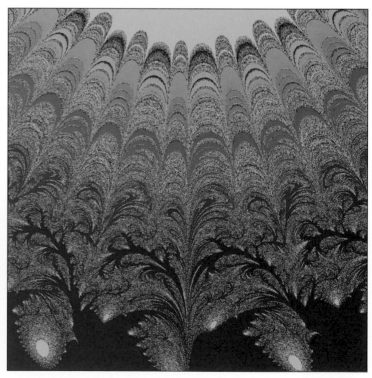

$f(z) = z^{25} + c$

$f(z) = z^{24} + c$

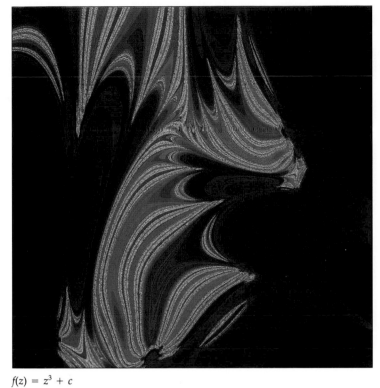

$f(z) = z^3 + c$

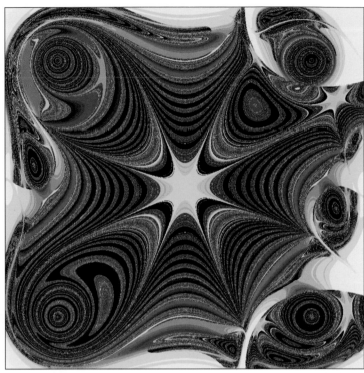

$f(z) = (z^4 + 1)^{.5} + c$

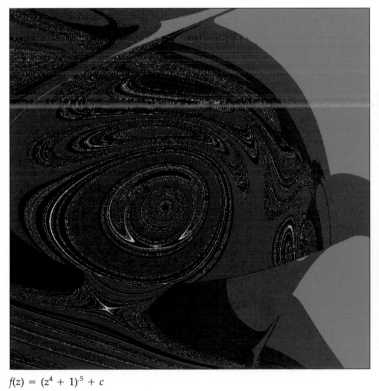

$f(z) = (z^4 + 1)^{.5} + c$

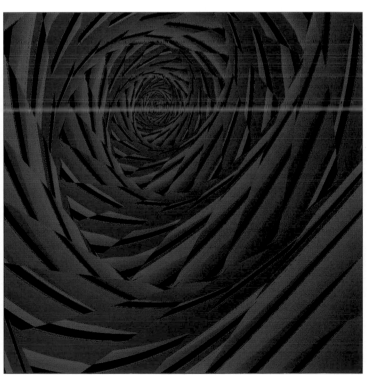

$f(z) = (z^4 + c)^{.5}$

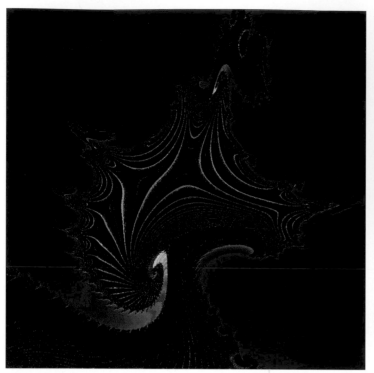

$f(z) = (z^2 + c)^2 + z + c$

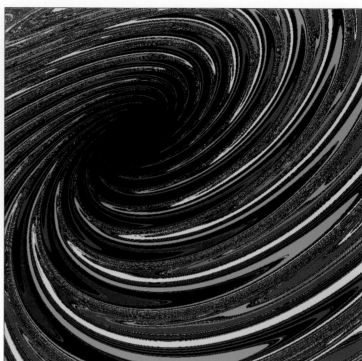

$f(z) = z^7 + c$

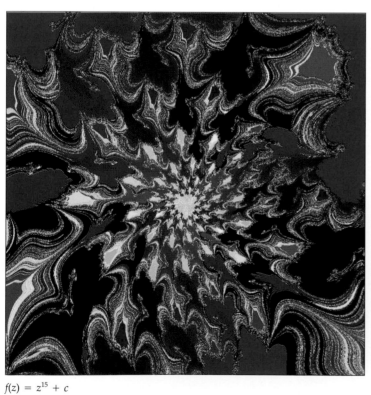

$f(z) = z^{15} + c$

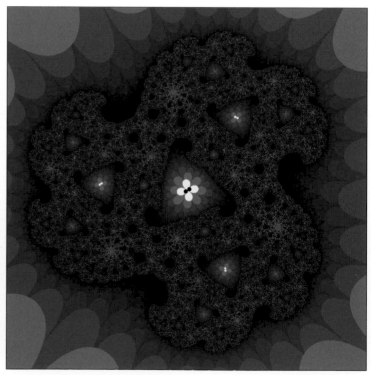

$f(z) = (z^3 + c)/z$

3-28

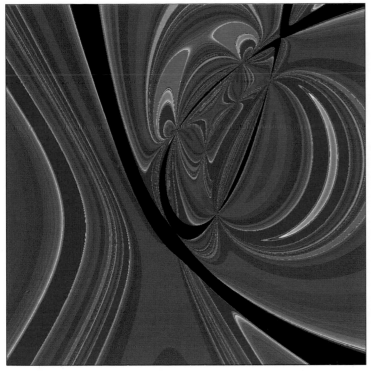

$f(z) = [(2x - y^2 + a)/(2x^2 + y - b)] + i[(2x^2 + y - a)/(2x - y^2 + b)]$

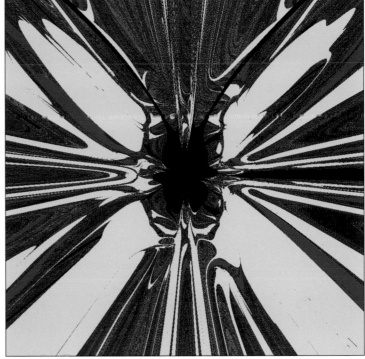

$f(z) = (6z^7 + c)/7z^6$

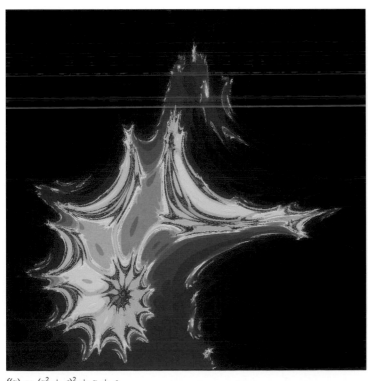

$f(z) = (z^2 + c)^2 + z + c$

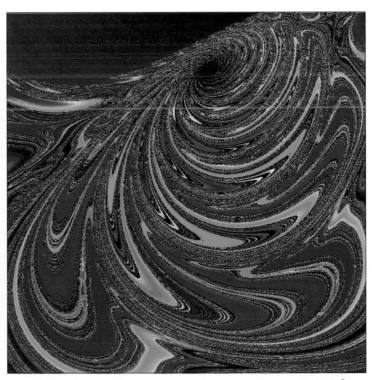

$f(z) = z^7 + c$

3-29

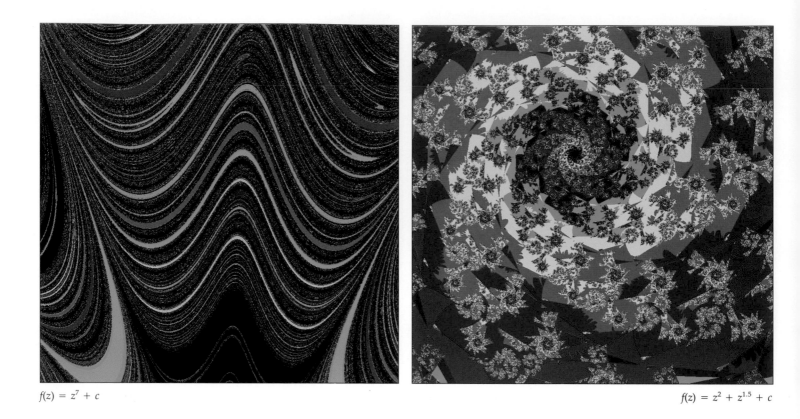

$f(z) = z^7 + c$

$f(z) = z^2 + z^{1.5} + c$

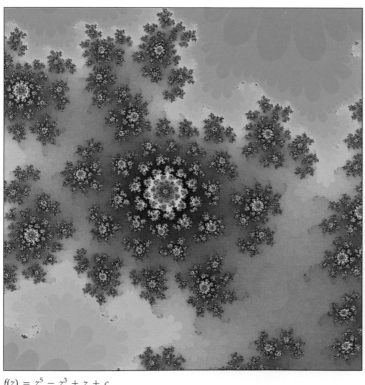

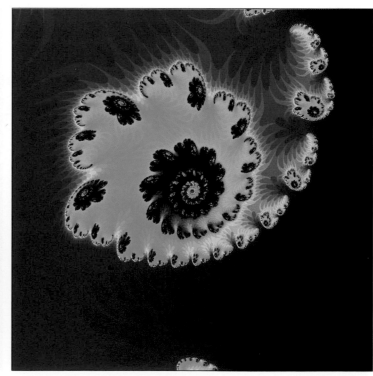

$f(z) = z^5 - z^3 + z + c$

$f(z) = cz^2 + c^2z$

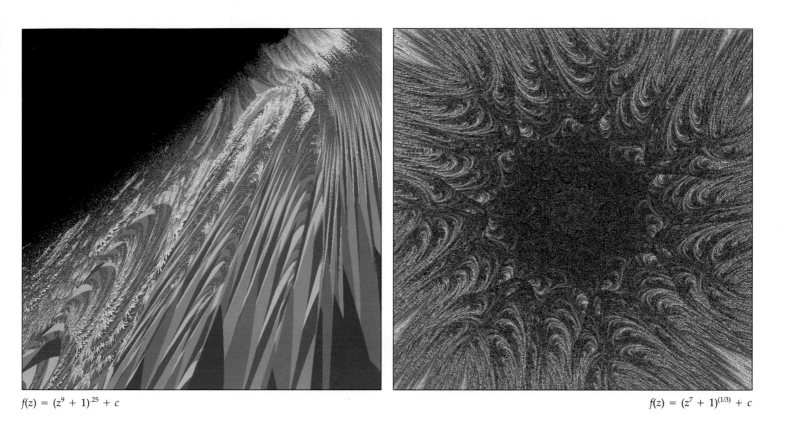

$f(z) = (z^9 + 1)^{.25} + c$

$f(z) = (z^7 + 1)^{(1/3)} + c$

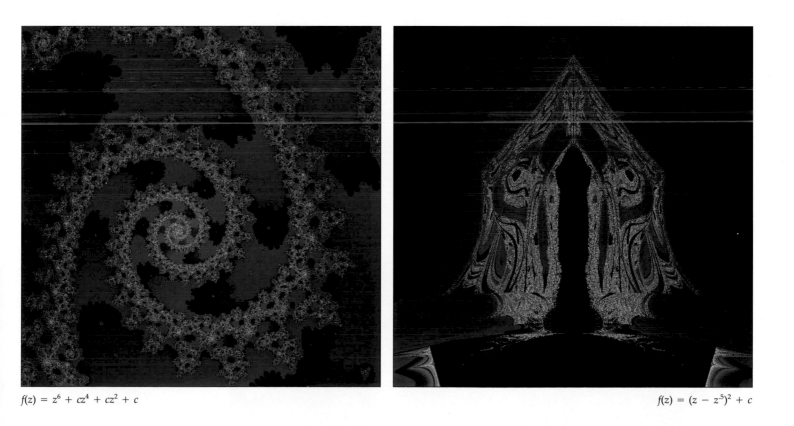

$f(z) = z^6 + cz^4 + cz^2 + c$

$f(z) = (z - z^{.5})^2 + c$

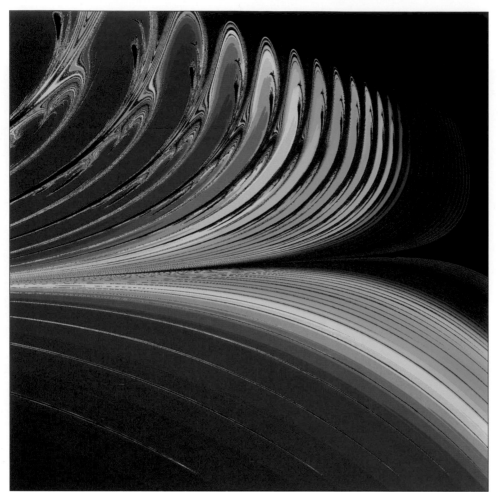

$f(z) = z^{24} + c$

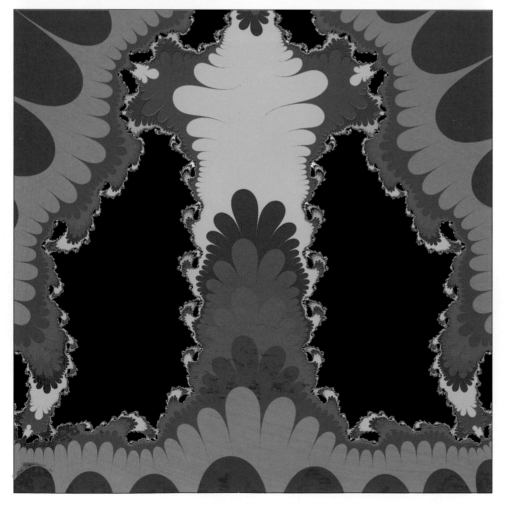

$f(z) = z^4 + z + c$

Mandelbrot/Julia Set Fractals of Exponentials, Logarithms, Trigonometrics, and Combinations Thereof

Chaos surely reigns supreme in many of the unusual images within this chapter. I really let my creativity go with some of the previously unpublished mathematical expressions shown in these pages. Though some of the images are reminiscent of those in Chapters 2 and 3, others are completely without comparison. Enjoy the seemingly random juxtaposition of order and relative stability (areas of one solid color) with those areas of totally unpredictable chaos.

Let me briefly explain what is meant by exponential, logarithmic and trigonometric expressions. An exponential expression involves using the special number "e" (named after the famous mathematician Leonhard Euler) as a base. This number e is called the "natural base," and is ubiquitously prevalent throughout science, engineering, and mathematics. It has a fixed value and like its cousin π, it is what is called a transcendental number. The approximate value of e is 2.7182818. Like any other number, e^2 still equals e times e. Our expressions involving e are generally far more complex than simple squaring.

But let us return to that e^2 expression. Here e is the base and 2 is the exponent or logarithm. We say that if we take the logarithm (we use the symbol "ln" for natural logarithm) of the expression e^2, we get the answer 2. Thus, we have the following: $\ln (e^{8.3})$ = 8.3. Furthermore, we can reverse the order of this and get the following: $e^{\ln 8.3} = 8.3$. These operations are inverses of each other. The expressions we use in our fractal calculations merely involve exponentials of and logarithms of complex numbers and functions instead of numbers like 2 and 8.3. Please consult a text on algebra for further explanation and clarification if you require them.

Trigonometric expressions are from a different realm altogether. The functions sine, cosine, and tangent are derived from the ratios of the different sides of a triangle. They are called sin, cos, and tan, for short, respectively. They, too, are extremely important in all physical and engineering calculations. Again, we extend their usage in these images to their application on complex variables and functions of complex variables. Please consult an appropriate text on trigonometry for further enlightenment in this area.

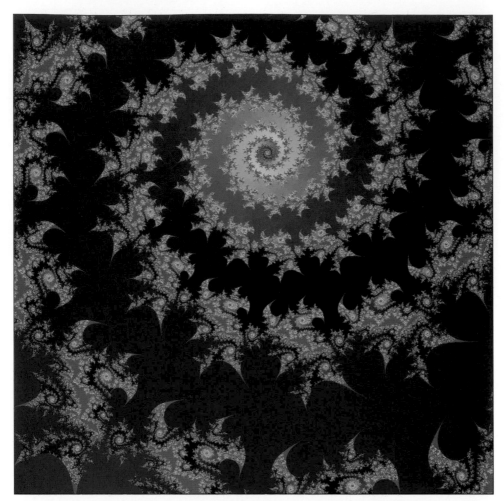

$$f(z) = z^2 e^z - z e^z + c$$

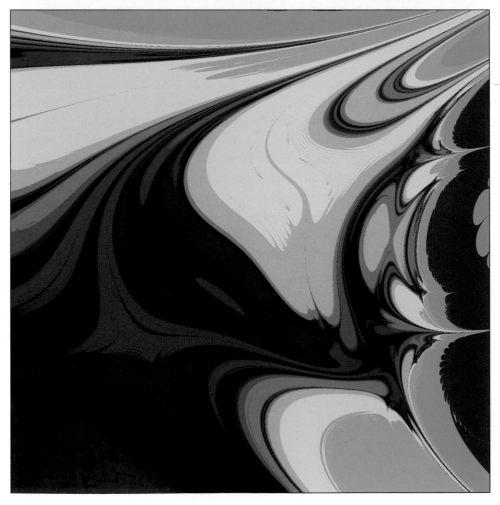

$$f(z) = (z + cz - cz^2) * ((z + \sin z)^2 + c)$$

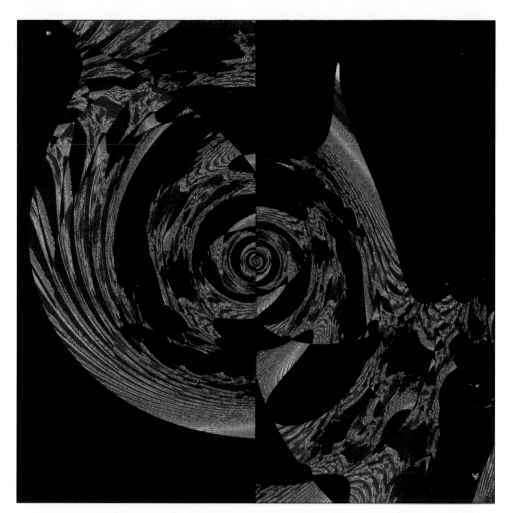

$f(z) = ce^z z^{.5}$

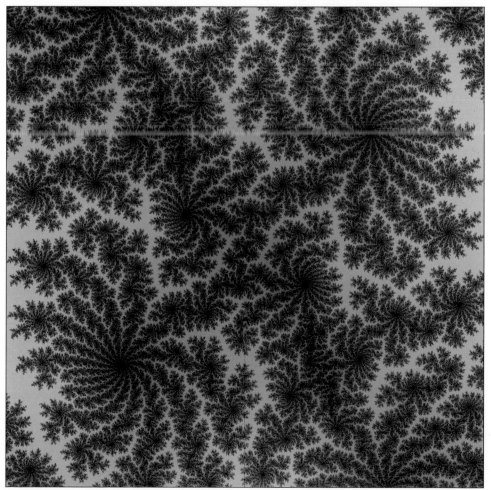

$f(z) = c * \cos z$

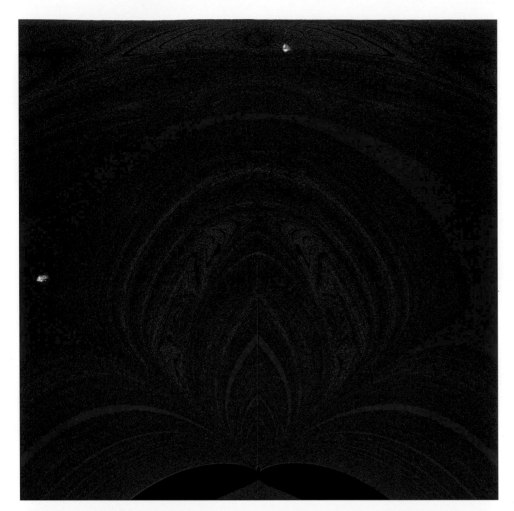

$f(z) = z * \tan(\ln z) + c$

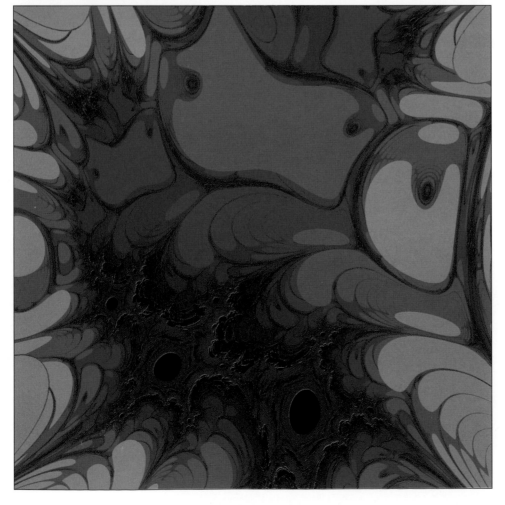

$f(z) = z^2\sin x + cz \cos y + c$

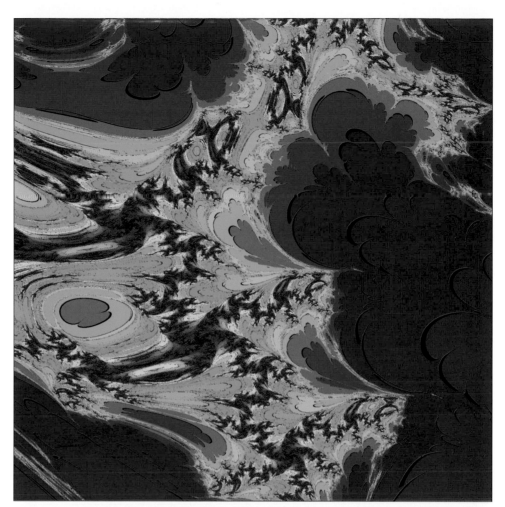

$f(z) = c(\sin z + \cos z) * (z^3 + z + c)$

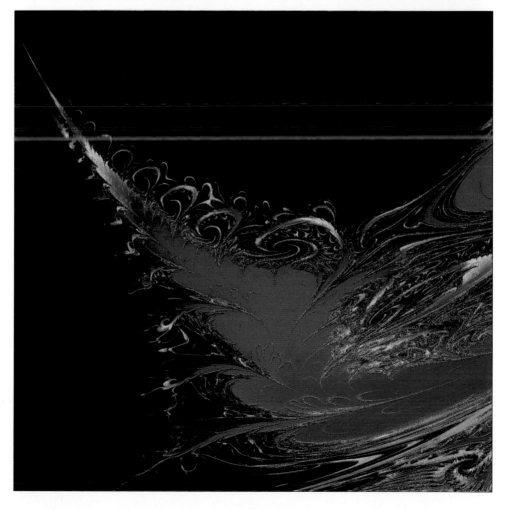

$f(z) = z^2\sin x + cyz + z^2\cos x + cz \sin y + c$

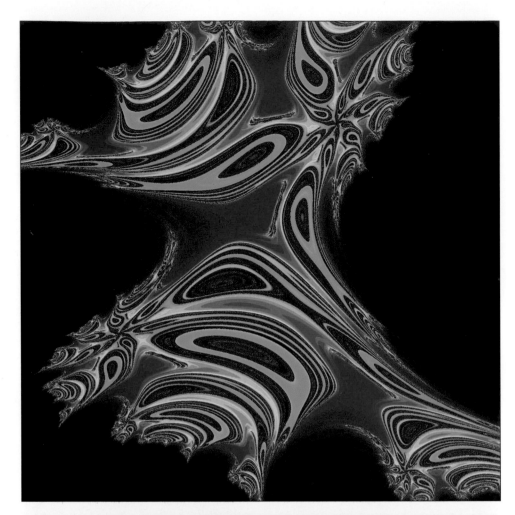

$f(z) = z^2 + ce^{-z}$

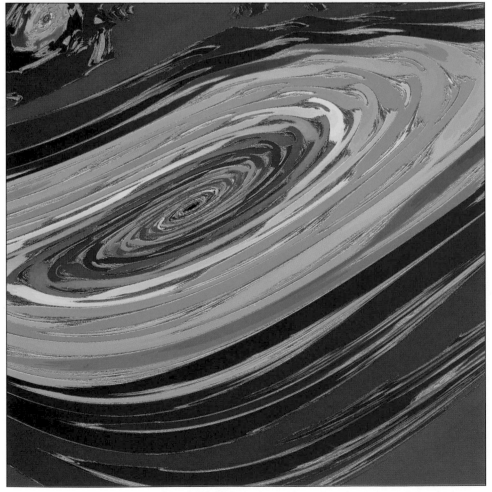

$f(z) = z^{12}\cos x - z^{11}\sin y - z^{10}\tan y + c$

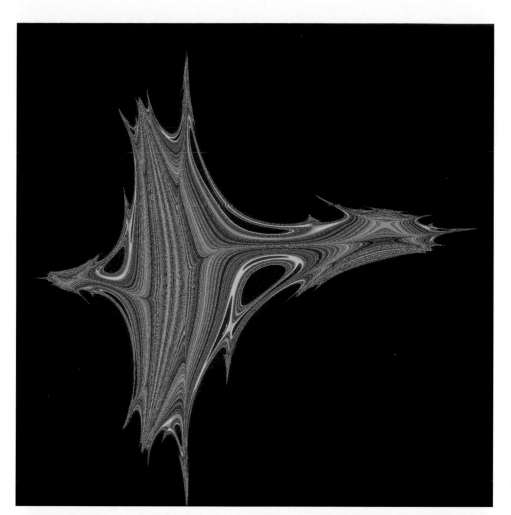

$f(z) = z^2 + ce^{-z}$

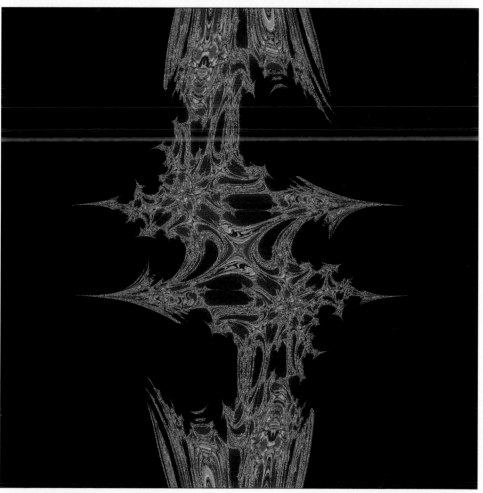

$f(z) = z^2\exp(z^2) + c$

4-7

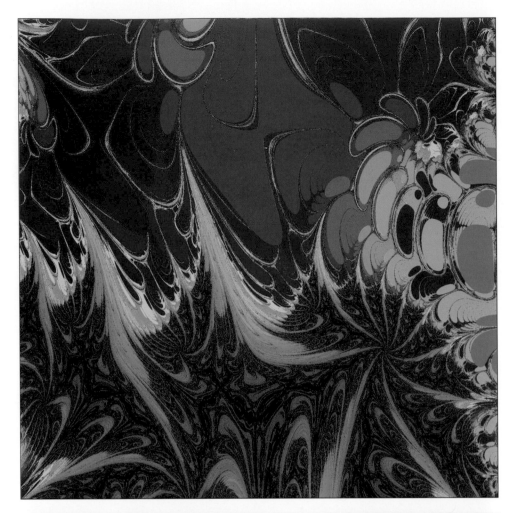

$f(z) = z^2\sin x + cz\cos y + c$

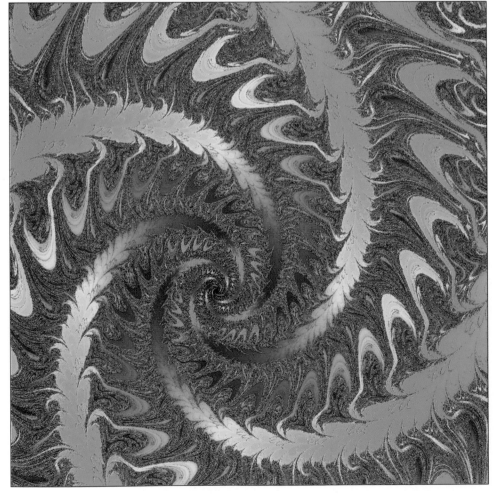

$f(z) = z^2\sin x + cyz + z^2\cos x + cz\sin y +$

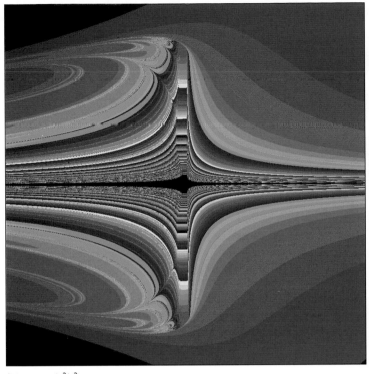

$f(z) = \exp(x^2/y^2) + y + c$

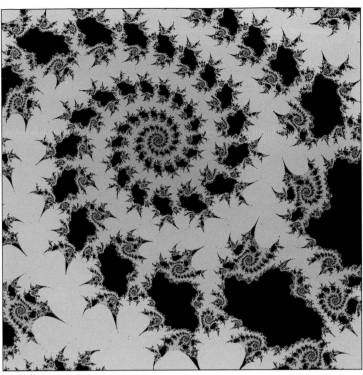

$f(z) = z^2 e^z - z e^z + c$

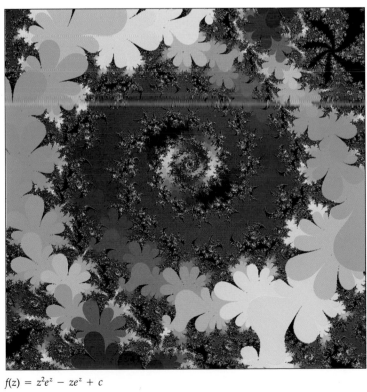

$f(z) = z^2 e^z - z e^z + c$

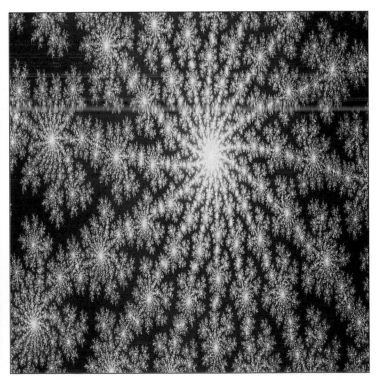

$f(z) = c * \cos z$

4-9

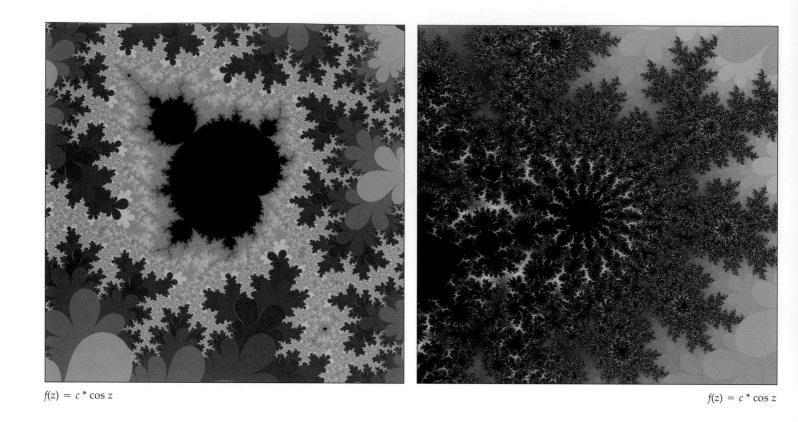

$f(z) = c * \cos z$

$f(z) = c * \cos z$

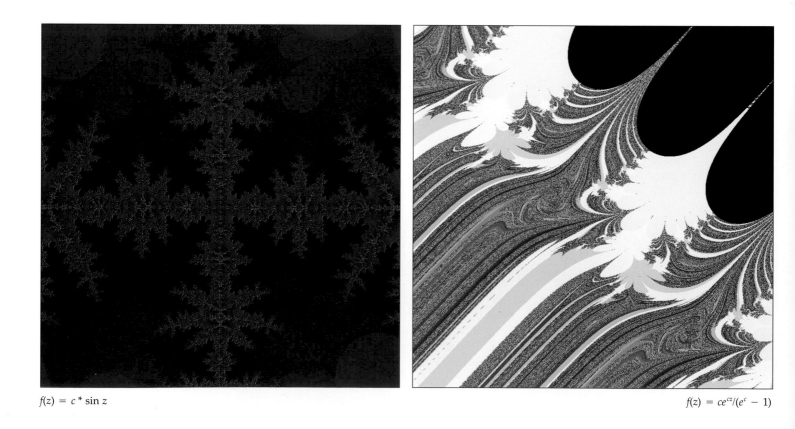

$f(z) = c * \sin z$

$f(z) = ce^{cz}/(e^c - 1)$

4-10

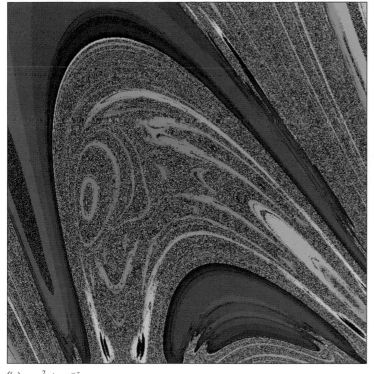

$f(z) = z^2 + ce^{-z}$

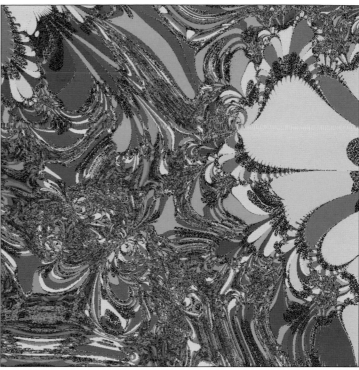

$f(z) = (z^3/(1 + cz^2)) + e^z - c$

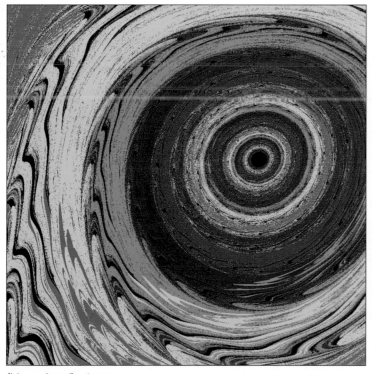

$f(z) = z * \tan(\ln z) + c$

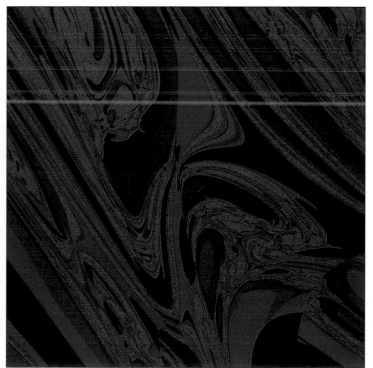

$f(z) = (z * \ln z)/e^c$

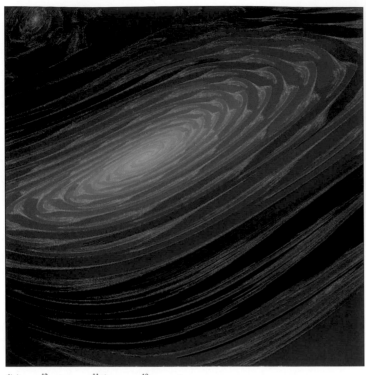

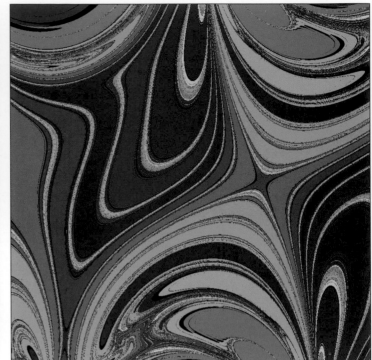

$f(z) = z^{12}\cos x - z^{11}\sin y - z^{10}\tan y + c$

$f(z) = c * (\sin z + \cos z)$

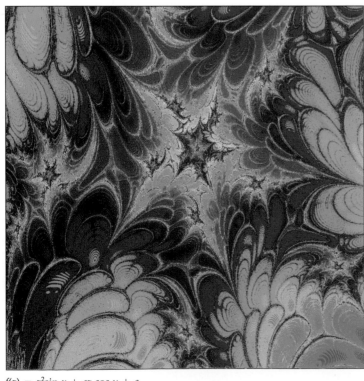

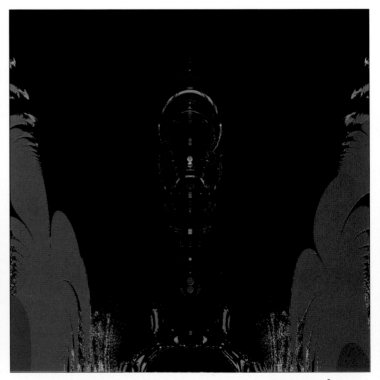

$f(z) = z^2\sin x + cz\cos y + c$

$f(z) = \exp(z^2)/(z + c)$

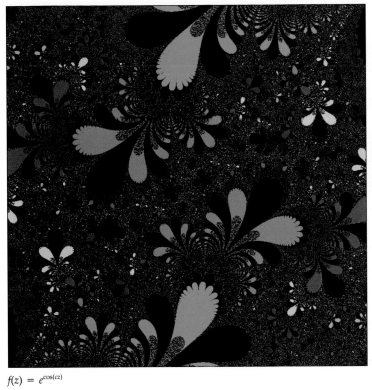

$f(z) = e^{\cos(cz)}$

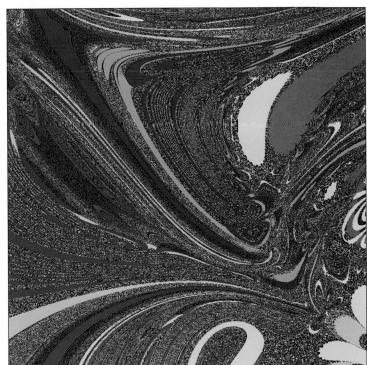

$f(z) = ce^z e^{\cos(cz)}$

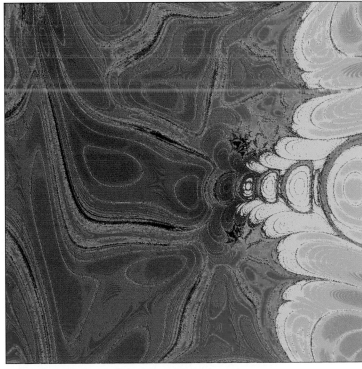

$f(z) = z^2 \sin x + cyz + z^2 \cos x + cz \sin y + c$

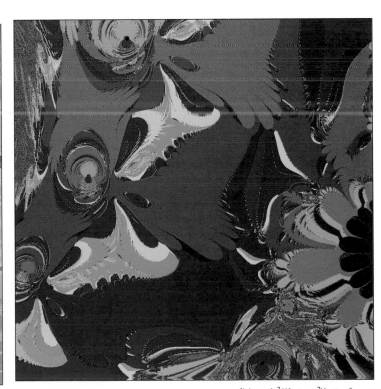

$f(z) = (z^3/(1 + cz^2)) + e^z - c$

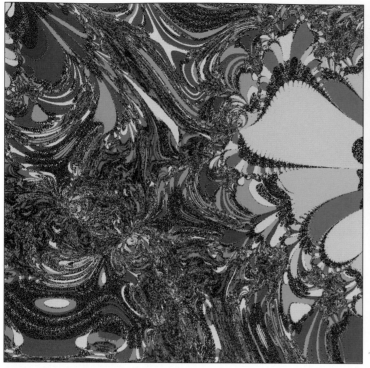

$f(z) = (z^3/(1 + cz^2)) + e^z - c$

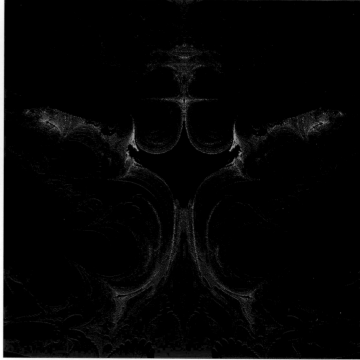

$f(z) = (z + \sin z)^2 + z^{.5} + c$

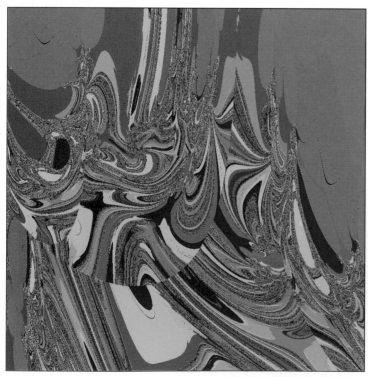

$f(z) = (e^z/\ln z) + c$

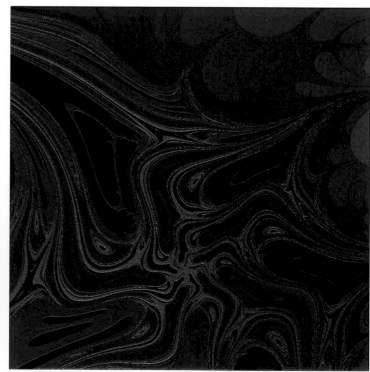

$f(z) = z^2\sin x + cyz + z^2\cos x + cz \sin y + c$

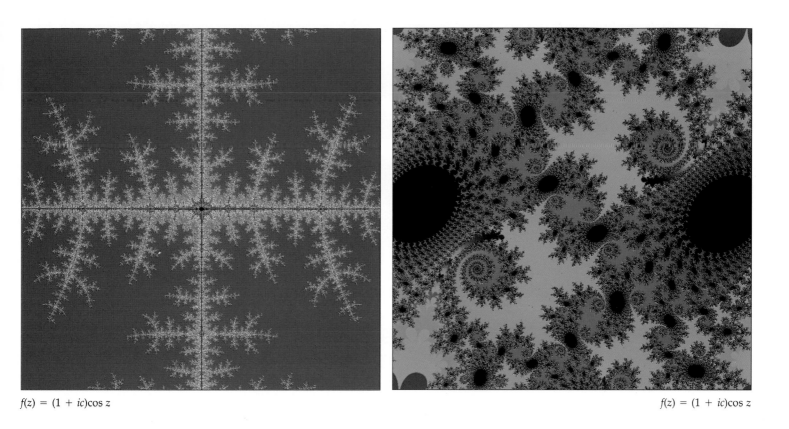

$f(z) = (1 + ic)\cos z$

$f(z) = (1 + ic)\cos z$

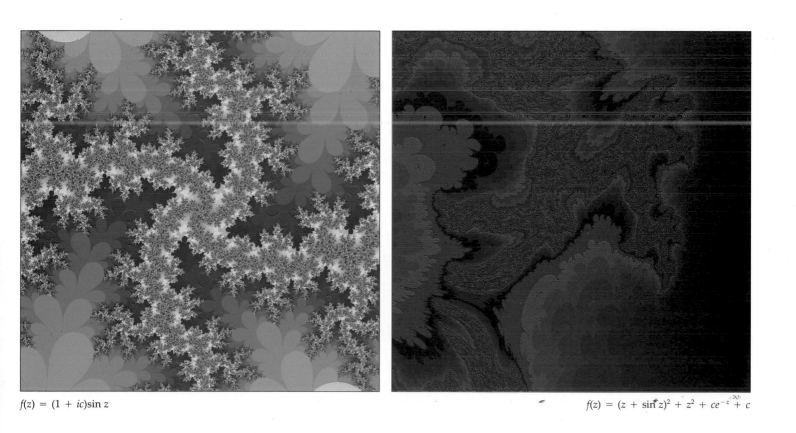

$f(z) = (1 + ic)\sin z$

$f(z) = (z + \sin z)^2 + z^2 + ce^{-z} + c$

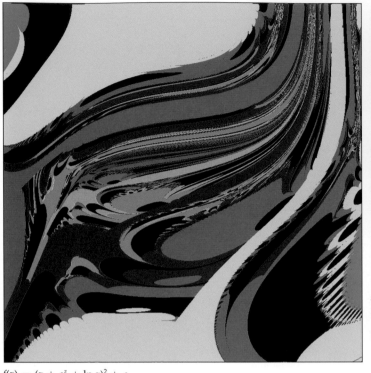

$f(z) = (z + e^z + \ln z)^2 + c$

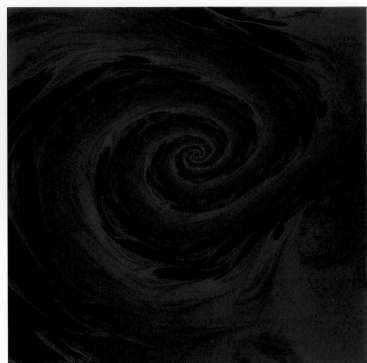

$f(z) = z^{12}\cos x - z^{11}\sin y - z^{10}\tan y + c$

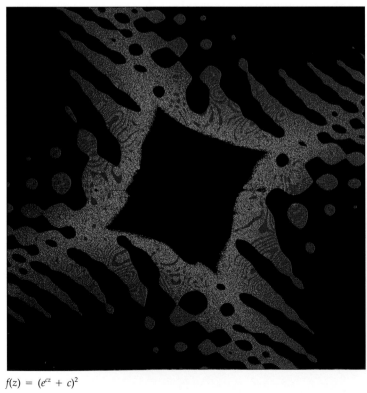

$f(z) = (e^{cz} + c)^2$

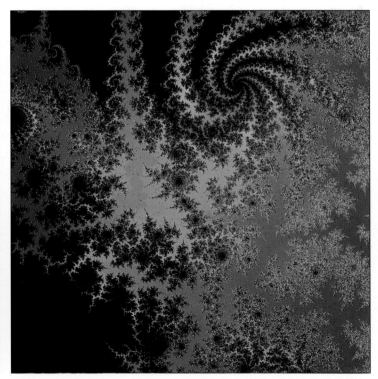

$f(z) = (1 + ic)\cos z$

4-16

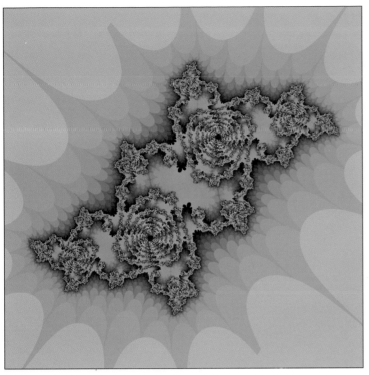

$f(z) = cz - 1 + ce^{-z}$

$f(x) = (\ln x^2)^{.5} + y * \sin x + a$
$f(y) = (\ln y^2)^{.5} - x * \cos y + b$

$f(z) = z^2 + ce^{-z}$

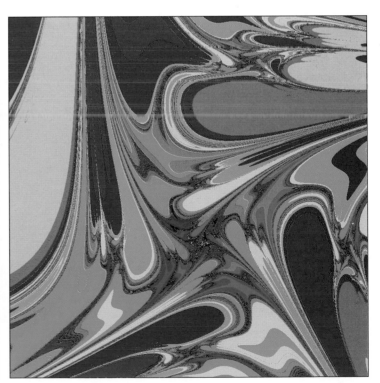

$f(z) = (z + cz - cz^2) * ((z + \sin z)^2 + c)$

4-17

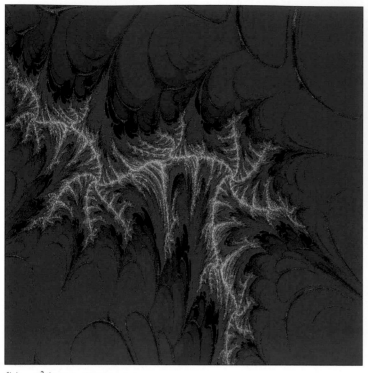

$f(z) = z^2\sin x + cz\cos y + c$

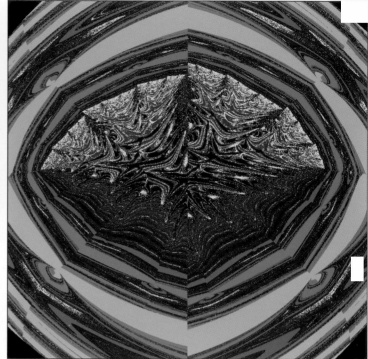

$f(z) = z * \tan(\ln z) + c$

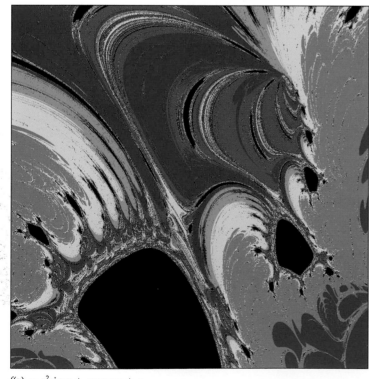

$f(z) = z^2\sin x + cz\cos y + c$

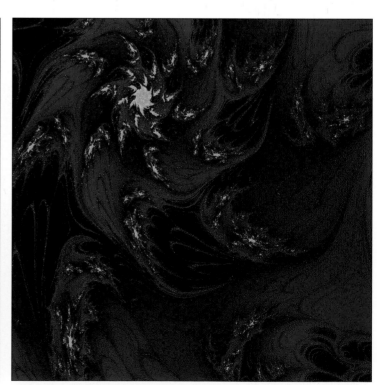

$f(z) = z^2\sin x + cz\cos y + c$

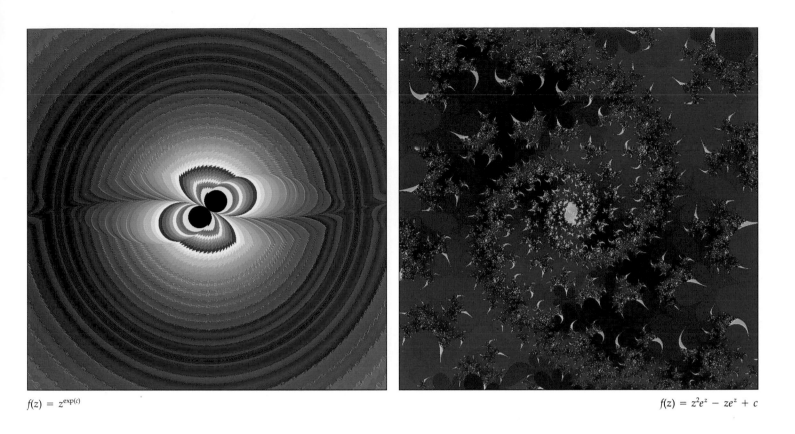

$f(z) = z^{\exp(c)}$

$f(z) = z^2e^z - ze^z + c$

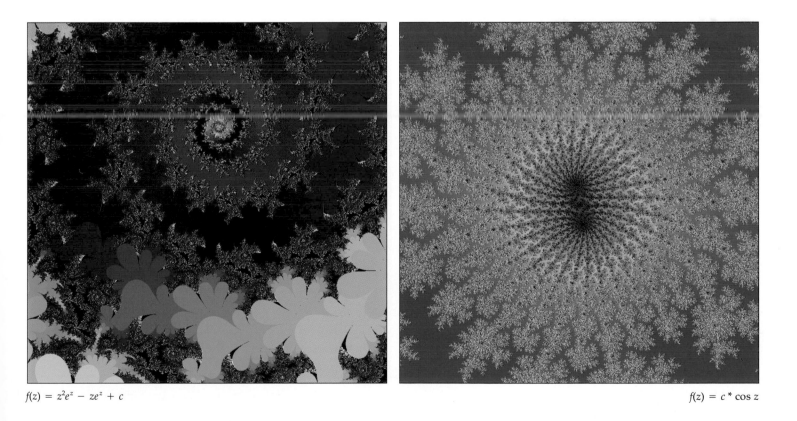

$f(z) = z^2e^z - ze^z + c$

$f(z) = c * \cos z$

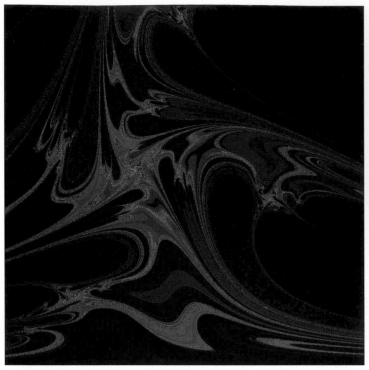

$f(z) = (z + cz - cz^2) * ((z + \sin z)^2 + c)$

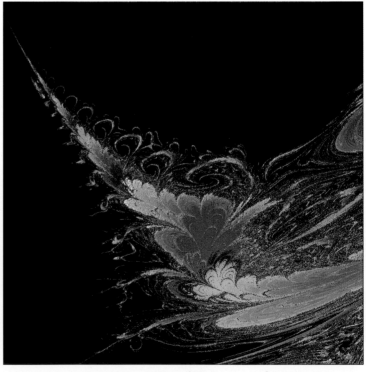

$f(z) = (z^2 + c)^2 + z + c$

$f(x) = x^2 \sin y + a$
$f(y) = y^2 \cos x + b$

$f(z) = z^2 \sin x + cyz + z^2 \cos x + cz \sin y + c$

Three-Dimensional
Fractal Compositions

This chapter is devoted to composed scenes that were created during the past eighteen months. Believe it or not, each object within every fractal composition is a purely mathematical object. Every mountain, every tree, every iceberg, and every texture and effect are generated by one mathematical means or another. For me, to know that I can create such "natural" beauty using just simple numbers and tools gives me a feeling for the creatorhood within each and every one of us.

All of the fractal data has been generated by my fractal program. I have then taken that data and found a variety of ways to render it in three dimensions. There are a number of commercial programs available that will render raw data such as fractal data and present them in various ways. I use a UNIX-based scientific visualization package for one type of rendering, and I use a PC-based program primarily designed to render U.S. Geological Survey data for another. I designed my own limited 3-D rendering package for still others. I use a couple of commercially available ray-tracing packages, both for PC and Macintosh, to introduce shadow and shading effects, and I compose all of the images, once the data has been ported over, on a Macintosh using some image-editing/special filter effects software packages.

The images were stored digitally on disk media, and then output as four-color separated film; printing plates were made, and the images were printed on a conventional printing press. The size of these images varies from roughly 12 MB to 60 MB each.

I should mention that the trees you see are not truly fractal objects. They are produced by a process called "affine transformation." This involves the manipulation of certain matrices which have certain random elements built into them so as to produce natural looking vegetation. The same method can also produce very realistic looking ferns, bushes, and walls. The textbook written by Barnsley (*Fractals Everywhere*; see Appendix B) clearly describes this process, should the reader be interested in pursuing the topic.

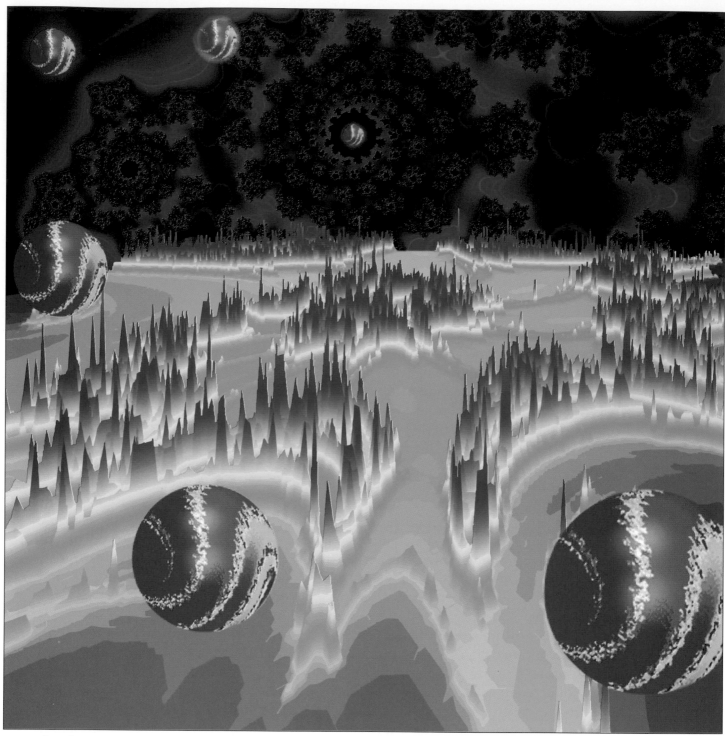

$f(z) = (z^2 + c)^2 + z + c$
$f(z) = z^2 + c$

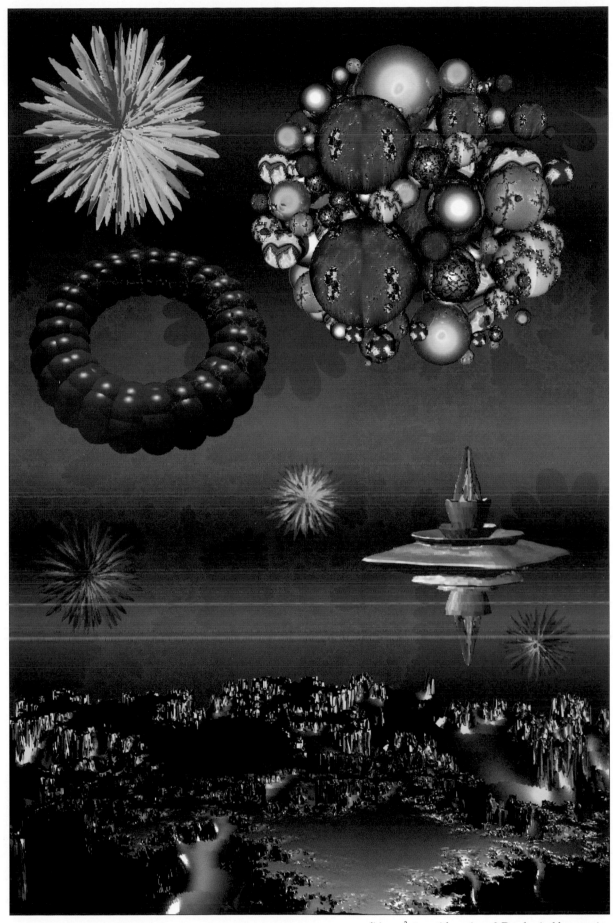

$f(z) = z^2 + c$ with various 3-D spherical harmonics

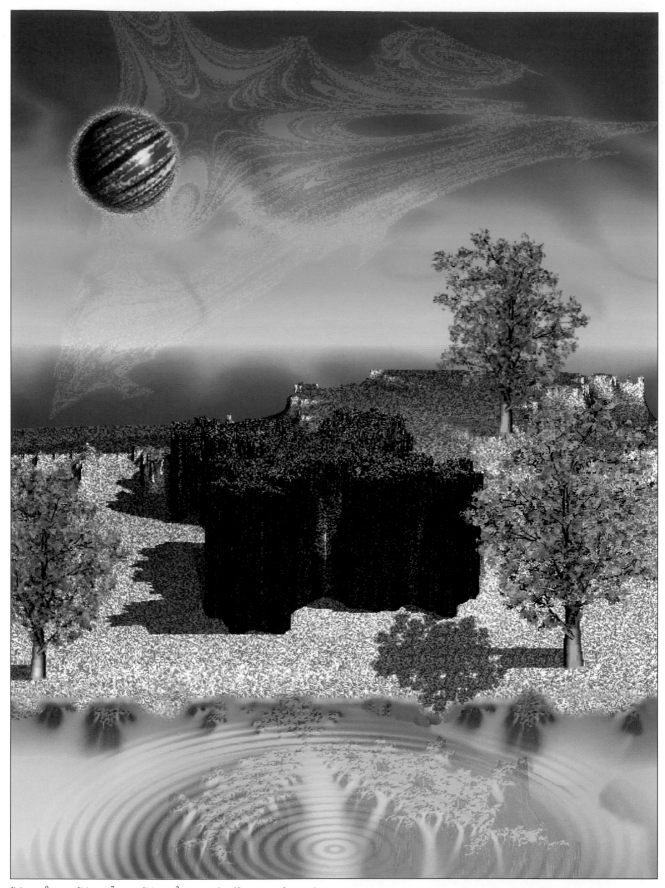

$f(z) = z^9 + c, f(z) = z^7 + c, f(z) = z^2 + c$ with affine transformations

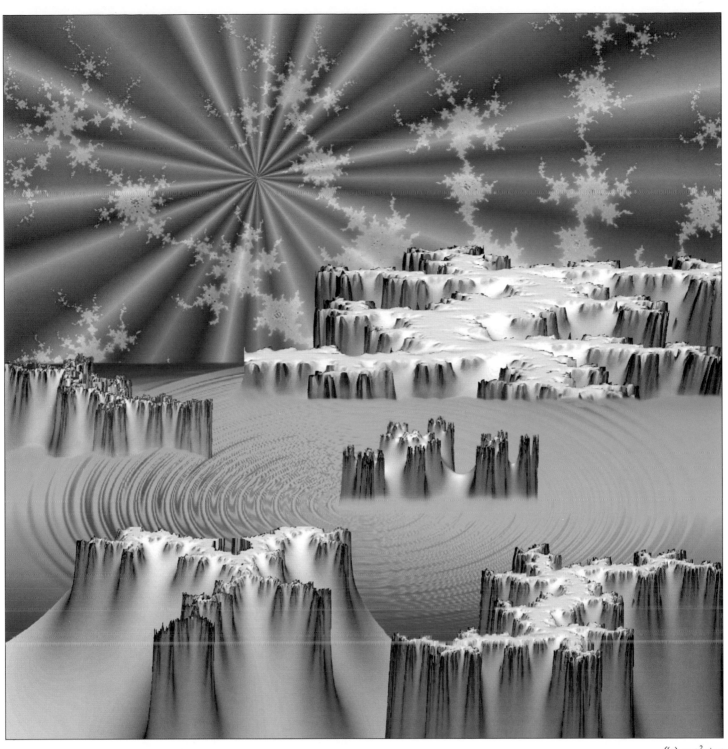

$f(z) = z^2 + c$

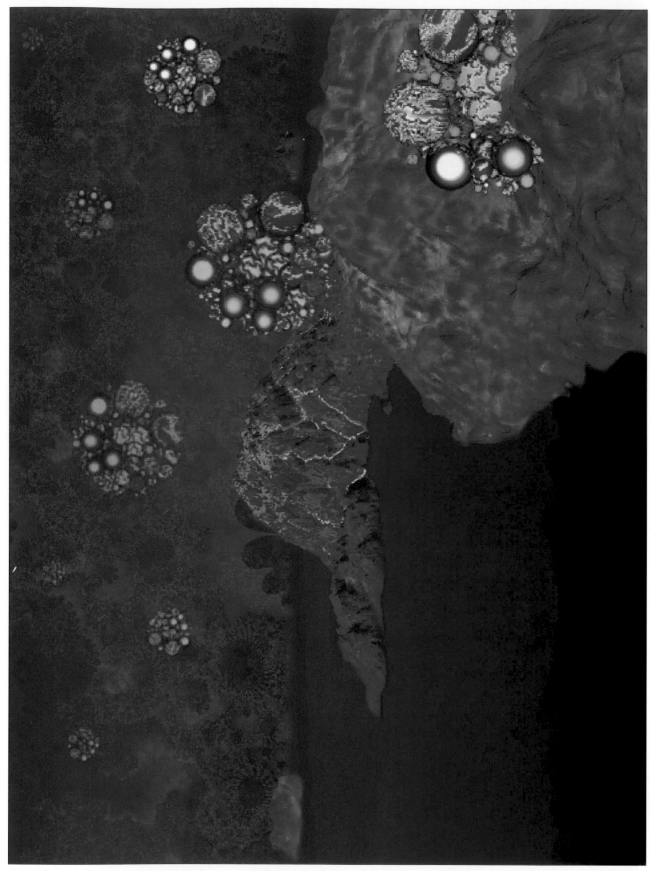

$f(z) = z^2 + c$ with random plasma fractals

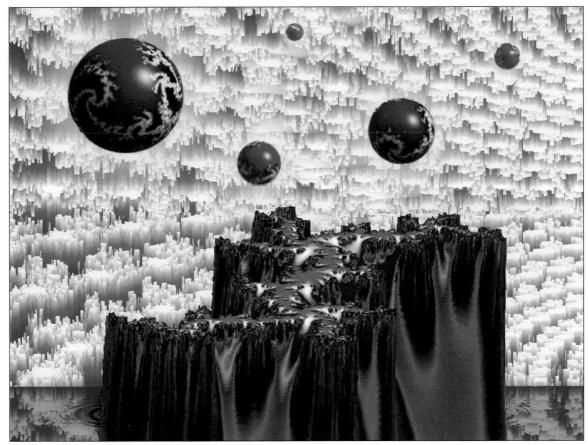

$f(z) = z^2 + c$

$f(z) = z^2 + c, f(z) = e^{cz} + c$
with random plasma fractals

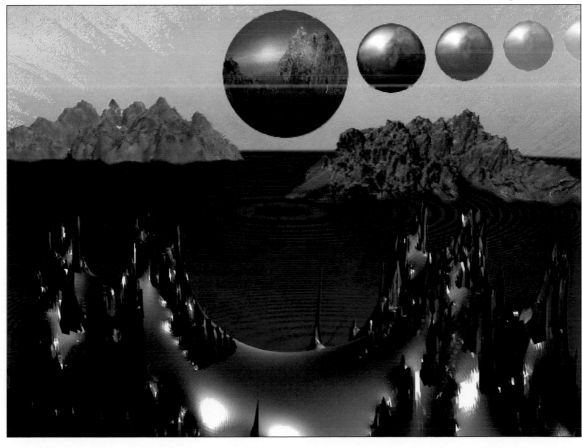

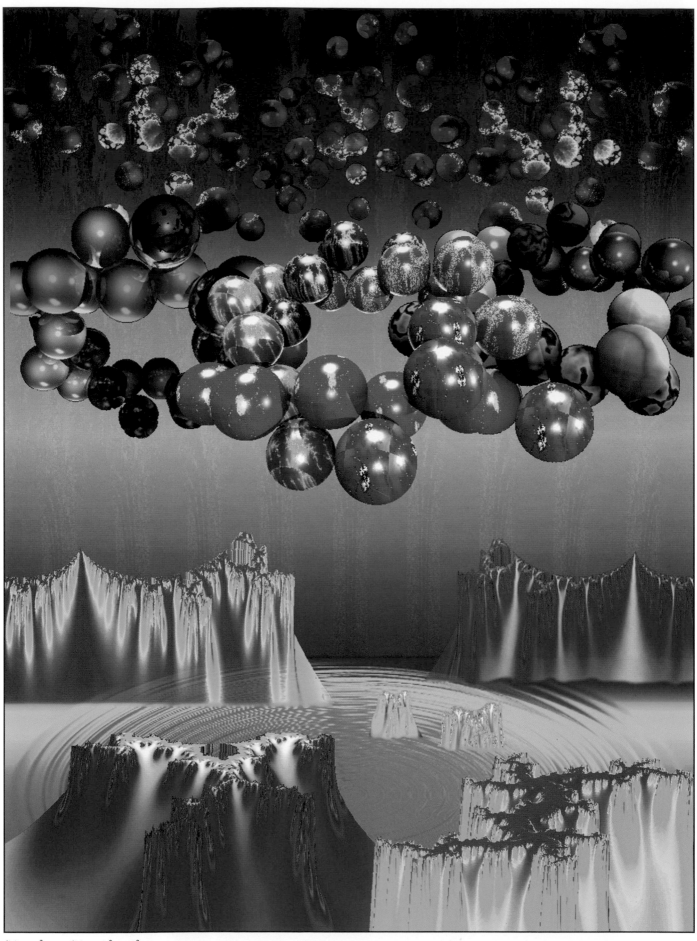

$f(z) = z^2 + c, f(z) = (z^2 + c)^2 + z + c$

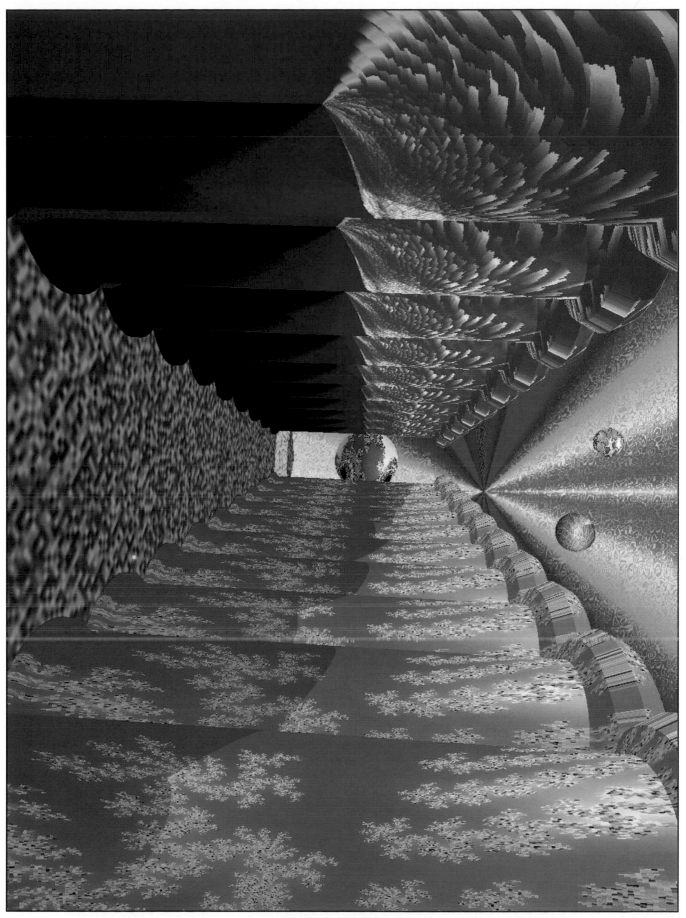

$f(z) = z^2 + c, f(z) = (z^4 + 1)^{.5} + c$

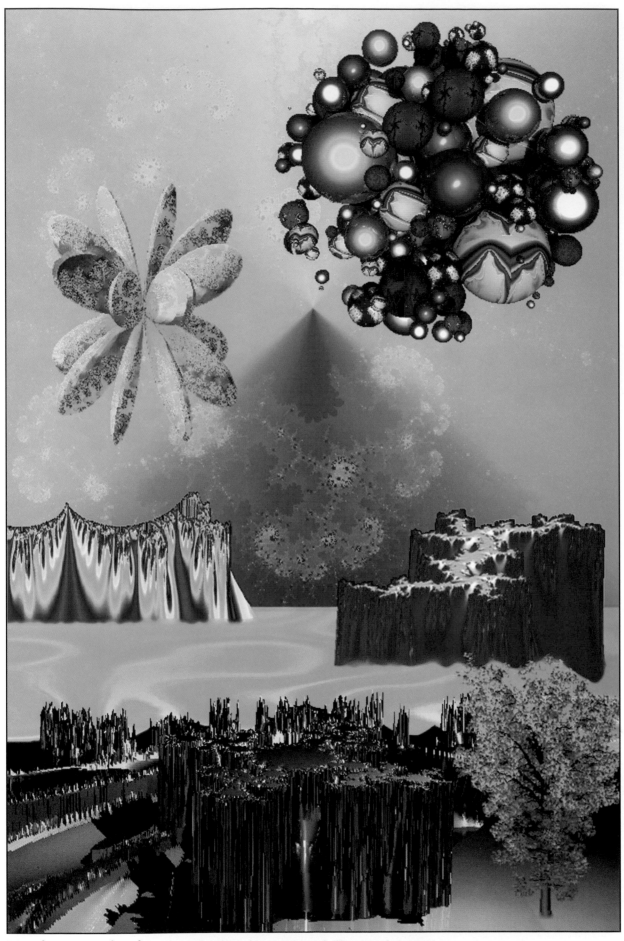

$f(z) = z^2 + c, f(z) = (z^2 + c)^2 + z + c$ with spherical harmonics and affine transformations

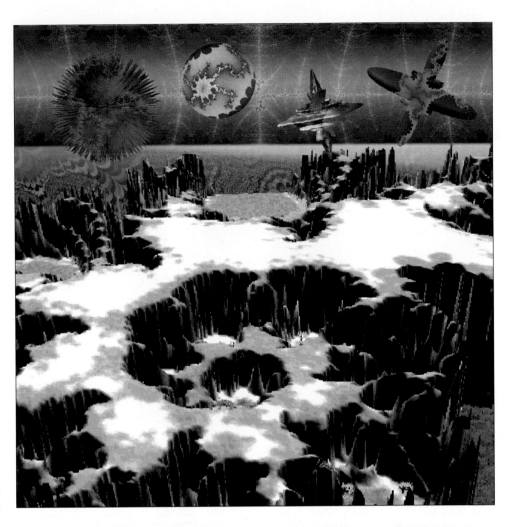

$f(z) = z^2 + c$
with spherical harmonics

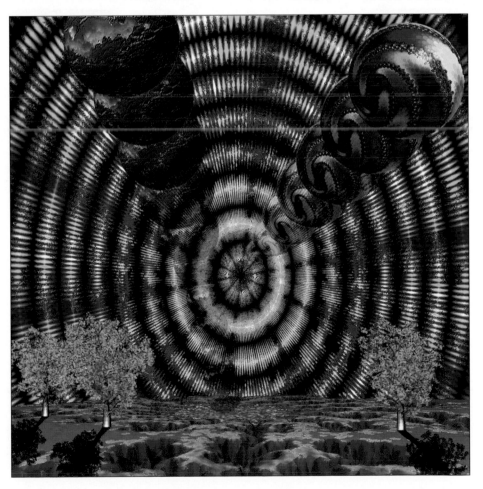

$f(z) = z^2 + c$
with random plasma fractals
and affine transformations

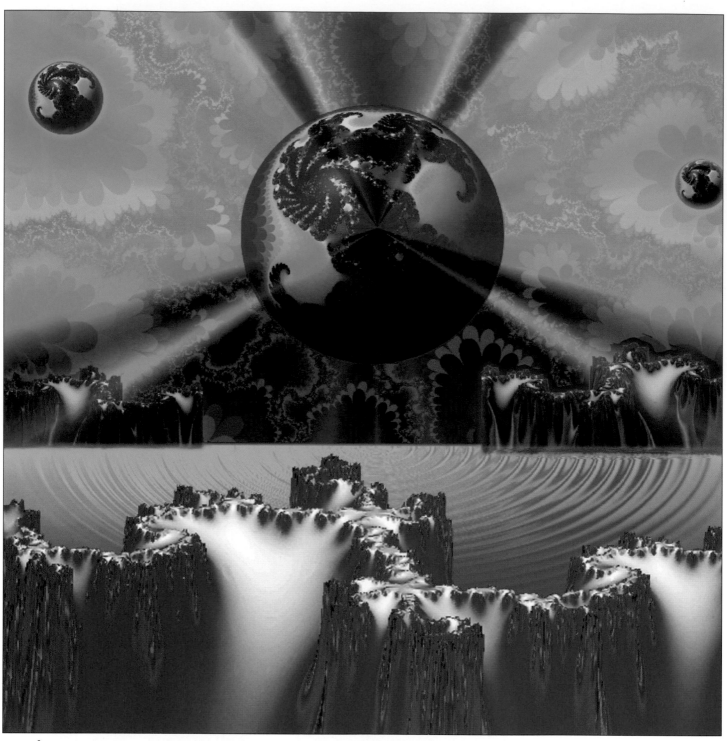

$f(z) = z^2 + c$

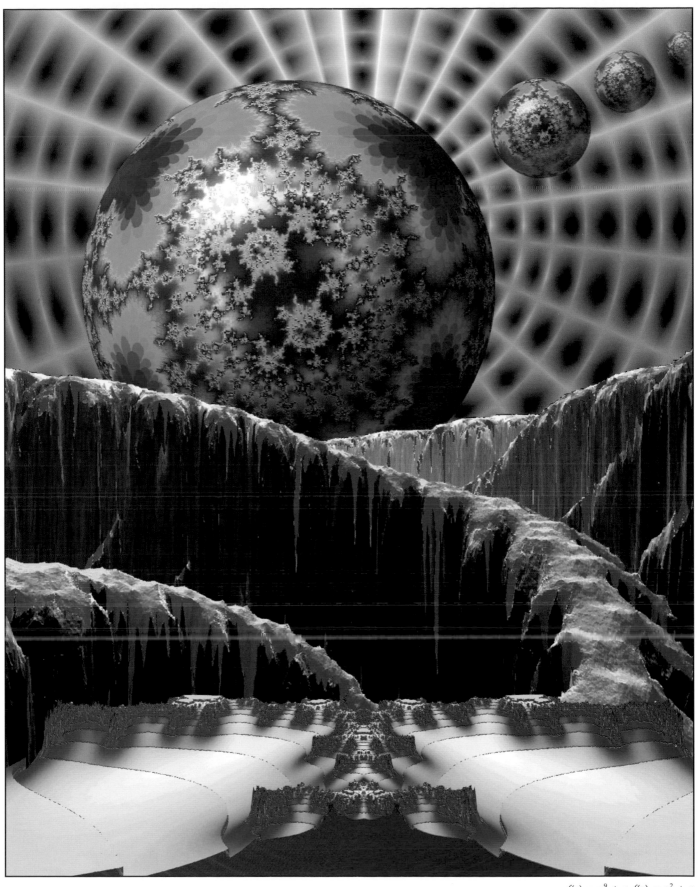

$f(z) = z^9 + c, f(z) = z^2 + c$

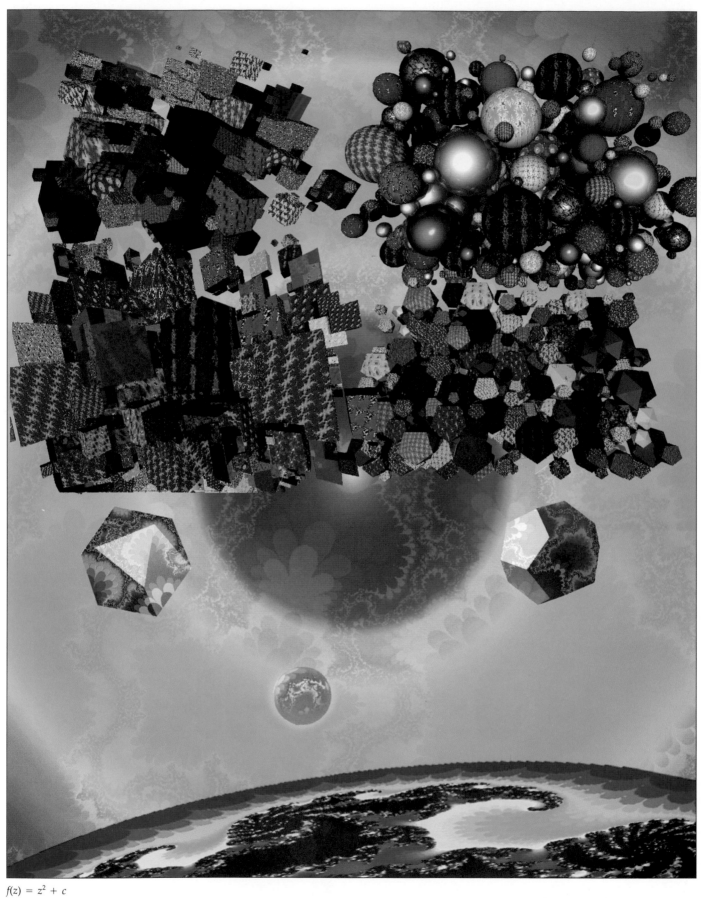

$f(z) = z^2 + c$

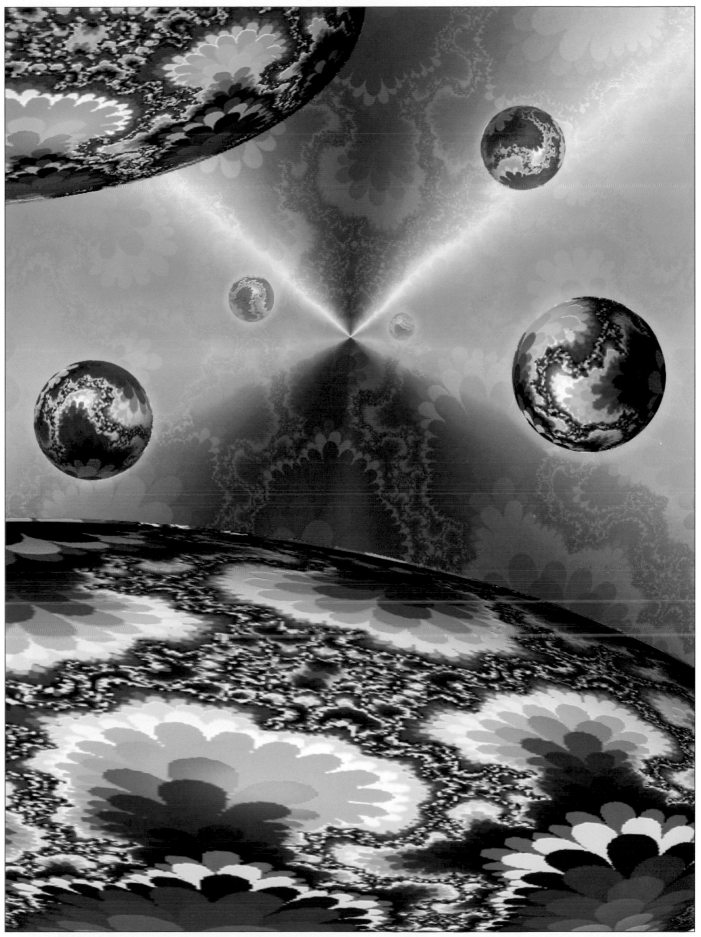

$f(z) = z^2 + c$

5-15

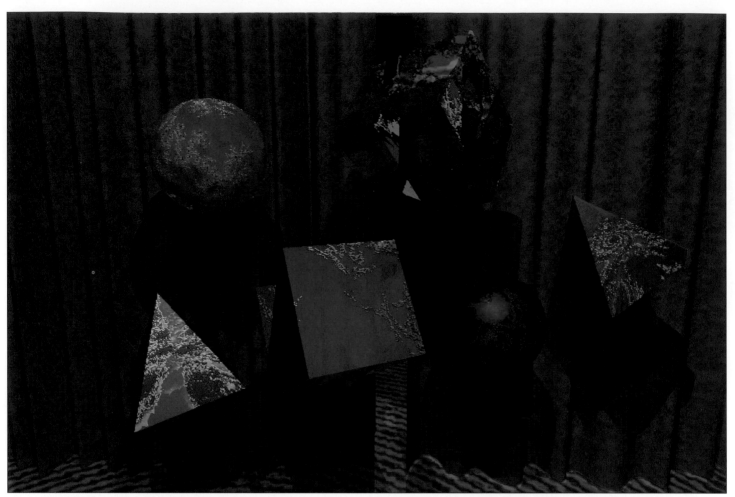

$f(z) = z^2 + c,\ f(z) = ze^z + c,\ f(z) = z^3/(cz^2 + 1)$

$f(z) = z^2 + c$

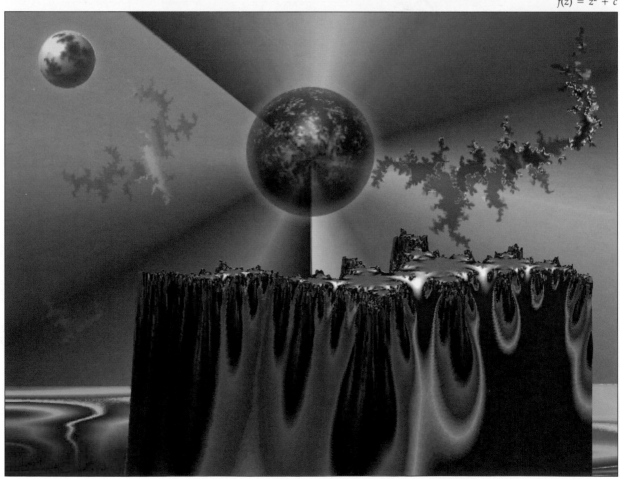

5-16

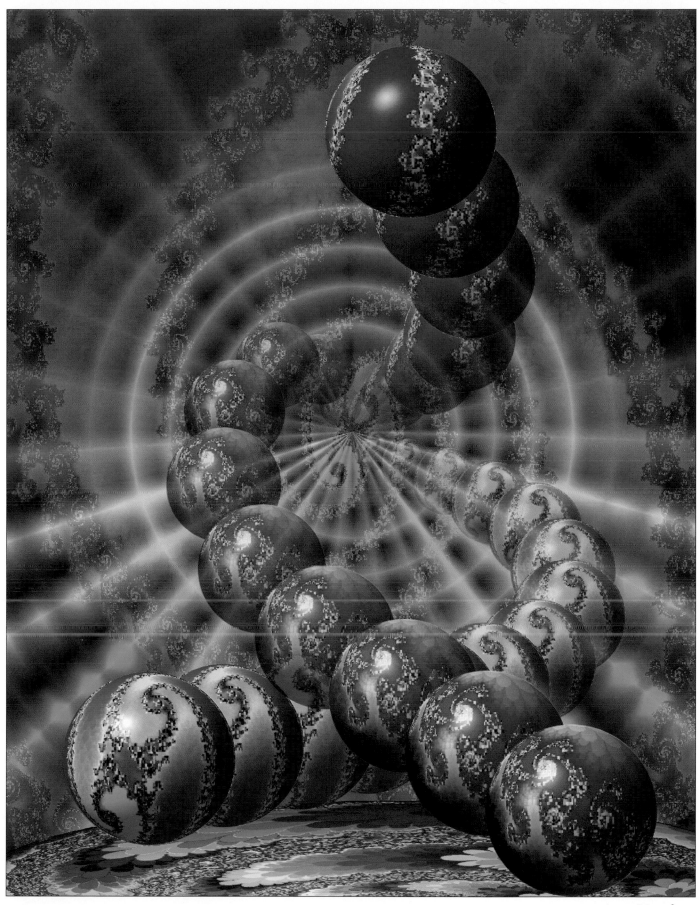

$f(z) = z^2 + c$

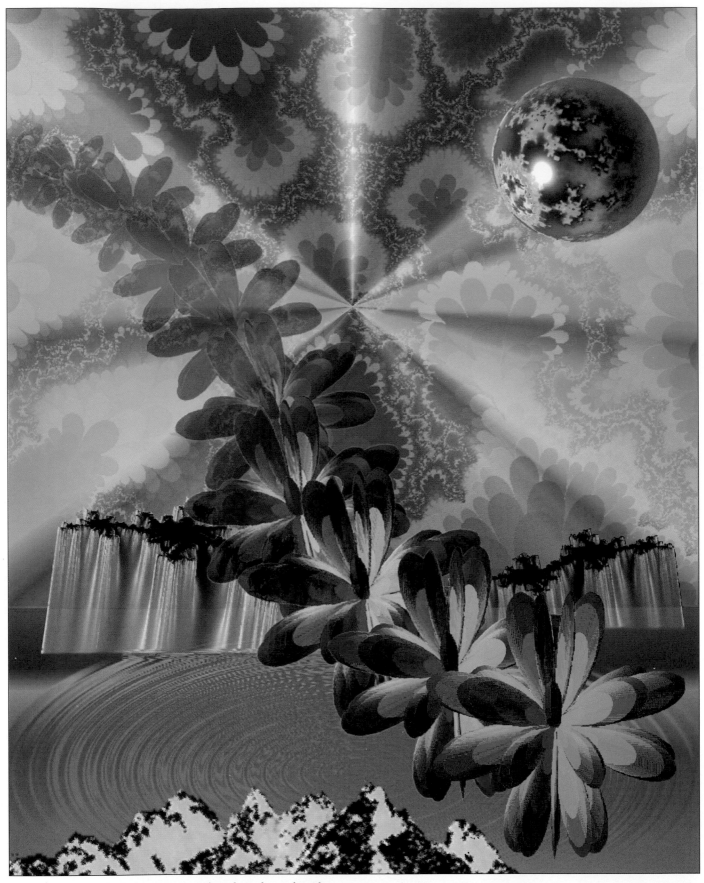

$f(z) = z^2 + c$ with spherical harmonics and random plasma fractals

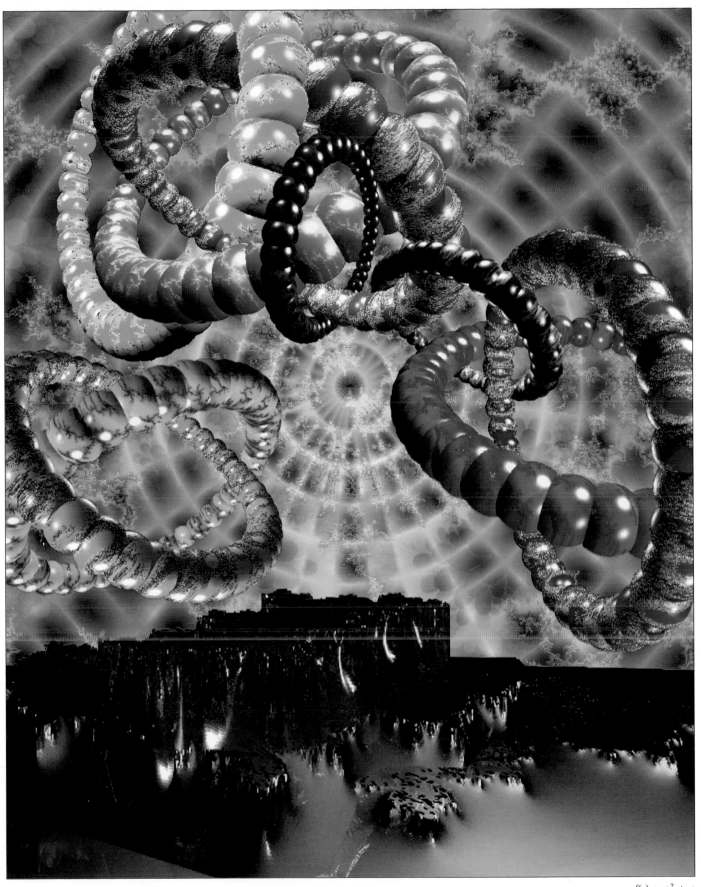

$f(z) = z^2 + c$

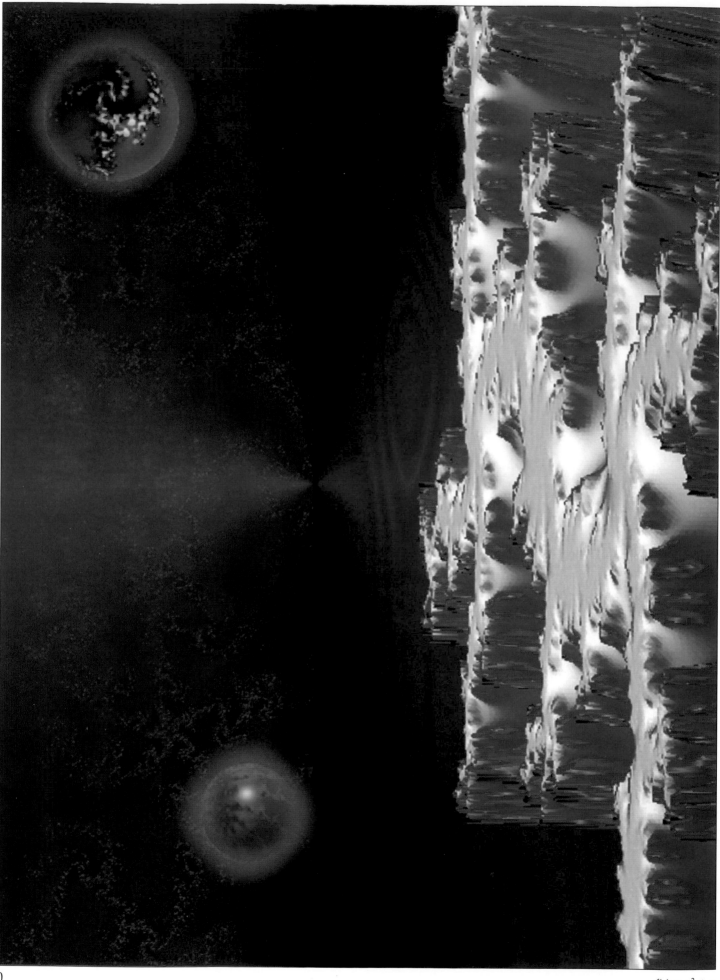

5-20

$f(z) = z^2 + c$

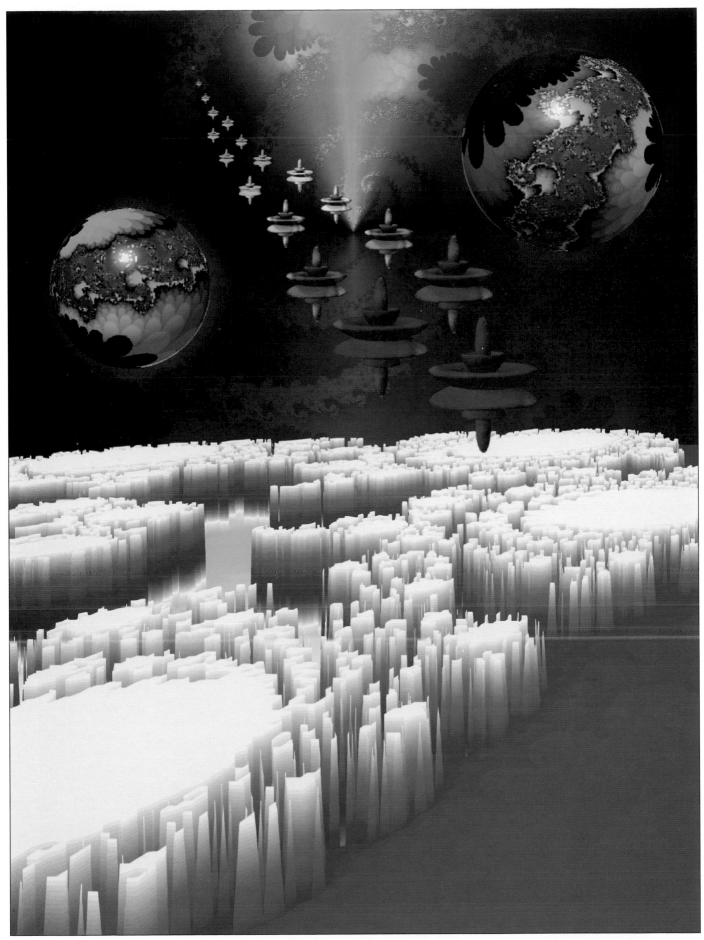

$f(z) = z^2 + c$ with spherical harmonics

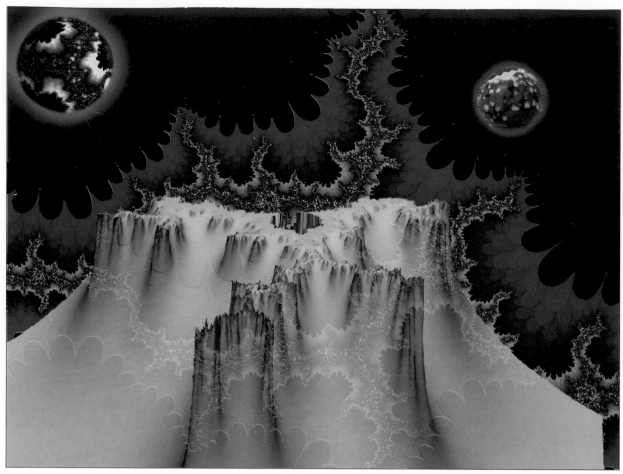

$f(z) = z^2 + c$

$f(z) = z^2 + c$

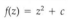

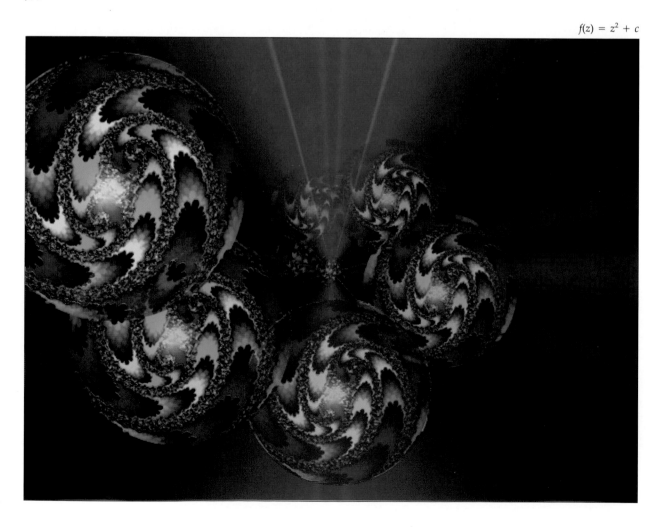

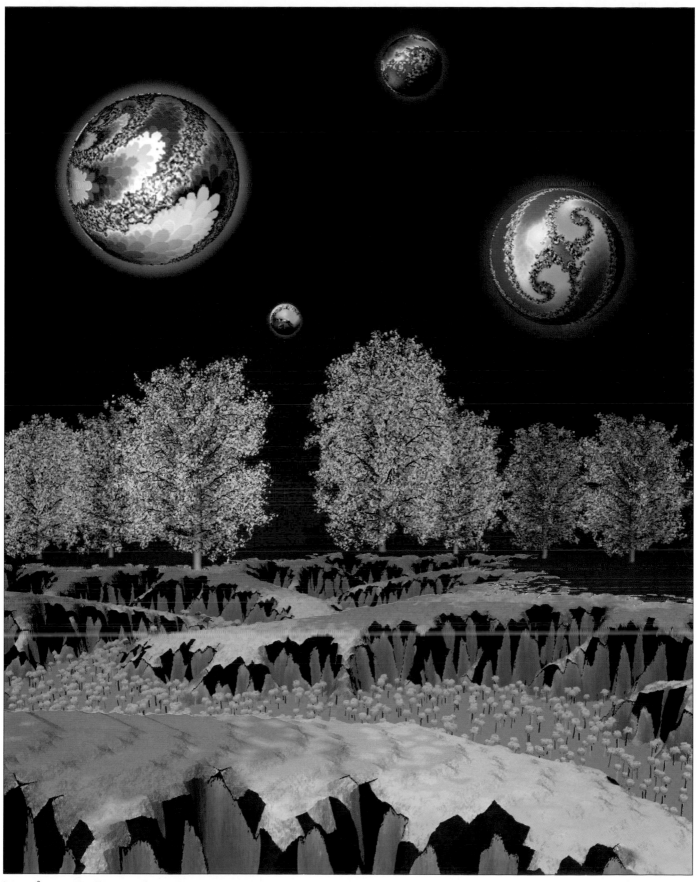

$f(z) = z^2 + c$ with affine transformations

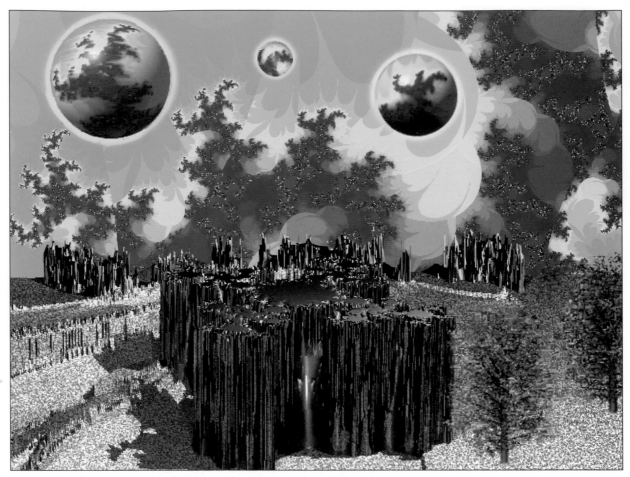

$f(z) = ((z^2 + 1)^2 + c)/z, f(z) = z^4 + c, f(z) = z^2 + c$ with affine transformations

$f(z) = z^2 + c$ with spherical harmonics

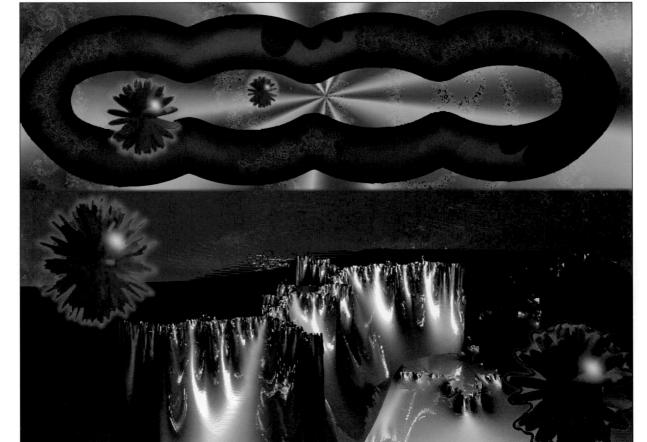

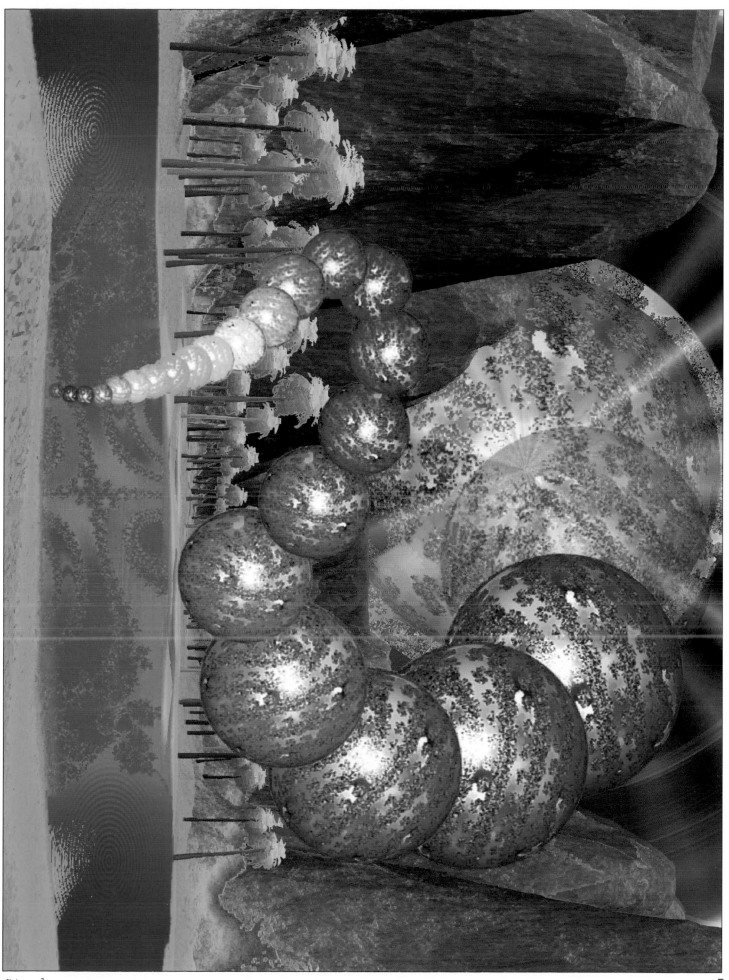

$f(z) = z^2 + c$

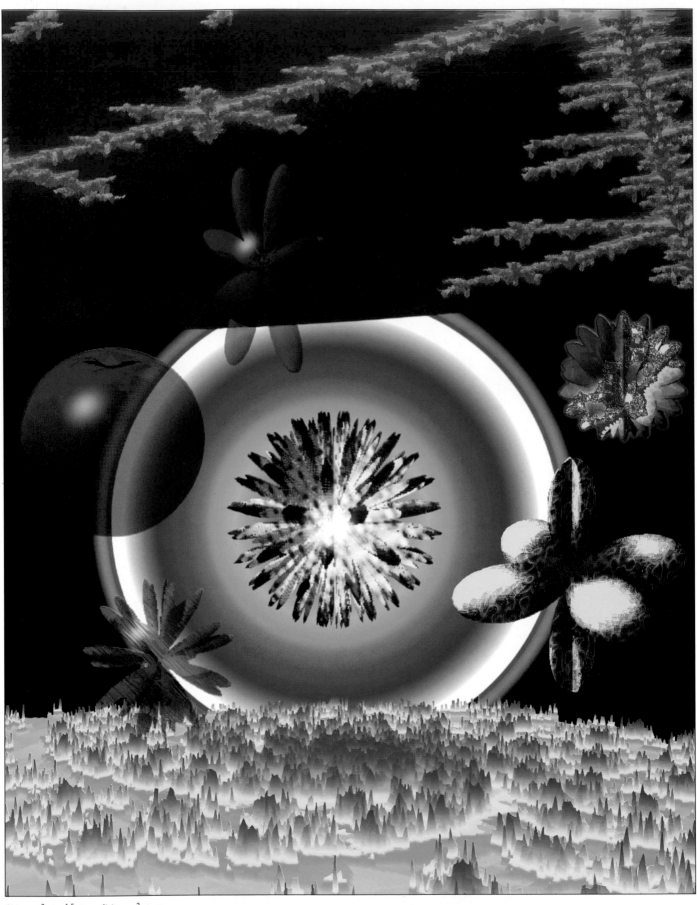

$f(z) = z^2 + z^{1.5} + c$, $f(z) = z^2 + c$
with spherical harmonics

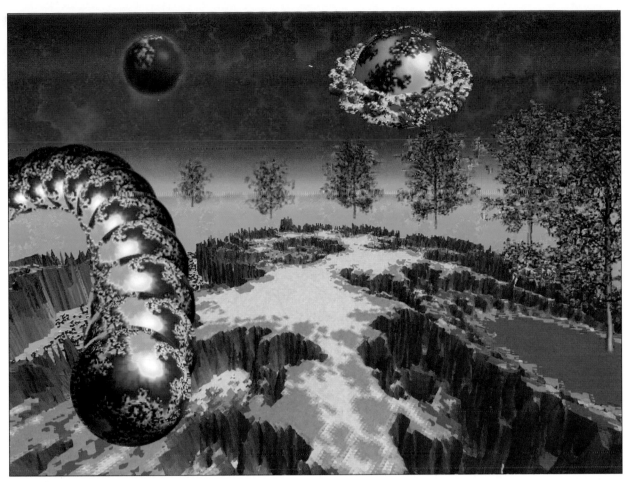

$f(z) = z^2 + c$ with affine transformations

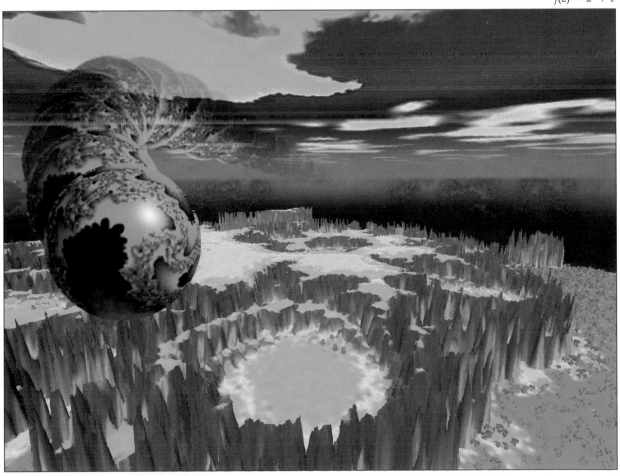

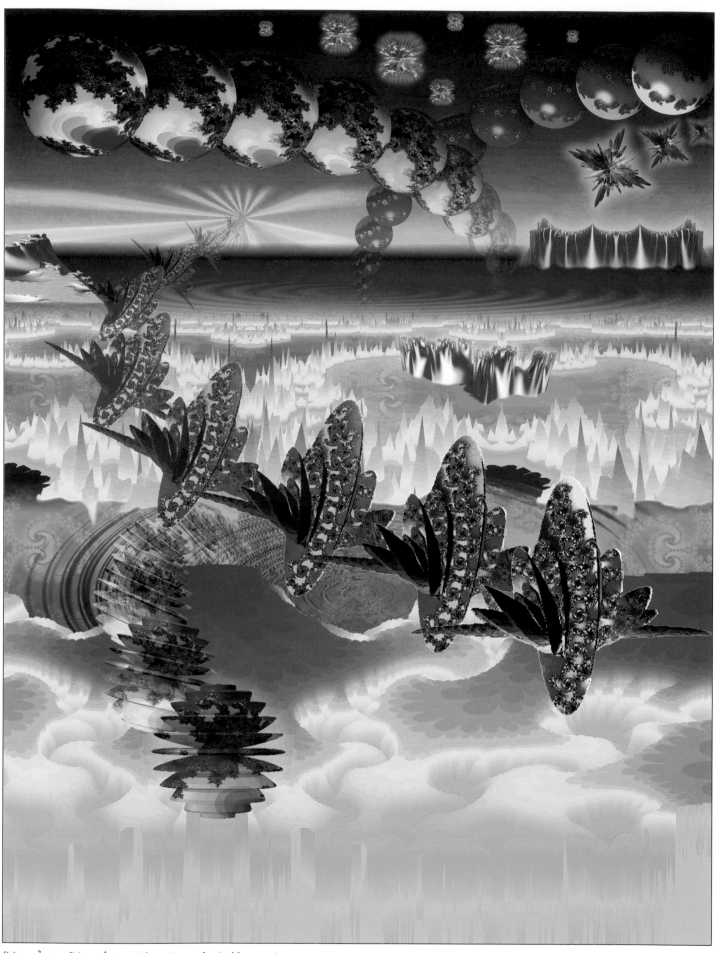

$f(z) = z^2 + c$, $f(z) = z^4 + c$ with various spherical harmonics

$f(z) = z^4 + z + c, f(z) = z^2 + c$

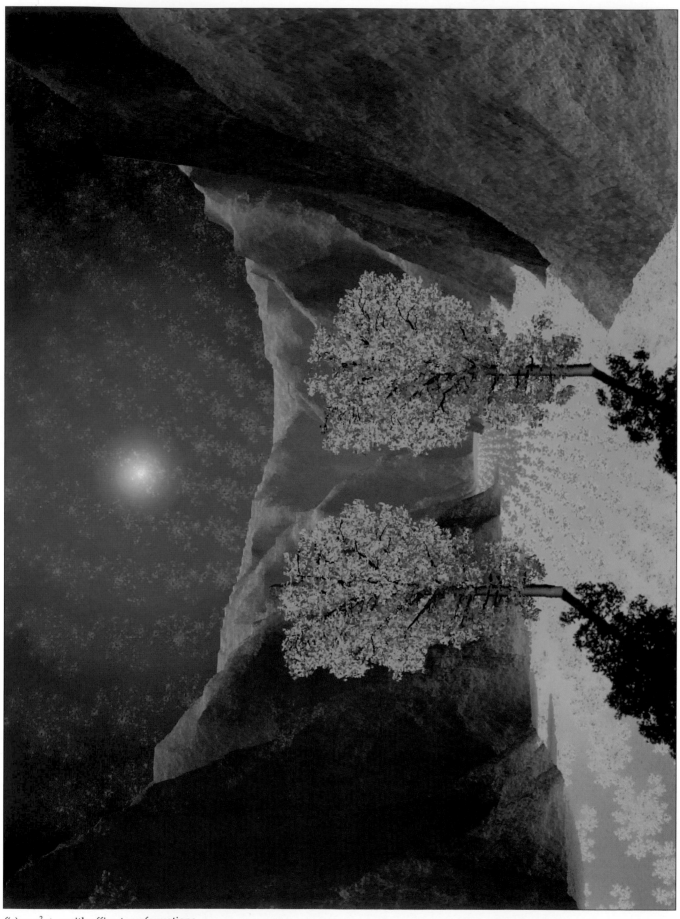

$f(z) = z^2 + c$ with affine transformations

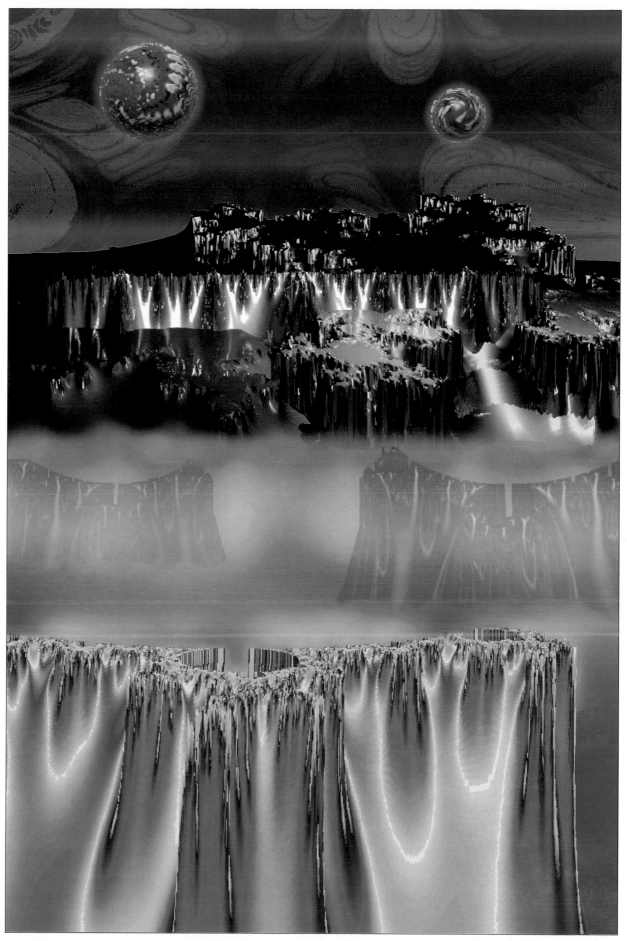

$f(z) = z^4 + z + c, f(z) = z^2 + c$

5-31

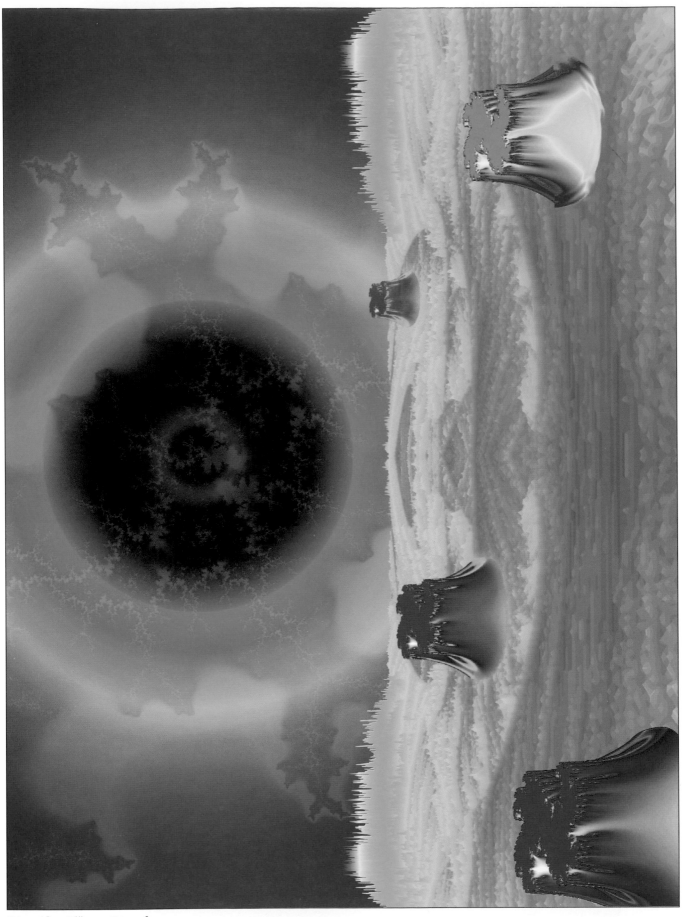

$f(z) = (z^8 + 1)^{1/4} + c, f(z) = z^2 + c$

5-32

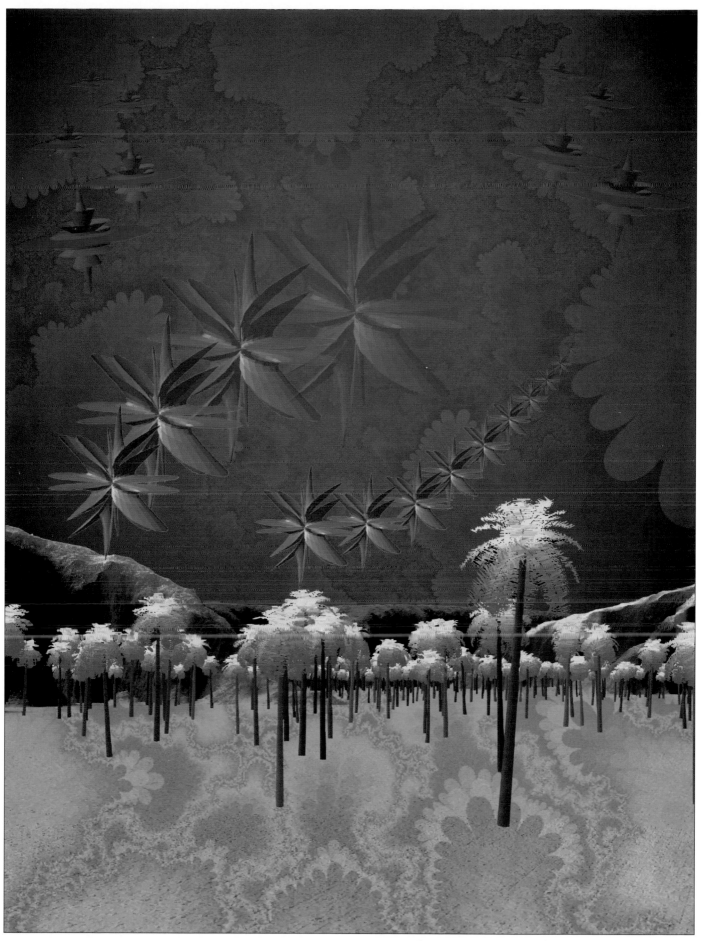

$f(z) = z^2 + c$ with affine transformations and spherical harmonics

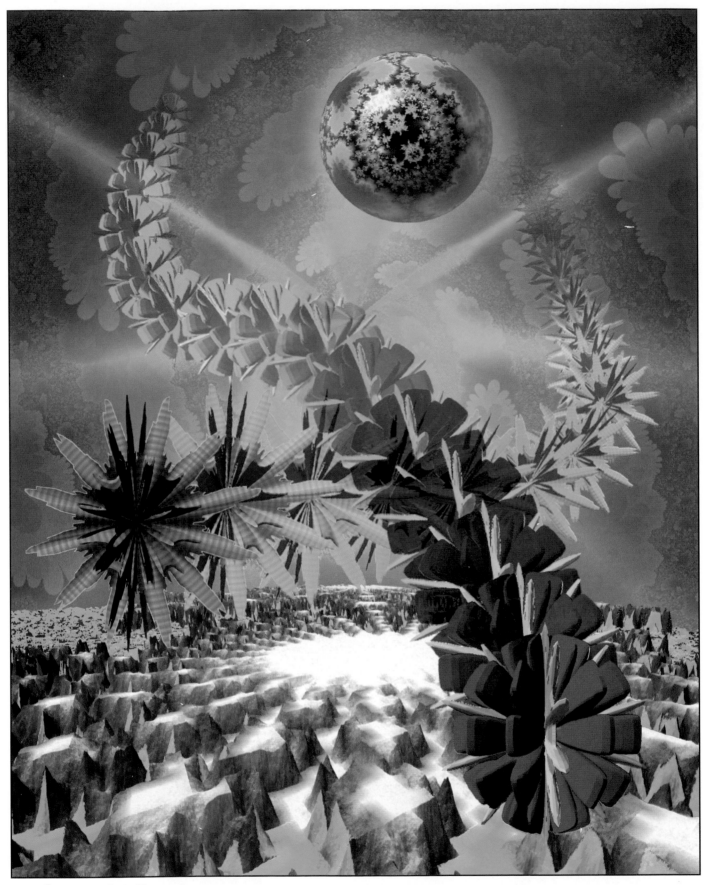

$f(z) = z^2 + c$ with spherical harmonics

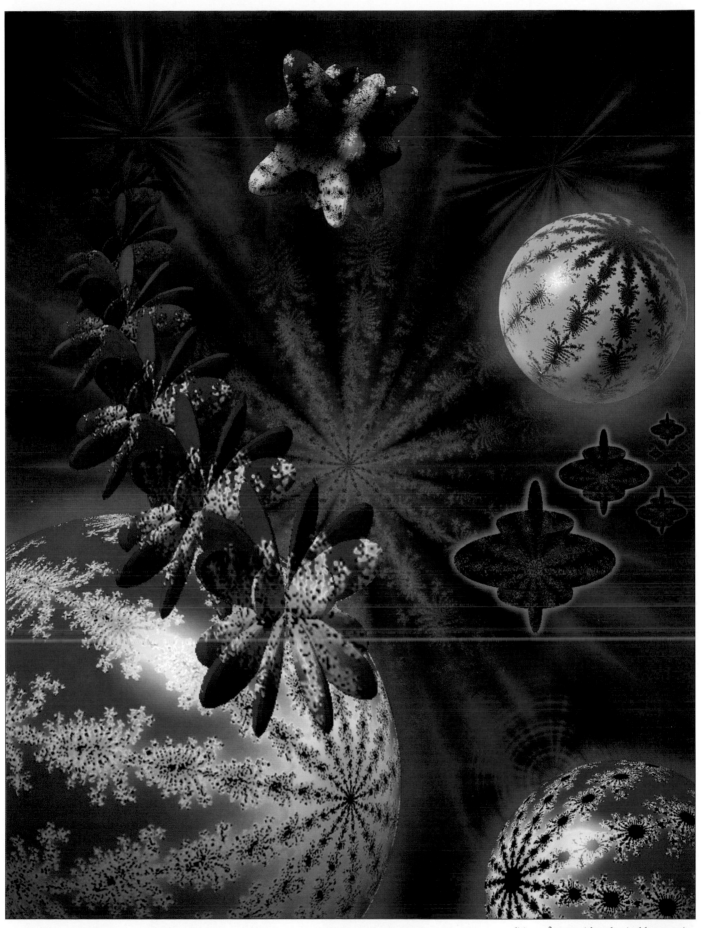

$f(z) = z^2 + c$ with spherical harmonics

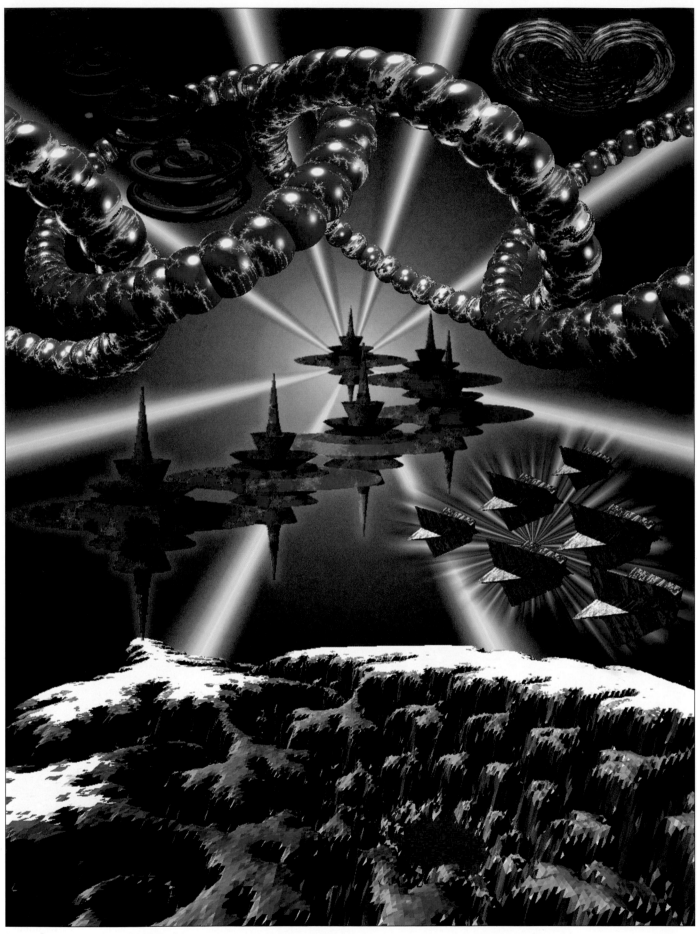

$f(z) = z^2 + c$ with spherical harmonics

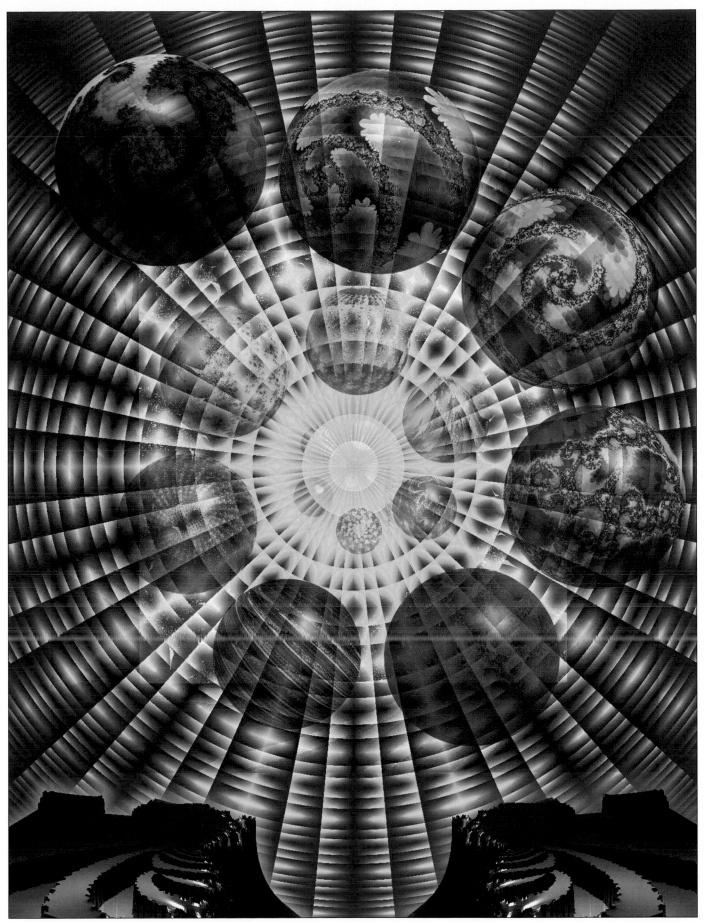

$f(z) = z^2 + c, f(z) = (z^4 + c)^{.5}$ and others

5-37

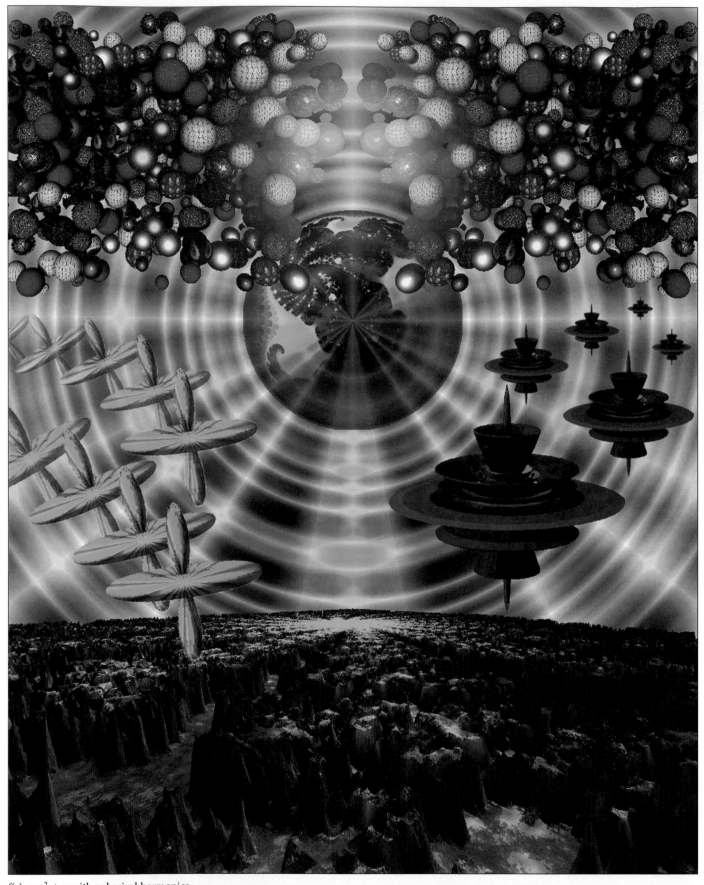

$f(z) = z^2 + c$ with spherical harmonics

[]

Special Image Studies in Fractals

This chapter has a special purpose. It is in this chapter that we try to explore certain aspects of fractals, and we hope that the observer enjoys them as we do. There are four types of studies within this chapter: Equation Study, Mandelbrot Set Study, Parameter Study, and Magnification Study.

The Equation Study involves looking at the variety of imagery that is contained within any one equation.

The Mandelbrot Set Study shows how the Mandelbrot set changes from one equation to the next, the similarities and the dissimilarities.

The Parameter Study shows how the fractal image changes through subtly altering one of the parameters. We change the complex constant c in each example.

The Magnification Study tries to exemplify the concept of self-similarity as we magnify one particular Julia set fractal to a magnification of 169 quintillion. Notice how the exact same structures are prevalent at each level of magnification. Just to give you an idea of how small a magnification of 169 quintillion truly is, if we were to lay out the entire original image at the scale of the most magnified image, we would need a square piece of paper 615,000 miles on a side to draw it completely. That piece of paper would be large enough to cover the entire surface of the Earth over one thousand times!

In conjunction with studying this chapter, please refer to Appendix D.

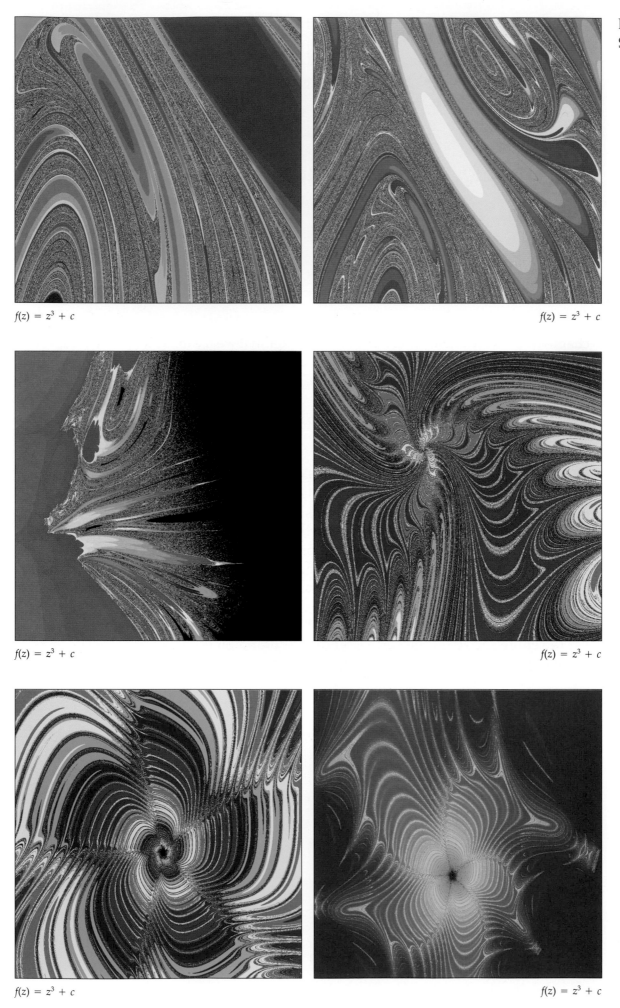

$f(z) = z^3 + c$

$f(z) = z^3 + c$

$f(z) = z^3 + c$

$f(z) = z^3 + c$

$f(z) = z^3 + c$

$f(z) = z^3 + c$

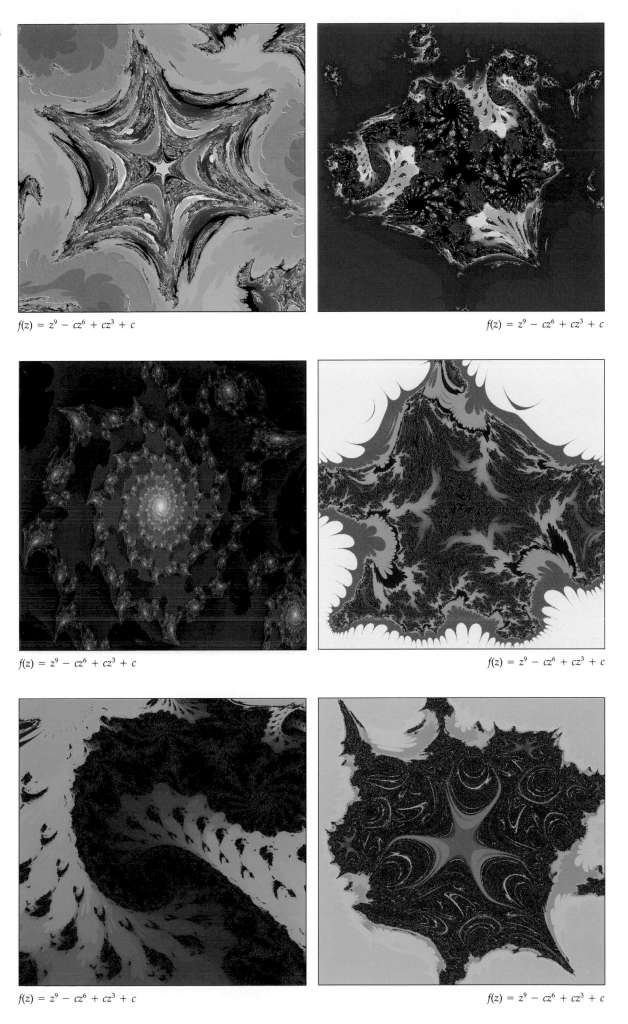

$f(z) = z^9 - cz^6 + cz^3 + c$

$f(z) = z^9 - cz^6 + cz^3 + c$

$f(z) = z^9 - cz^6 + cz^3 + c$

$f(z) = z^9 - cz^6 + cz^3 + c$

$f(z) = z^9 - cz^6 + cz^3 + c$

$f(z) = z^9 - cz^6 + cz^3 + c$

6-3

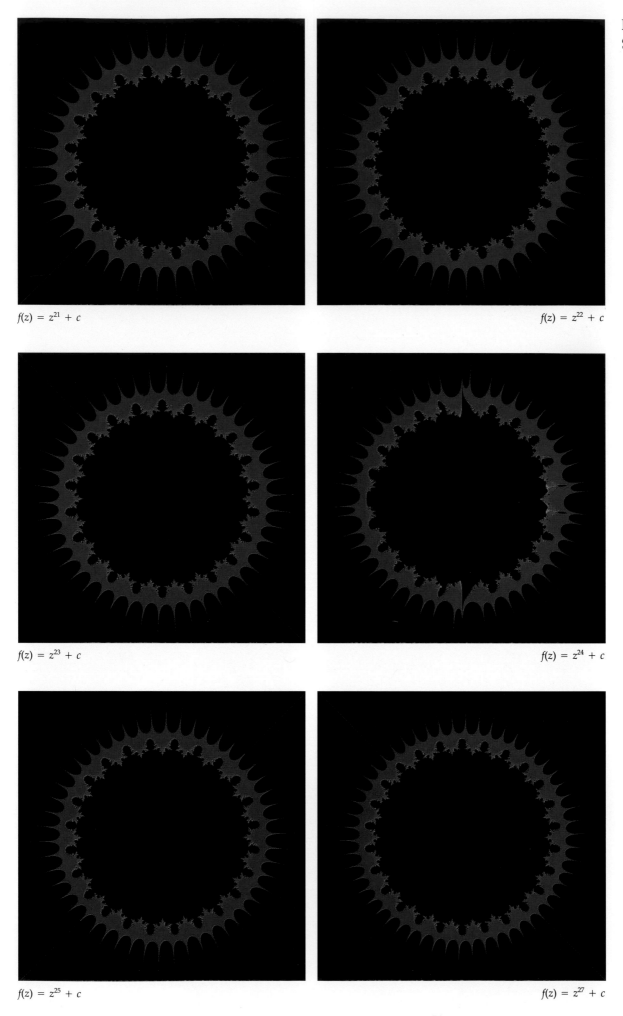

$f(z) = z^{21} + c$

$f(z) = z^{22} + c$

$f(z) = z^{23} + c$

$f(z) = z^{24} + c$

$f(z) = z^{25} + c$

$f(z) = z^{27} + c$

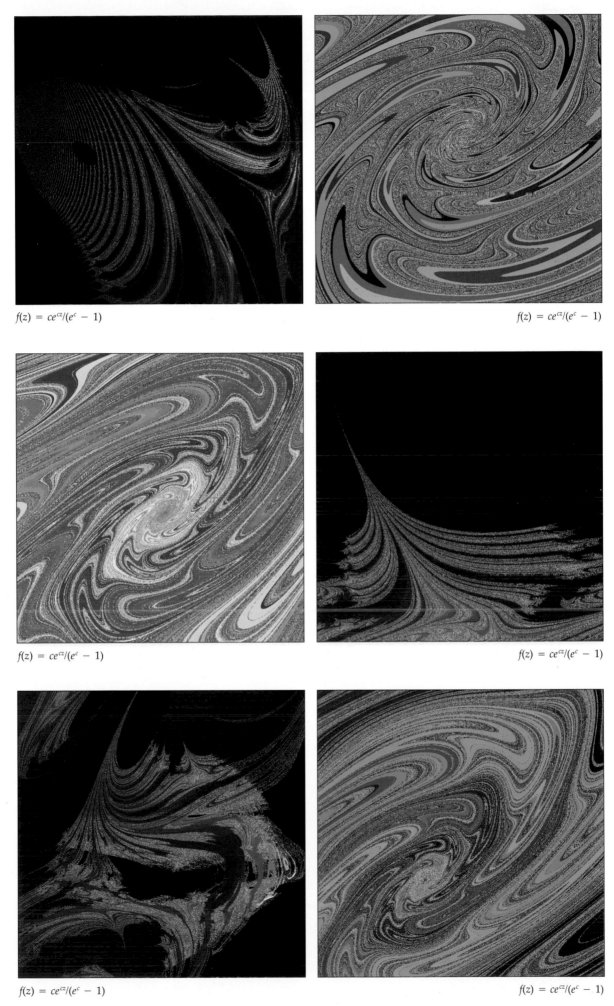

$f(z) = ce^{cz}/(e^c - 1)$

$f(z) = ce^{cz}/(e^c - 1)$

$f(z) = ce^{cz}/(e^c - 1)$

$f(z) = ce^{cz}/(e^c - 1)$

$f(z) = ce^{cz}/(e^c - 1)$

$f(z) = ce^{cz}/(e^c - 1)$

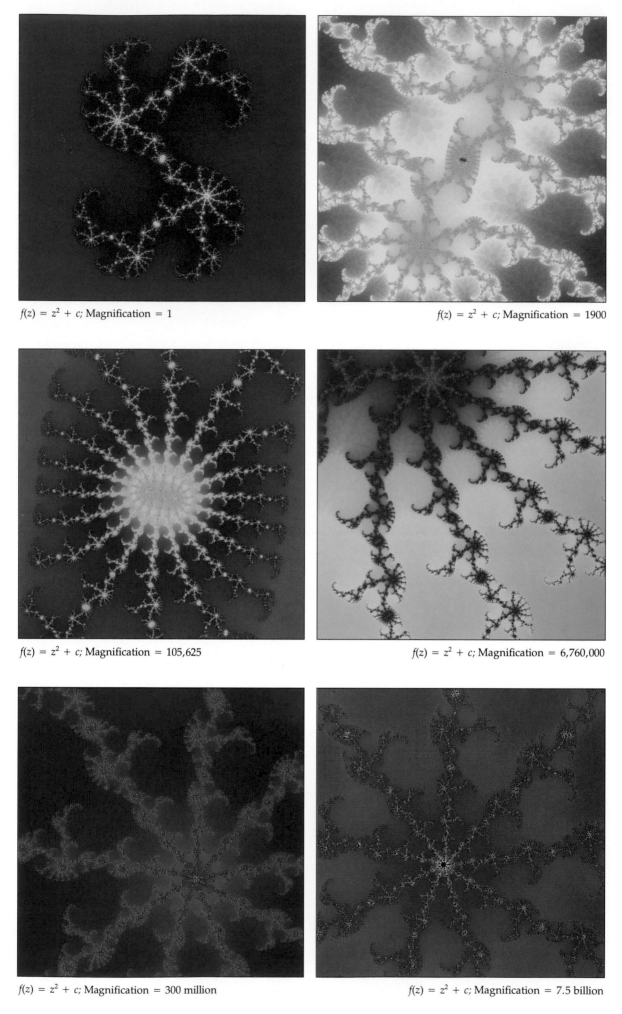

$f(z) = z^2 + c$; Magnification = 1

$f(z) = z^2 + c$; Magnification = 1900

$f(z) = z^2 + c$; Magnification = 105,625

$f(z) = z^2 + c$; Magnification = 6,760,000

$f(z) = z^2 + c$; Magnification = 300 million

$f(z) = z^2 + c$; Magnification = 7.5 billion

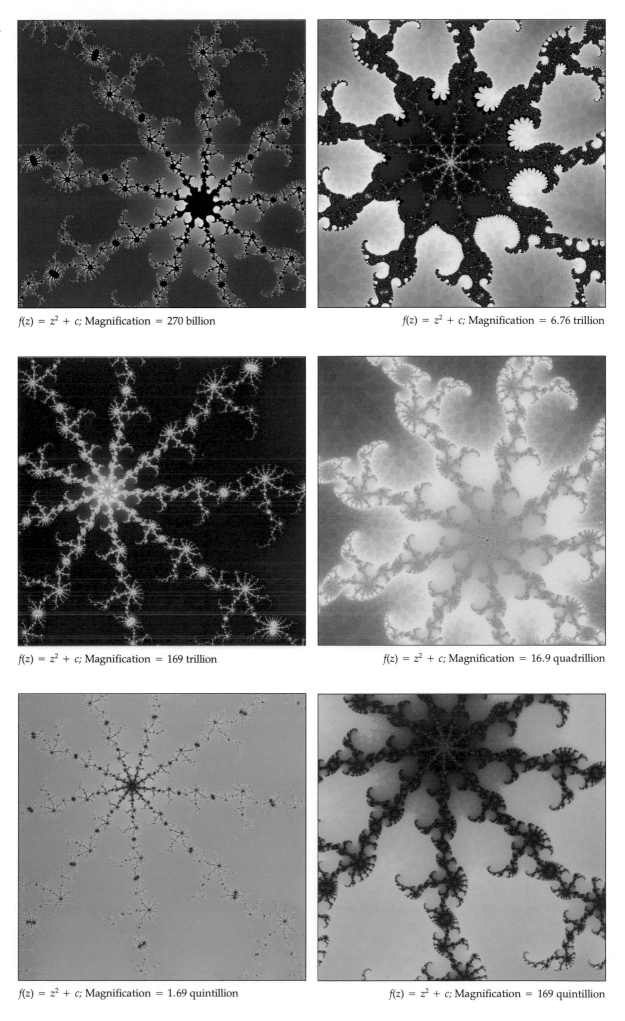

$f(z) = z^2 + c$; Magnification = 270 billion

$f(z) = z^2 + c$; Magnification = 6.76 trillion

$f(z) = z^2 + c$; Magnification = 169 trillion

$f(z) = z^2 + c$; Magnification = 16.9 quadrillion

$f(z) = z^2 + c$; Magnification = 1.69 quintillion

$f(z) = z^2 + c$; Magnification = 169 quintillion

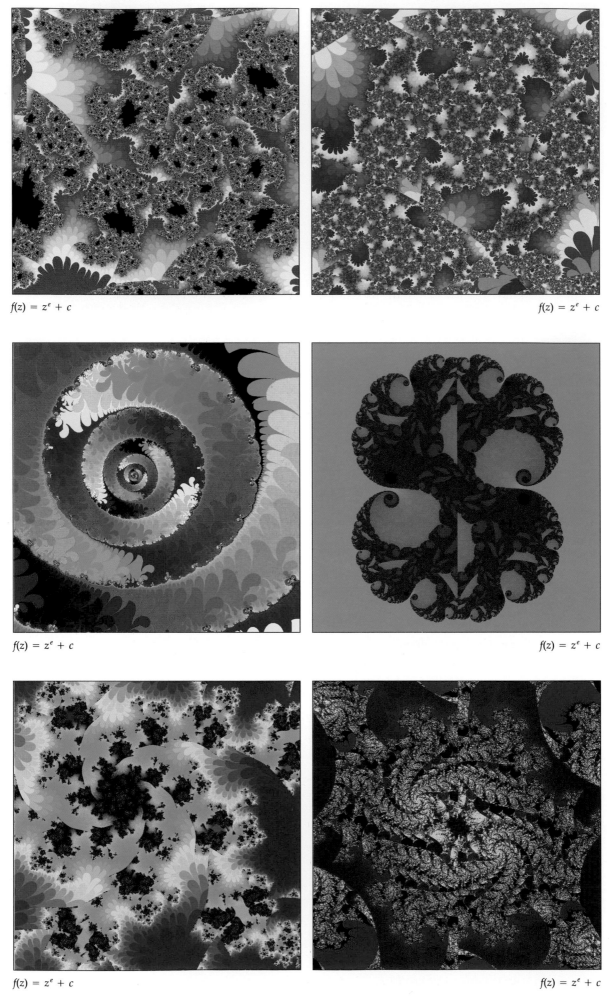

$f(z) = z^e + c$

$f(z) = z^e + c$

$f(z) = z^e + c$

$f(z) = z^e + c$

6-8 $f(z) = z^e + c$

$f(z) = z^e + c$

Equation
Study

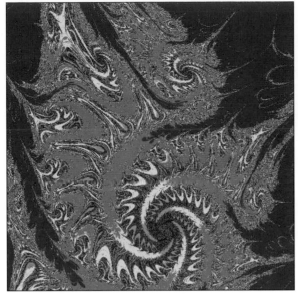

$f(z) = z^2\sin x + cyz + z^2\cos x + cz \sin y + c$

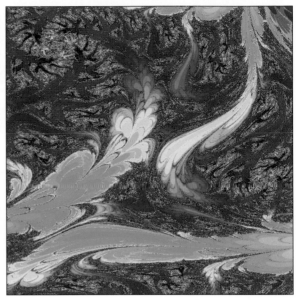

$f(z) = z^2\sin x + cyz + z^2\cos x + cz \sin y + c$

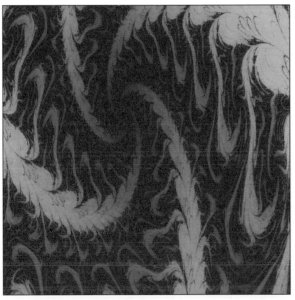

$f(z) = z^2\sin x + cyz + z^2\cos x + cz \sin y + c$

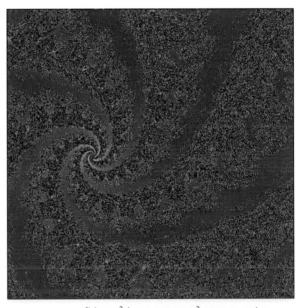

$f(z) = z^2\sin x + cyz + z^2\cos x + cz \sin y + c$

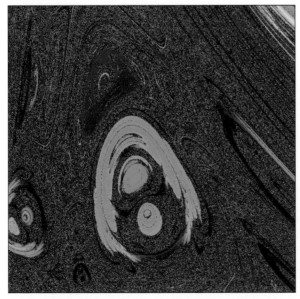

$f(z) = z^2\sin x + cyz + z^2\cos x + cz \sin y + c$

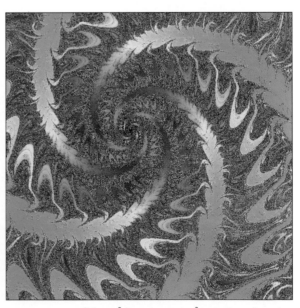

$f(z) = z^2\sin x + cyz + z^2\cos x + cz \sin y + c$

6-9

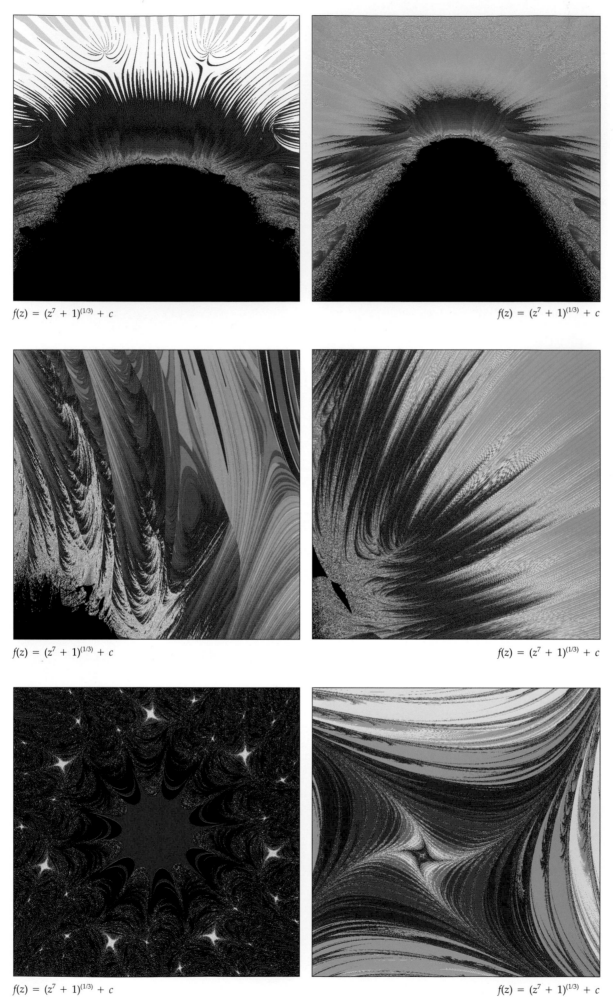

$f(z) = (z^7 + 1)^{(1/3)} + c$

$f(z) = (z^7 + 1)^{(1/3)} + c$

$f(z) = (z^7 + 1)^{(1/3)} + c$

$f(z) = (z^7 + 1)^{(1/3)} + c$

$f(z) = (z^7 + 1)^{(1/3)} + c$

$f(z) = (z^7 + 1)^{(1/3)} + c$

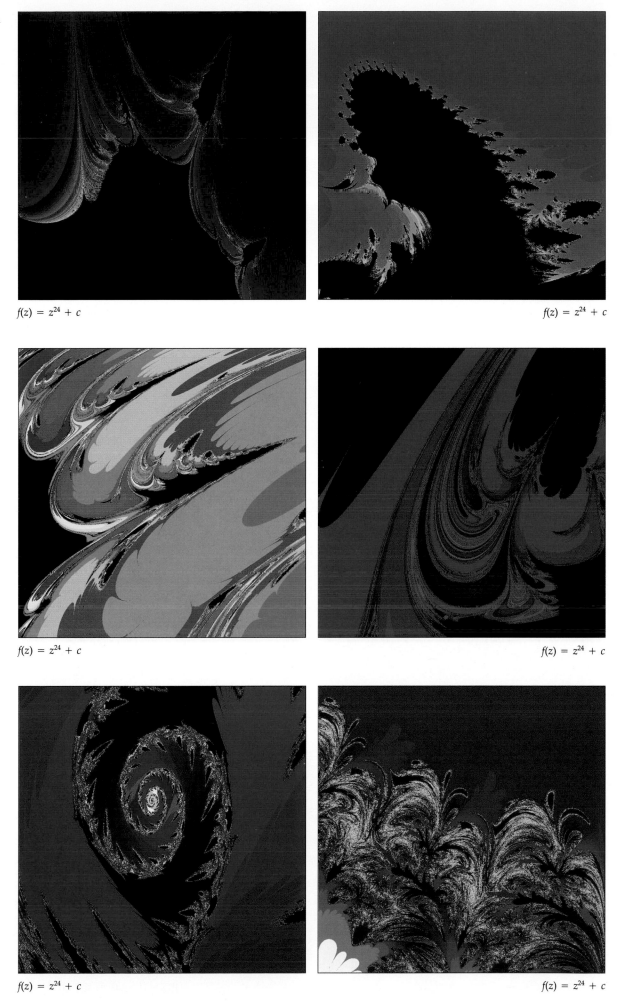

$f(z) = z^{24} + c$

$f(z) = z^{24} + c$

$f(z) = z^{24} + c$

$f(z) = z^{24} + c$

$f(z) = z^{24} + c$

$f(z) = z^{24} + c$ 6-11

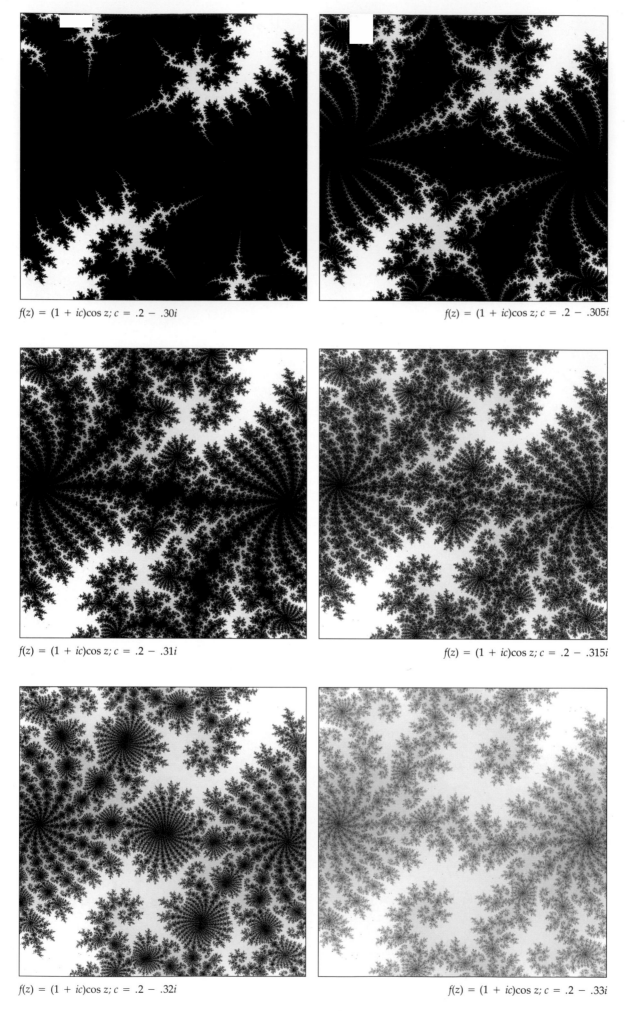

$f(z) = (1 + ic)\cos z; c = .2 - .30i$

$f(z) = (1 + ic)\cos z; c = .2 - .305i$

$f(z) = (1 + ic)\cos z; c = .2 - .31i$

$f(z) = (1 + ic)\cos z; c = .2 - .315i$

6-12

$f(z) = (1 + ic)\cos z; c = .2 - .32i$

$f(z) = (1 + ic)\cos z; c = .2 - .33i$

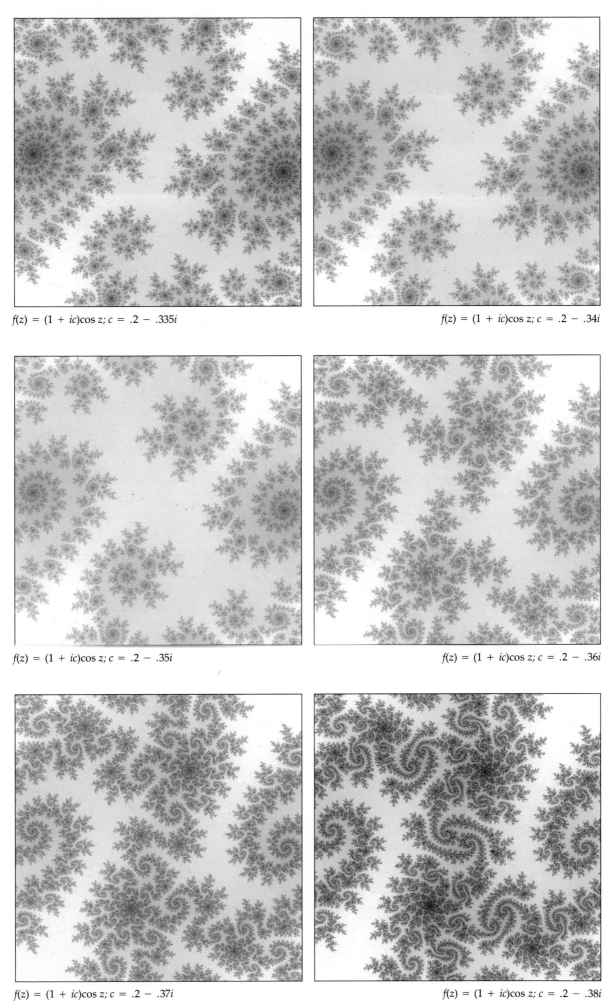

$f(z) = (1 + ic)\cos z; c = .2 - .335i$

$f(z) = (1 + ic)\cos z; c = .2 - .34i$

$f(z) = (1 + ic)\cos z; c = .2 - .35i$

$f(z) = (1 + ic)\cos z; c = .2 - .36i$

$f(z) = (1 + ic)\cos z; c = .2 - .37i$

$f(z) = (1 + ic)\cos z; c = .2 - .38i$

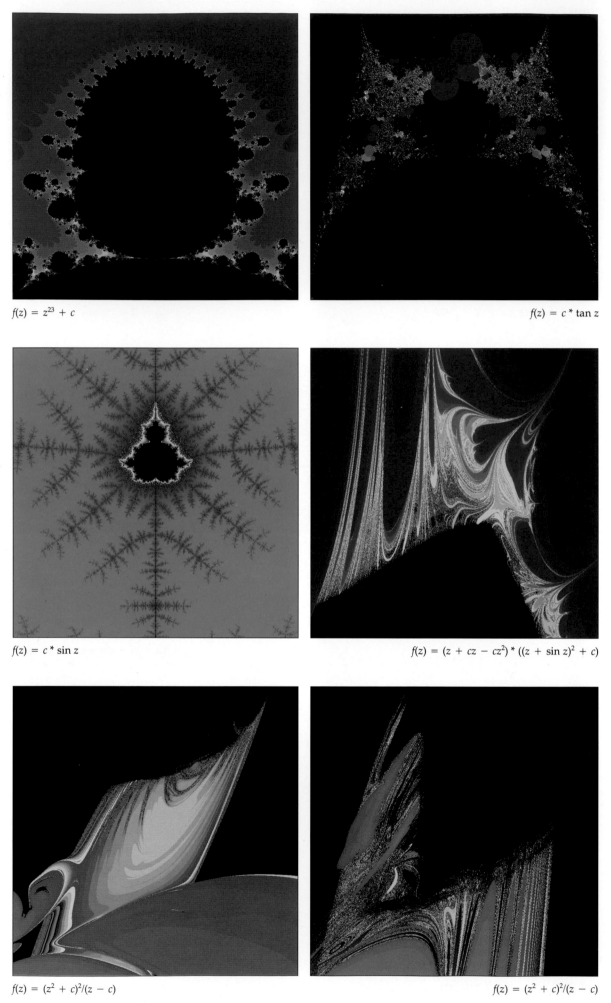

$f(z) = z^{23} + c$

$f(z) = c * \tan z$

$f(z) = c * \sin z$

$f(z) = (z + cz - cz^2) * ((z + \sin z)^2 + c)$

6-14 $f(z) = (z^2 + c)^2/(z - c)$

$f(z) = (z^2 + c)^2/(z - c)$

Mandelbrot
Set Study

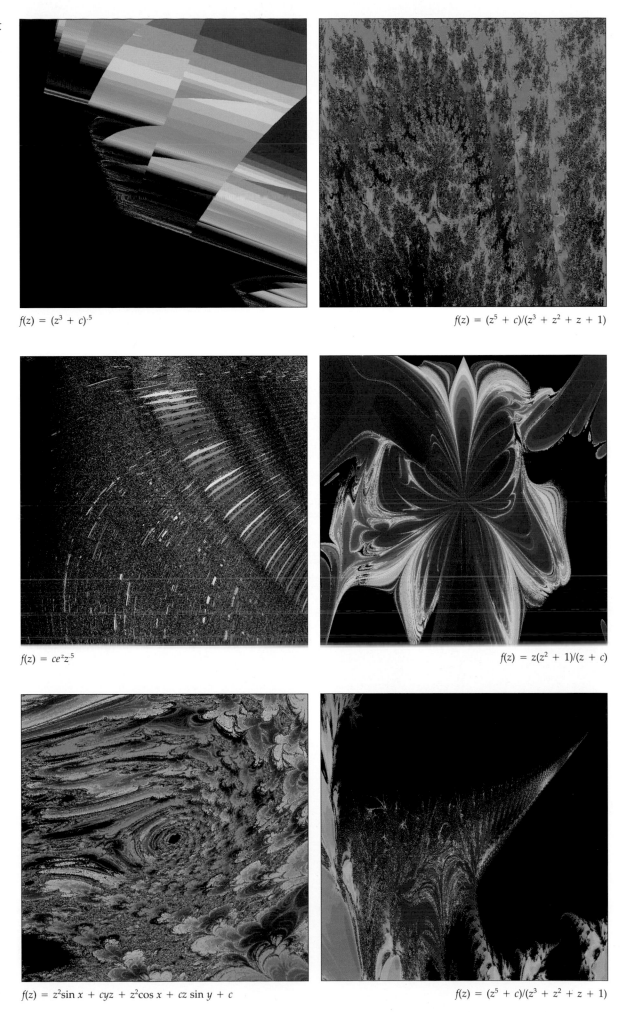

$f(z) = (z^3 + c)^{.5}$

$f(z) = (z^5 + c)/(z^3 + z^2 + z + 1)$

$f(z) = ce^z z^{.5}$

$f(z) = z(z^2 + 1)/(z + c)$

$f(z) = z^2\sin x + cyz + z^2\cos x + cz \sin y + c$

$f(z) = (z^5 + c)/(z^3 + z^2 + z + 1)$

6-15

APPENDIX A

Generating Julia Set Fractals

Most of the fractal images in this book are called Julia sets, named for the early twentieth century French mathematician Gaston Julia, who pioneered the method by which they are produced. The method is not difficult to understand, provided you have enough background. A good course in Algebra II is sufficient to cover all of the topics involved in producing these images. But without a semester or two for study, let me offer the reader some of the important technical highlights before describing how the computer actually produces the images. For the layperson, I strongly suggest a thorough and repeated reading throughout this section to achieve the desired comprehension.

First, you'll need to know what a **square root** is. We say that the square root of 25 is 5 or −5 because both 5 times 5 and −5 times −5 equals 25. Likewise, the square root of 81 is 9 or −9. This is all very normal and proper.

But a strange thing occurs when we try to take the square root of a negative number like −4. After all, 2 times 2 equals 4 and −2 times −2 equals 4. To work around this uncomfortable situation, mathematicians use an **imaginary number** to represent the square root of a negative number. We say that the square root of −1 is *i;* that means that *i* times *i* equals −1. What is the square root of −9? Why, 3*i* (or −3*i*), of course. Numbers like 3*i*, −¾*i*, 8.6*i* and *i* itself are called imaginary numbers. Though they do not exist in the realm of **real numbers,** these imaginary numbers play a vital role in physical and engineering calculations as well as in the generation of Julia and Mandelbrot set fractals.

Now we can add (or subtract) real numbers like 7, 43, 2/5, and −9.6 to imaginary numbers to form **complex numbers** like 4 + 6*i* or −18 − .2*i*. The complex number set contains both the real number set and the imaginary number set.

If you can remember back to junior high or high school, you learned how to graph an equation by plotting points on a grid at their coordinates and then connecting those points. Some were straight lines and some were curves. That grid was called the **Cartesian plane** (after René Descartes) and had two **axes.** The *x*-axis went left to right and the *y*-axis went bottom to top as it went from negative to positive values along its length. The generation of Julia set fractals is done on a coordinate plane like this one except that the plane is called the **complex plane** and the axes are now the real axis (*x*) and the imaginary axis (*y*). The real axis represents the real part of a complex number and the imaginary axis represents the imaginary part of a complex number. Thus, the complex number 2 + 3*i* would be plotted two units to the right of center and three units up from there. See Figure 1.

Let us now discuss the idea of **functions.** A function is a sort of mathematical machine. You put a number into the machine and you get another number out of the machine. A function might tell you to double a number and then add three to that number. It is written as $f(x) = 2x + 3$ and read as "f of x equals two-x-plus-three," where the x represents whatever number we choose to put into this function. Thus, if we put 6 into our function, we get 2 times 6 plus 3 or 15 as the result. If our input value is 57, our output value would be 117, and so on. We can then write $f(6) = 15$ and $f(57) = 117$.

In this case the function and its **variable** x are both in the realm of the real numbers. When we generate Julia set fractals, we use functions of a **complex variable.** The convention has been to use the letter z to represent a complex number or variable. As before, a complex variable is the sum of a real variable and an imaginary variable. That is, $z = x + yi$.

One of the remarkable things about working with complex numbers is that, outside of a very few exceptions, no matter what mathematical function you perform on a complex number, you always get a complex number as the result. You can add, subtract, multiply, or divide them. You can exponentiate them, take any root, or use any of the trigonometric functions and you will get a complex number as the result.

The simplest function we use to generate a Julia set fractal is the function $f(z) = z^2 + c$. This means that we would put in a complex number z (which is really $x + yi$), then multiply it by itself (a process called **squaring a number**), and then add another complex number c to the result. The c is a complex **constant,** that is, a number that does not change throughout the entire fractal calculation.

The following example illustrates one of these calculations:

Let $z = 2 + 3i$ and $c = 4 + 5i$. Then*

$$
\begin{aligned}
f(z) &= z^2 + c \\
&= [(2 + 3i) \cdot (2 + 3i)] + (4 + 5i) \\
&= [(2 \cdot 2) + (2 \cdot 3i) + (3i \cdot 2) + (3i \cdot 3i)] + (4 + 5i) \\
&= [4 + 6i + 6i + (-9)] + (4 + 5i) \\
&= (-5 + 12i) + (4 + 5i) \\
&= -1 + 17i
\end{aligned}
$$

So $f(z) = f(2 + 3i) = (2 + 3i)^2 + (4 + 5i) = -1 + 17i$.

There are an infinite number of functions that can be devised. The procedure for each is essentially the same, except that the operations involved within the function will be more complicated and numerous.

*We use a dot to signify multiplication in algebra as " \times " might be confused with the variable x.
In computer programming languages, an asterisk is used to denote multiplication.

The next thing you need to know is how to find the size or **norm** of a complex number. The size or norm of a real number is just the number itself, that is, the norm of 7 is 7. But the size of a complex number is found a bit differently:

$$\text{norm of } z = \|z\| = \|x + yi\| = (x^2 + y^2)^{1/2}$$

As an example we have the following:

$$\|3 - 4i\| = [3^2 + (-4)^2]^{1/2} = (9 + 16)^{1/2} = (25)^{1/2} = 5.$$

Notice that the size is always a real number.

There is just one more topic to discuss before we get into what the computer does. Let's revisit the complex plane one more time. Please refer to Figure 1 again, as well as Figure 2.

The numbers in parentheses are the real and imaginary coordinates of the points marked on the graph. The number of points your computer screen can display usually determines how finely you can divide the graph that you begin from. I usually begin as above and break the screen into 900 divisions by 900 divisions (because the largest square my monitor displays is 900 by 900 individual color dots or **pixels**). This means there are 810,000 points on our graph above, corresponding to the 810,000 pixels that my monitor will display. Each one of these 810,000 points has numerical coordinates corresponding to its location on the graph. These coordinates become the starting values of $x + yi$ for inputting values into our function.

Let's finally describe the actual steps of the computer's program as an **algorithm:**

1) This is the user input step in which we tell the computer what equation to use, what our value for the complex constant c will be, how big our coordinate plane will be, our "blowup" parameter, the maximum number of **iterations** allowed, and the **color map** with which we wish the computer to display its results.

2) The computer starts with its upper-left-most point and its coordinates. In our case, the coordinates would be $(-1, -1)$. These are the values for x and y that we plug into our function.

3) The computer does to those coordinate values whatever the particular function you chose specifies it to do. In the simplest case, it would square the complex number $(-1 - i)$ and add whatever value for c you inputted in Step 1.

4) Then the computer finds the size or norm of the outputted complex number result and compares it with the blowup parameter.

5) If the norm of the outputted result is not larger than the blowup value, the *outputted* x and y values become our new *inputted* values to the function the next time around. We repeat Steps 3 through 5 over and over until the outputted norm is larger than the blowup parameter. In the meantime, we must keep track of the number of cycles, or iterations, it takes for the output to exceed our blowup value. Usually if the outputted norm does not exceed this value in 256 cycles, we stop calculating and call its **iteration number** 256.

6) Once the size of the outputted value exceeds our blowup value, we stop calculating, and we record the number of cycles it took to exceed this blowup value as the original point's iteration number.

7) The number of cycles or iterations is the crucial number for telling the computer what color to print for that very first point on our graph and screen. Say that it took 56 iterations for that first point to exceed the blowup value. The computer might plot that point red (the actual color depends on the color map you chose). If it only took 55 iterations, the computer might be instructed to plot a slightly lighter shade of red. If it took only 54, a lighter shade still.

8) Then we return to Step 2 above to begin anew with the very next point (and its coordinates) on the screen and repeat Steps 3 through 7 for every one of the 810,000 points on the screen. Once iteration numbers are calculated for each point and pixels are colored appropriately, a picture emerges. You can now see how it can take up to $900 \times 900 \times 256 = 200,000,000+$ calculations for each fractal image. Furthermore, we have only described the simplest of functions!

This is just the basic procedure. One thing we have not described is the importance of the complex number c that we introduced when we started talking about complex functions. Remember that as a complex number, it too is the sum of a real number and an imaginary number. This complex number ostensibly acts as a "seed value" and remains constant throughout the entire two hundred million possible calculations for each fractal image. Interestingly, though the function we choose determines what family of images we will get, it is this value c that determines what picture we will get within that family.

It turns out that certain values of c yield very plain, stable images of two or three colors, whereas other values of c produce wildly chaotic images involving all 256 colors and more. Finding the interesting values of c is crucial to making intriguing Julia set fractals. We use a related fractal called the **Mandelbrot set** for each function we use, to first find the interesting values of c. There is only one Mandelbrot set for each complex function, but there is an infinite number of possible Julia sets. But do not be fooled; within the depths of each Mandelbrot set is another infinitude of interesting fractal images just waiting to be uncovered.

Fractal objects and images all exhibit the quality of **self-similarity.** That is, if you were to focus in on a small portion of a fractal object like the Mandelbrot set and continue to magnify it, you would uncover objects that are exactly like the original set. This process of self-similarity goes on to infinity within each and every fractal image.

THE COMPLEX PLANE

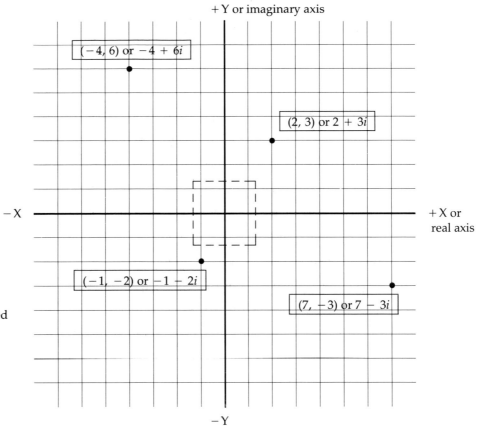

Figure 1. The dotted section in the center of the graph is the portion we have divided up on our computer monitor in Figure 2.

THE COMPUTER MONITOR

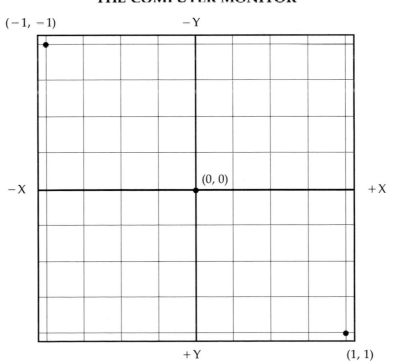

Figure 2. The computer monitor is divided into 900 horizontal and 900 vertical divisions.

APPENDIX B

Selected Bibliography

Books

(Listed alphabetically under title's very first word, followed by author, publisher, and date)

Advanced Fractal Programming in C and C + +, Stevens, Henry Holt, New York, 1992.

An Eye for Fractals: A Graphic & Photographic Essay, McGuire, Addison-Wesley, Redwood City, CA, 1991.

An Introduction to Chaotic Dynamical Systems, Devaney, Addison-Wesley, New York, 1986.

Bifurcation Theory and its Applications, Kaplan, Yorke, and Williams, New York Academy of Sciences, New York, 1979.

Chaos: Making a New Science, Gleick, Viking Press, New York, 1987.

Computers and the Imagination, Pickover, St. Martin's Press, New York, 1989.

Computers, Patterns, Chaos, and Beauty: Graphics from an Unseen World, Pickover, St. Martin's Press, New York, 1990.

Deterministic Chaos, Schuster, Physik-Verlag, Weinheim, 1984.

Does God Play Dice: The Mathematics of Chaos, Stewart, Basil Blackwell, Cambridge, 1990.

Dynamical Systems and Evolution Equations, Walker, Plenum Press, New York, 1980.

Dynamical Systems and Fractals: Computer Graphics Experiments in Pascal, Becker and Dörfler, Cambridge University Press, Cambridge, 1986.

Exploring the Geometry of Nature: Computer Modeling of Chaos, Fractals, Cellular Automata, and Neural Networks, Rietman, Windcrest Books, 1989.

Fractal Programming in C, Stevens, Henry Holt, New York, 1990.

Fractal Programming in Turbo Pascal, Stevens, Henry Holt, New York, 1991.

Fractals, Feder, Plenum Press, New York, 1988.

Fractals, Lauwerier, Princeton University Press, Princeton, NJ, 1992.

Fractals and Multifractals, Mandelbrot, Springer-Verlag, New York, 1991.

Fractals, Chaos, Power Laws, Schroeder, Freeman, New York, 1991.

Fractals Everywhere, Barnsley, Academic Press, Boston, 1988.

Fractals: Form, Chance, and Dimension, Mandelbrot, Freeman, San Francisco, 1977.

Fractals, The Patterns of Chaos, Briggs, Touchstone/Simon & Schuster, New York, 1992.

FractalVision: Put Fractals to Work for You, Oliver, Prentice-Hall, Carmel, IN, 1992.

Fun with Fractals, Robbins, Sybex, Alameda, CA, 1992.

Handbook of Mathematical Functions, Abramowitz and Stegun, Dover, New York, 1968.

Islands of Truth: A Mathematical Mystery Cruise, Peterson, Freeman, New York, 1990.

Iterated Maps on the Interval as Dynamical Systems, Collet and Ekmann, Birkhauser, Boston, 1980.

Mathematics and the Unexpected, Ekeland, University of Chicago Press, Chicago, 1988.

Order Out of Chaos: Man's New Dialogue with Nature, Prigogine and Stengers, Bantam, New York, 1984.

Symmetry in Chaos, Field and Golubitsky, Oxford University Press, New York, 1992.

The Beauty of Fractals, Peitgen and Richter, Springer-Verlag, Berlin, 1986.

The Fractal Explorer, Garcia, Dynamic Press, Santa Cruz, CA, 1991.

The Fractal Geometry of Nature, Mandelbrot, Freeman, New York, 1980.

The Geometry of Fractal Sets, Falconer, Cambridge University Press, Cambridge, 1985.

The Mathematical Tourist: Snapshots of Modern Mathematics, Peterson, Freeman, New York, 1988.

The Science of Fractal Images, Peitgen and Saupe, Springer-Verlag, Berlin, 1988.

Turbulent Mirror: An Illustrated Guide to Chaos Theory and the Science of Wholeness, Briggs and Peat, Harper Collins, New York, 1989.

Papers

(Listed alphabetically under author)

Dewdney, A. K., "Computer Recreations," *Scientific American*, September 1986, pp. 140–145.

Fatou, P., 1906. Sur les solutions uniformes de certains équations fonctionelles. *Comptes rendus (Paris)* **143**, 546–548.

———, 1919–20. Sur les équations fonctionelles. *Bull. Société Mathématique de France* **47**, 161–271; **48**, 208–314.

Feigenbaum, M. J., "Quantitative Universality for a Class of Nonlinear Transformations," *Journal of Statistical Physics* **19**, 25–52 (1978).

———, "The Universal Metric Properties of Nonlinear Transformations," *Journal of Statistical Physics* **21**, 669–706 (1979).

Hausdorff, F., 1919. "Dimension und äusseres Mass." *Mathematische Annalen*, **79**, 157–179.

Julia, G., 1918. Mémoire sur l'itération des fonctions rationnelles. *J. de Mathématiques Pures et Appliqués* **4**, 47–245. Reprinted (with related texts) in *Oeuvres de Gaston Julia*, Paris, Gauthier-Villars. 1968, pp. 121–319.

Lorenz, E., 1963. "Deterministic Nonperiodic Flows," *Journal of the Atmospheric Sciences*, **20**, 130–141.

Mandelbrot, B. B., 1980. Fractal aspects of the iteration of $z = \lambda z(1 - z)$ for complex λ and z. *Non Linear Dynamics*, ed. R. H. G. Helleman. Annals of New York Academy of Sciences, 357, 249–259.

Verhulst, P. F., 1845. Récherches mathématiques sur la loi d'accroissement de la population. *Nouv. Mém. de l'Acad. Roy. des Sciences et Belles-Lettres de Bruxelles* XVIII. 8, 1–38.

Voss, R. F., 1985. "Random Fractal Forgeries," *Fundamental Algorithms for Computer Graphics*, Springer-Verlag, Berlin.

APPENDIX C

Important Formulae for Complex Numbers

1) $z = x + iy$ where $x =$ Real part of z and $y =$ Imaginary part of z

2) $c = a + ib$ where $a =$ Real part of c and $b =$ Imaginary part of c

3) $z = re^{i\theta} = (\text{sqrt}(x^2 + y^2))(\cos \theta + i \sin \theta)$ where $\theta = \arctan(y/x)$,
 $r = \text{sqrt}(x^2 + y^2)$, and
 "sqrt" means square root

4) $z^n = r^n e^{in\theta} = (\text{sqrt}(x^2 + y^2))^n (\cos n\theta + i \sin n\theta)$

5) $\text{sqrt}(z) = (\text{sqrt}(r)\text{sqrt}(e^{i\theta}))$
 $= (\text{sqrt}(\text{sqrt}(x^2 + y^2)))[\cos(.5 \arctan(y/x)) + i \sin(\arctan(y/x))]$

6) $\ln z = \ln[\text{sqrt}(x^2 + y^2)] + i \arctan(y/x)$

7) $e^z = e^x(\cos y + i \sin y)$

8) $\sin z = \sin x \cosh y + i \cos x \sinh y = -i \sinh iz = (e^{iz} - e^{-iz})/2i$

9) $\cos z = \cos x \cosh y - i \sin x \sinh y = \cosh iz = (e^{iz} + e^{-iz})/2$

10) $\sinh z = -i \sinh iz = (e^z - e^{-z})/2$

11) $\cosh z = \cos iz = (e^z + e^{-z})/2$

12) $\sin^2 z + \cos^2 z = 1$

13) $\cosh^2 z - \sinh^2 z = 1$

14) $\tan z = (\sin 2x + i \sinh 2y)/(\cos 2x + \cosh 2y)$

15) $\cot z = (\sin 2x - i \sinh 2y)/(\cosh 2y - \cos 2x)$

16) nth root of $z = [n$th root of $(x^2 + y^2)](\cos(\theta/n) + i \sin(\theta/n))$

17) Newton's Method $z_{n+1} = z_n - [f(z_n)/f'(z_n)]$

18) Henon Attractor (for $z_n = x_n + iy_n$) $x_{n+1} = ax_n + y_n$ and $y_{n+1} = bx_n$

19) Halley Map $z_{n+1} = z_n - \lambda[(2f(z_n)f'(z_n))/(2(f'(z_n))^2 - f''(z_n)f(z_n))]$

20) Lorenz Attractor $dx/dt = a(y - x)$ $dy/dt = x(r - z) - y$ $dz/dt = xy - bz$

Supplemental Fractal Data
for Color Plates

Page 2-2

Position on page:	Top
Image type:	Julia set
Equation:	$f(z) = z^2 + c$
Complex constant:	$c = -.12 + .89i$
Screen parameters:	$x_max = .05 \qquad x_min = -.05$
	$y_max = .05 \qquad y_min = -.05$
Blowup parameter:	10
Maximum number of iterations:	256

Position on page:	Bottom
Image type:	Julia set
Equation:	$f(z) = z^2 + c$
Complex constant:	$c = -.9204897 + .324196i$
Screen parameters:	$x_max = .02 \qquad x_min = -.02$
	$y_max = .02 \qquad y_min = -.02$
Blowup parameter:	10
Maximum number of iterations:	256

Page 2-3

Position on page:	Top
Image type:	Julia set
Equation:	$f(z) = z^2 + c$
Complex constant:	$c = -1.2025737 - .1965742i$
Screen parameters:	$x_max = .02 \qquad x_min = -.02$
	$y_max = .02 \qquad y_min = -.02$
Blowup parameter:	10
Maximum number of iterations:	256

Page 2-3 (*continued*)

Position on page:	Bottom
Image type:	Julia set
Equation:	$f(z) = z^2 + c$
Complex constant:	$c = -.7678 + .10363i$
Screen parameters:	$x_max = 1 \qquad x_min = -1$
	$y_max = 1 \qquad y_min = -1$
Blowup parameter:	10
Maximum number of iterations:	256

Page 2-4

Position on page:	Top
Image type:	Julia set
Equation:	$f(z) = z^2 + c$
Complex constant:	$c = -.920513 + .324199i$
Screen parameters:	$x_max = .01 \qquad x_min = -.01$
	$y_max = .01 \qquad y_min = -.01$
Blowup parameter:	10
Maximum number of iterations:	256

Position on page:	Bottom
Image type:	Julia set
Equation:	$f(z) = z^2 + c$
Complex constant:	$c = .3770397 - .0863162i$
Screen parameters:	$x_max = .02 \qquad x_min = -.02$
	$y_max = .02 \qquad y_min = -.02$
Blowup parameter:	10
Maximum number of iterations:	512

Page 2-5

Position on page:	Top
Image type:	Mandelbrot set
Equation:	$f(z) = z^2 + c$
Screen parameters:	$x_max = -.413170 \qquad x_min = -.421590$
	$y_max = .605918 \qquad y_min = .600770$
Blowup parameter:	10
Maximum number of iterations:	256

Position on page:	Bottom
Image type:	Mandelbrot set
Equation:	$f(z) = z^2 + c$
Screen parameters:	$x_max = -.416502 \qquad x_min = -.417646$
	$y_max = .603208 \qquad y_min = .602501$
Blowup parameter:	10
Maximum number of iterations:	256

Page 2-6

Position on page:	Top
Image type:	Mandelbrot set
Equation:	$f(z) = z^2 + c$
Screen parameters:	$x_max = -1.257$ $\qquad x_min = -1.2615$
	$y_max = -.037$ $\qquad y_min = -.0415$
Blowup parameter:	10
Maximum number of iterations:	256

Position on page:	Bottom
Image type:	Mandelbrot set
Equation:	$f(z) = z^2 + c$
Screen parameters:	$x_max = -1.257$ $\qquad x_min = -1.2615$
	$y_max = -.037$ $\qquad y_min = -.0415$
Blowup parameter:	10
Maximum number of iterations:	256

Page 2-7

Position on page:	Top
Image type:	Julia set
Equation:	$f(z) = z^2 + c$
Complex constant:	$c = -1.202456 - .196658i$
Screen parameters:	$x_max = .01$ $\qquad x_min = -.01$
	$y_max = .01$ $\qquad y_min = -.01$
Blowup parameter:	10
Maximum number of iterations:	256

Position on page:	Bottom
Image type:	Julia set
Equation:	$f(z) = z^2 + c$
Complex constant:	$c = -.76906 + .10436i$
Screen parameters:	$x_max = .1$ $\qquad x_min = -.1$
	$y_max = .1$ $\qquad y_min = -.1$
Blowup parameter:	10
Maximum number of iterations:	256

Page 2-8

Position on page:	Top
Image type:	Julia set
Equation:	$f(z) = z^2 + c$
Complex constant:	$c = -1.2025737 - .1965742i$
Screen parameters:	$x_max = .06$ $\qquad x_min = -.06$
	$y_max = .06$ $\qquad y_min = -.06$
Blowup parameter:	10
Maximum number of iterations:	256

Position on page:	Bottom
Image type:	Julia set
Equation:	$f(z) = z^2 + c$
Complex constant:	$c = -1.2025737 - .1965742i$
Screen parameters:	$x_max = .0067$ $\qquad x_min = -.0067$
	$y_max = .0067$ $\qquad y_min = -.0067$
Blowup parameter:	10
Maximum number of iterations:	256

Page 2-9

Position on page:	Top
Image type:	Julia set
Equation:	$f(z) = z^2 + c$
Complex constant:	$c = .3439487 + .056072i$
Screen parameters:	$x_max = .925$ $\qquad x_min = -.075$
	$y_max = .9$ $\qquad y_min = -.1$
Blowup parameter:	10
Maximum number of iterations:	256

Position on page:	Bottom
Image type:	Julia set
Equation:	$f(z) = z^2 + c$
Complex constant:	$c = -.54549221 - .5049322i$
Screen parameters:	$x_max = .02$ $\qquad x_min = -.02$
	$y_max = .02$ $\qquad y_min = -.02$
Blowup parameter:	10
Maximum number of iterations:	512

Page 2-10

Position on page:	Top
Image type:	Julia set
Equation:	$f(z) = z^2 + c$
Complex constant:	$c = .349371785 - .512074446i$
Screen parameters:	$x_max = .003$ $\qquad x_min = -.003$
	$y_max = .003$ $\qquad y_min = -.003$
Blowup parameter:	10
Maximum number of iterations:	256

Position on page:	Bottom
Image type:	Julia set
Equation:	$f(z) = z^2 + c$
Complex constant:	$c = -1.253349 + .023075i$
Screen parameters:	$x_max = .1$ $\qquad x_min = -.1$
	$y_max = .1$ $\qquad y_min = -.1$
Blowup parameter:	10
Maximum number of iterations:	256

Page 2-11

Position on page:	Top
Image type:	Julia set
Equation:	$f(z) = z^2 + c$
Complex constant:	$c = .191035774 - .593232841i$
Screen parameters:	$x_max = .005 \qquad x_min = -.005$
	$y_max - .005 \qquad y_min - -.005$
Blowup parameter:	10
Maximum number of iterations:	256

Position on page:	Bottom
Image type:	Julia set
Equation:	$f(z) = z^2 + c$
Complex constant:	$c = -.3277 + .6289i$
Screen parameters:	$x_max = 1 \qquad x_min = -1$
	$y_max = 1 \qquad y_min = -1$
Blowup parameter:	10
Maximum number of iterations:	256

Page 2-12

Position on page:	Top
Image type:	Julia set
Equation:	$f(z) = z^2 + c$
Complex constant:	$c = -1.261236 - .04772111i$
Screen parameters:	$x_max = .001 \qquad x_min = -.001$
	$y_max = .001 \qquad y_min = -.001$
Blowup parameter:	10
Maximum number of iterations:	256

This particular image (above) was a serendipitous "mistake." Originally I had input twelve-digit values for c but had only set the machine up for nine. The machine responded by what is called "round-off error," and these blocks were the fortunate result.

Position on page:	Bottom
Image type:	Julia set
Equation:	$f(z) = z^2 + c$
Complex constant:	$c = -1.6739 - .000034i$
Screen parameters:	$x_max = .025 \qquad x_min = -.025$
	$y_max = .025 \qquad y_min = -.025$
Blowup parameter:	10
Maximum number of iterations:	256

Page 2-13

Position on page:	Top
Image type:	Julia set
Equation:	$f(z) = z^2 + c$
Complex constant:	$c = -.74691 + .10725i$
Screen parameters:	$x_max = .25$ $x_min = -.25$
	$y_max = .25$ $y_min = -.25$
Blowup parameter:	10
Maximum number of iterations:	256

Position on page:	Bottom
Image type:	Julia set
Equation:	$f(z) = z^2 + c$
Complex constant:	$c = -1.401754 - .00001i$
Screen parameters:	$x_max = .1$ $x_min = -.1$
	$y_max = .1$ $y_min = -.1$
Blowup parameter:	10
Maximum number of iterations:	256

Page 2-14

Image type:	Julia and Mandelbrot sets
Equation:	Seven various equations used

Page 2-15

Position on page:	Top
Image type:	Julia set
Equation:	$f(z) = z^2 + c$
Complex constant:	$c = -.001579 + .740619i$
Screen parameters:	$x_max = .01$ $x_min = -.01$
	$y_max = .01$ $y_min = -.01$
Blowup parameter:	10
Maximum number of iterations:	256

Position on page:	Bottom
Image type:	Julia set
Equation:	$f(z) = z^2 + c$
Complex constant:	$c = -.124422584 + .839099345i$
Screen parameters:	$x_max = .01$ $x_min = -.01$
	$y_max = .01$ $y_min = -.01$
Blowup parameter:	10
Maximum number of iterations:	256

Page 2-16

Position on page:	Top
Image type:	Julia set
Equation:	$f(z) = z^2 + c$
Complex constant:	$c = .32 + .043i$
Screen parameters:	$x_max = 1.5$ \quad $x_min = -1.5$
	$y_max = 1.5$ \quad $y_min = -1.5$
Blowup parameter:	10
Maximum number of iterations:	256

This image (above) was the very first fractal my program generated in late 1988 at California State University, Northridge. It became my company logo.

Position on page:	Bottom
Image type:	Julia set
Equation:	$f(z) = z^2 + c$
Complex constant:	$c = .3493716753 - .5120746642i$
Screen parameters:	$x_max = .003$ \quad $x_min = -.003$
	$y_max = .003$ \quad $y_min = -.003$
Blowup parameter:	10
Maximum number of iterations:	256

Page 2-17

Position on page:	Top
Image type:	Julia set
Equation:	$f(z) = z^2 + c$
Complex constant:	$c = -.168688 - .896123i$
Screen parameters:	$x_max = .04$ \quad $x_min = -.04$
	$y_max = .04$ \quad $y_min = -.04$
Blowup parameter:	10
Maximum number of iterations:	256

Position on page:	Bottom
Image type:	Julia set
Equation:	$f(z) = z^2 + c$
Complex constant:	$c = -1.6739 - .000034i$
Screen parameters:	$x_max = .05$ \quad $x_min = -.05$
	$y_max = .05$ \quad $y_min = -.05$
Blowup parameter:	10
Maximum number of iterations:	256

Page 2-18

Image type:	Julia set
Equation:	$f(z) = z^2 + c$
Complex constant:	$c = -.780490743 + .149039565i$
Screen parameters:	$x_max = .05$ \quad $x_min = -.05$
	$y_max = .05$ \quad $y_min = -.05$
Blowup parameter:	10
Maximum number of iterations:	256

Page 2-19

Position on page:	Top
Image type:	Mandelbrot set
Equation:	$f(z) = z^2 + c$
Screen parameters:	x_max = −1.260043 x_min = −1.2607
	y_max = − .039793 y_min = − .040195
Blowup parameter:	10
Maximum number of iterations:	256

Position on page:	Bottom
Image type:	Julia set
Equation:	$f(z) = z^2 + c$
Complex constant:	$c = -.101096 - .956287i$
Screen parameters:	x_max = .01 x_min = −.01
	y_max = .01 y_min = −.01
Blowup parameter:	10
Maximum number of iterations:	256

Page 2-20

Position on page:	Top
Image type:	Julia set
Equation:	$f(z) = z^2 + c$
Complex constant:	$c = .2730068 + .0059115i$
Screen parameters:	x_max = .015 x_min = −.015
	y_max = .015 y_min = −.015
Blowup parameter:	10
Maximum number of iterations:	768

Position on page:	Bottom
Image type:	Julia set
Equation:	$f(z) = z^2 + c$
Complex constant:	$c = -.798108 - .164138i$
Screen parameters:	x_max = .005 x_min = −.005
	y_max = .005 y_min = −.005
Blowup parameter:	10
Maximum number of iterations:	256

Page 2-21

Position on page:	Top
Image type:	Julia set
Equation:	$f(z) = z^2 + c$
Complex constant:	$c = -.7369341 - .174830i$
Screen parameters:	x_max = 1 x_min = −1
	y_max = 1 y_min = −1
Blowup parameter:	10
Maximum number of iterations:	256

Page 2-21 (*continued*)

Position on page:	Bottom
Image type:	Julia set
Equation:	$f(z) = z^2 + c$
Complex constant:	$c = -.4406 + .5778i$
Screen parameters:	$x_max = .2 \qquad x_min = -.2$
	$y_max = .2 \qquad y_min = .2$
Blowup parameter:	10
Maximum number of iterations:	256

Page 2-22

Position on page:	Top
Image type:	Julia set
Equation:	$f(z) = z^2 + c$
Complex constant:	$c = -.5122 + .5204i$
Screen parameters:	$x_max = .1 \qquad x_min = -.1$
	$y_max = .1 \qquad y_min = -.1$
Blowup parameter:	10
Maximum number of iterations:	256

Position on page:	Bottom
Image type:	Julia set
Equation:	$f(z) = z^2 + c$
Complex constant:	$c = -.1480798 + .6515558i$
Screen parameters:	$x_max = .1 \qquad x_min = -.1$
	$y_max = .1 \qquad y_min = -.1$
Blowup parameter:	10
Maximum number of iterations:	256

Page 2-23

Image type:	Julia set
Equation:	$f(z) = z^2 + c$
Complex constant:	$c = -.0165552 + .7150057i$
Screen parameters:	$x_max = .01 \qquad x_min = -.01$
	$y_max = .01 \qquad y_min = -.01$
Blowup parameter:	10
Maximum number of iterations:	256

Page 2-24

Position on page:	Top left
Image type:	Julia set
Equation:	$f(z) = z^2 + c$
Complex constant:	$c = -1.156760482 - .303862229i$
Screen parameters:	$x_max = .04 \qquad x_min = -.04$
	$y_max = .04 \qquad y_min = -.04$
Blowup parameter:	10
Maximum number of iterations:	256

Position on page: Top right
Image type: Julia set
Equation: $f(z) = z^2 + c$
Complex constant: $c = -.780492985 + .149040696i$
Screen parameters: $x_max = .001$ $x_min = -.001$
 $y_max = .001$ $y_min = -.001$
Blowup parameter: 10
Maximum number of iterations: 256

Position on page: Bottom left
Image type: Julia set
Equation: $f(z) = z^2 + c$
Complex constant: $c = -.0488207242 - .6494526905i$
Screen parameters: $x_max = .05$ $x_min = -.05$
 $y_max = .05$ $y_min = -.05$
Blowup parameter: 10
Maximum number of iterations: 256

Position on page: Bottom right
Image type: Julia set
Equation: $f(z) = z^2 + c$
Complex constant: $c = -.6513342 - .4927157i$
Screen parameters: $x_max = .1$ $x_min = -.1$
 $y_max = .1$ $y_min = -.1$
Blowup parameter: 10
Maximum number of iterations: 256

Page 2-25

Position on page: Top left
Image type: Julia set
Equation: $f(z) = z^2 + c$
Complex constant: $c = -1.1846478 - .3030356i$
Screen parameters: $x_max = .2$ $x_min = -.2$
 $y_max = .2$ $y_min = -.2$
Blowup parameter: 10
Maximum number of iterations: 256

Position on page: Top right
Image type: Julia set
Equation: $f(z) = z^2 + c$
Complex constant: $c = -.1846478 - .3030356i$
Screen parameters: $x_max = .05$ $x_min = -.05$
 $y_max = .05$ $y_min = -.05$
Blowup parameter: 10
Maximum number of iterations: 256

Position on page:	Bottom left
Image type:	Julia set
Equation:	$f(z) = z^2 + c$
Complex constant:	$c = -1.1845549 - .3028412i$
Screen parameters:	$x_max = .1$ \qquad $x_min = -.1$
	$y_max = 1$ \qquad $y_min = -1$
Blowup parameter:	10
Maximum number of iterations:	256

Position on page:	Bottom right
Image type:	Julia set
Equation:	$f(z) = z^2 + c$
Complex constant:	$c = -1.1845549 - .3028412i$
Screen parameters:	$x_max = .007$ \qquad $x_min = -.007$
	$y_max = .007$ \qquad $y_min = -.007$
Blowup parameter:	10
Maximum number of iterations:	256

Page 2-26

Position on page:	Top left
Image type:	Julia set
Equation:	$f(z) = z^2 + c$
Complex constant:	$c = .415880330 - .352924770i$
Screen parameters:	$x_max = .01$ \qquad $x_min = -.01$
	$y_max = .01$ \qquad $y_min = -.01$
Blowup parameter:	10
Maximum number of iterations:	256

Position on page:	Top right
Image type:	Julia set
Equation:	$f(z) = z^2 + c$
Complex constant:	$c = -.2275 \quad .6949i$
Screen parameters:	$x_max = .01$ \qquad $x_min = -.01$
	$y_max = .01$ \qquad $y_min = -.01$
Blowup parameter:	10
Maximum number of iterations:	256

Position on page:	Bottom left
Image type:	Julia set
Equation:	$f(z) = z^2 + c$
Complex constant:	$c = -1.74010435 + .01205392i$
Screen parameters:	$x_max = .001$ \qquad $x_min = -.001$
	$y_max = .001$ \qquad $y_min = -.001$
Blowup parameter:	10
Maximum number of iterations:	256

Position on page:	Bottom right
Image type:	Julia set
Equation:	$f(z) = z^2 + c$
Complex constant:	$c = -.7928681 + .1608934i$
Screen parameters:	$x_max = .02 \qquad x_min = -.02$
	$y_max = .02 \qquad y_min = -.02$
Blowup parameter:	10
Maximum number of iterations:	256

Page 2-27

Position on page:	Top left
Image type:	Julia set
Equation:	$f(z) = z^2 + c$
Complex constant:	$c = -.655419795 - .420380435i$
Screen parameters:	$x_max = .005 \qquad x_min = -.005$
	$y_max = .005 \qquad y_min = -.005$
Blowup parameter:	10
Maximum number of iterations:	256

Position on page:	Top right
Image type:	Julia set
Equation:	$f(z) = z^2 + c$
Complex constant:	$c = -.78049646 + .149038226i$
Screen parameters:	$x_max = .001 \qquad x_min = -.001$
	$y_max = .001 \qquad y_min = -.001$
Blowup parameter:	10
Maximum number of iterations:	256

Position on page:	Bottom left
Image type:	Julia set
Equation:	$f(z) = z^2 + c$
Complex constant:	$c = -.780494121 + .149041347i$
Screen parameters:	$x_max = .01 \qquad x_min = -.01$
	$y_max = .01 \qquad y_min = -.01$
Blowup parameter:	10
Maximum number of iterations:	256

Position on page:	Bottom right
Image type:	Julia set
Equation:	$f(z) = z^2 + c$
Complex constant:	$c = -.655422558 - .420378964i$
Screen parameters:	$x_max = .1 \qquad x_min = -.1$
	$y_max = .1 \qquad y_min = -.1$
Blowup parameter:	10
Maximum number of iterations:	256

Page 2-28

Position on page:	Top left
Image type:	Mandelbrot set
Equation:	$f(z) = z^2 + c$
Screen parameters:	$x_max = -.413170$ $x_min = -.421590$
	$y_max = .605918$ $y_min = .600770$
Blowup parameter:	10
Maximum number of iterations:	256

Position on page:	Top right
Image type:	Mandelbrot set
Equation:	$f(z) = z^2 + c$
Screen parameters:	$x_max = -1.260043$ $x_min = -1.260700$
	$y_max = -.039793$ $y_min = -.040195$
Blowup parameter:	10
Maximum number of iterations:	256

Position on page:	Bottom left
Image type:	Mandelbrot set
Equation:	$f(z) = z^2 + c$
Screen parameters:	$x_max = -.416502$ $x_min = -.417646$
	$y_max = .603200$ $y_min = .602501$
Blowup parameter:	10
Maximum number of iterations:	256

These three early images (above) were generated using a program called "rpcmand" and allowed us in the CSU Northridge Advanced Function Workstation Lab to link ten workstations together to calculate each image by dividing the screen into blocks. By sending these blocks out from a central server computer to the satellite client computers using the remote process control ("rpc") protocol and recollecting the results, we cut our computing time by a factor of ten.

Position on page:	Bottom right
Image type:	Julia set
Equation:	$f(z) = z^2 + c$
Complex constant:	$c = -.1480798 + .6515558i$
Screen parameters:	$x_max = .1$ $x_min = -.1$
	$y_max = .1$ $y_min = -.1$
Blowup parameter:	10
Maximum number of iterations:	256

Page 3-2

Position on page:	Top
Image type:	Julia set
Equation:	$f(z) = (z^3 + z^2 + z + c)/(z - c)$
Complex constant:	$c = -1.47 + 1.2i$
Screen parameters:	$x_max = .8$ $x_min = 0$
	$y_max = -.4$ $y_min = -1.2$
Blowup parameter:	10
Maximum number of iterations:	256

Position on page: Bottom
Image type: Mandelbrot set
Equation: $f(z) = (z^2 + c)/(z - c)$
Screen parameters: $x_max = -1.2$ $x_min = -1.4$
 $y_max = -.2$ $y_min = -.4$
Blowup parameter: 10000
Maximum number of iterations: 128

Page 3-3

Position on page: Top
Image type: Julia set
Equation: $f(z) = ((z + 1)^2 + c)/z$
Complex constant: $c = 0 + 0i$
Screen parameters: $x_max = -.3$ $x_min = -.5$
 $y_max = -1.3$ $y_min = -1.5$
Blowup parameter: 100
Maximum number of iterations: 128

Position on page: Bottom
Image type: Julia set
Equation: $f(z) = (z^3 + c)/z$
Complex constant: $c = .19 - .006i$
Screen parameters: $x_max = .9$ $x_min = .8$
 $y_max = .4$ $y_min = .3$
Blowup parameter: 10
Maximum number of iterations: 256

Page 3-4

Position on page: Top
Image type: Julia set
Equation: $f(z) = (z^2 + c)^2 + z + c$
Complex constant: $c = -.015801 + .740618i$
Screen parameters: $x_max = 1$ $x_min = -1$
 $y_max = 1$ $y_min = -1$
Blowup parameter: 10
Maximum number of iterations: 256

Position on page: Bottom
Image type: Julia set
Equation: $f(z) = z^3 + c$
Complex constant: $c = .36 + .45i$
Screen parameters: $x_max = .33$ $x_min = .15$
 $y_max = .60$ $y_min = .42$
Blowup parameter: 10
Maximum number of iterations: 256

Page 3-5

Position on page:	Top
Image type:	Mandelbrot set
Equation:	$f(x) = x^2 + xy + a$
	$f(y) = y^2 - xy + b$
Screen parameters:	$x_max = -1.54$ $x_min = -1.64$
	$y_max = .11$ $y_min = .01$
Blowup parameter:	10
Maximum number of iterations:	256

Position on page:	Bottom
Image type:	Mandelbrot set
Equation:	$f(z) = (z^2 + c)^2/(z - c)$
Screen parameters:	$x_max = 0$ $x_min = -.2$
	$y_max = .44$ $y_min = .24$
Blowup parameter:	10000
Maximum number of iterations:	128

Page 3-6

Position on page:	Top
Image type:	Julia set
Equation:	$f(z) = z^3 + c$
Complex constant:	$c = .2525 + .63i$
Screen parameters:	$x_max = .45$ $x_min = -.15$
	$y_max = .75$ $y_min = .15$
Blowup parameter:	10
Maximum number of iterations:	256

Position on page:	Bottom
Image type:	Julia set
Equation:	$f(z) - z^3 + c$
Complex constant:	$c = .2525 + .63i$
Screen parameters:	$x_max - .21$ $x_min - .06$
	$y_max = .60$ $y_min = .45$
Blowup parameter:	10
Maximum number of iterations:	256

Page 3-7

Position on page:	Top
Image type:	Julia set
Equation:	$f(z) = z^7 + c$
Complex constant:	$c = -.33 + .502i$
Screen parameters:	$x_max = .8$ $x_min = .5$
	$y_max = .5$ $y_min = .2$
Blowup parameter:	10
Maximum number of iterations:	256

Position on page:	Bottom
Image type:	Julia set
Equation:	$f(z) = (4z^5 + c)/5z^4$
Complex constant:	$c = .6344 - .9718i$
Screen parameters:	$x_max = 3$ $x_min = -3$
	$y_max = 3$ $y_min = -3$
Blowup parameter:	10
Maximum number of iterations:	256

Page 3-8

Position on page:	Top
Image type:	Julia set
Equation:	$f(z) = z^3 + c$
Complex constant:	$c = -.3357 + .4974i$
Screen parameters:	$x_max = .1$ $x_min = -.8$
	$y_max = 1.5$ $y_min = -1.2$
Blowup parameter:	10
Maximum number of iterations:	256

Position on page:	Bottom
Image type:	Julia set
Equation:	$f(z) = z^{20} + c$
Complex constant:	$c = -.3143 + .8165i$
Screen parameters:	$x_max = .36$ $x_min = -.12$
	$y_max = -.54$ $y_min = -1.04$
Blowup parameter:	10
Maximum number of iterations:	256

Page 3-9

Position on page:	Top
Image type:	Julia set
Equation:	$f(z) = z^9 + c$
Complex constant:	$c = .7920 - .1165i$
Screen parameters:	$x_max = .05$ $x_min = -.60$
	$y_max = -.25$ $y_min = -.90$
Blowup parameter:	10
Maximum number of iterations:	256

Position on page:	Bottom
Image type:	Mandelbrot set
Equation:	$f(z) = z^2 - z + c$
Screen parameters:	$x_max = .425$ $x_min = .415$
	$y_max = -.625$ $y_min = -.635$
Blowup parameter:	10
Maximum number of iterations:	256

Page 3-10

Position on page:	Top
Image type:	Julia set
Equation:	$f(z) = z^{22} + c$
Complex constant:	$c = -.1183125 - .964350i$
Screen parameters:	$x_max = .11 \qquad x_min = -.11$
	$y_max = -.44 \qquad y_min = -.66$
Blowup parameter:	10
Maximum number of iterations:	256

Position on page:	Bottom
Image type:	Julia set
Equation:	$f(z) = cz^2 + c^2z$
Complex constant:	$c = .98 - .3i$
Screen parameters:	$x_max = .05 \qquad x_min = -.05$
	$y_max = .05 \qquad y_min = -.05$
Blowup parameter:	10
Maximum number of iterations:	256

Page 3-11

Position on page:	Top
Image type:	Mandelbrot set
Equation:	$f(z) = z^{24} + c$
Screen parameters:	$x_max = -.1425 \qquad x_min = -.1575$
	$y_max = -.883 \qquad y_min = -.898$
Blowup parameter:	10
Maximum number of iterations:	64

Position on page:	Bottom
Image type:	Julia set
Equation:	$f(z) = (z^3 + 1)^{.5} + c$
Complex constant:	$c = -.347 + .291i$
Screen parameters:	$x_max = -.4 \qquad x_min = -.8$
	$y_max = .4 \qquad y_min = 0$
Blowup parameter:	10
Maximum number of iterations:	256

Page 3-12

Position on page:	Top
Image type:	Julia set
Equation:	$f(z) = z^2 + z^{1.5} + c$
Complex constant:	$c = .12 + .12i$
Screen parameters:	$x_max = .102 \qquad x_min = .098$
	$y_max = .082 \qquad y_min = .078$
Blowup parameter:	10
Maximum number of iterations:	256

Page 3-12 (*continued*)

Position on page:	Bottom
Image type:	Julia set
Equation:	$f(z) = z^{24} + c$
Complex constant:	$c = .8997175 - .0575625i$
Screen parameters:	$x_max = .33 \qquad x_min = -.33$
	$y_max = -.33 \qquad y_min = -1.04$
Blowup parameter:	10
Maximum number of iterations:	256

Page 3-13

Position on page:	Top
Image type:	Julia set
Equation:	$f(z) = z^4 + z + c$
Complex constant:	$c = -.4 + .04i$
Screen parameters:	$x_max = .2 \qquad x_min = -.2$
	$y_max = .2 \qquad y_min = -.2$
Blowup parameter:	10
Maximum number of iterations:	256

Position on page:	Bottom
Image type:	Julia set
Equation:	$f(z) = z^{11} + c$
Complex constant:	$c = .8765 + .204i$
Screen parameters:	$x_max = .24 \qquad x_min = -.12$
	$y_max = 1.15 \qquad y_min = .72$
Blowup parameter:	10
Maximum number of iterations:	256

Page 3-14

Position on page:	Top
Image type:	Mandelbrot set
Equation:	$f(z) = (z^5 + c)/(z^3 + z^2 + z + 1)$
Screen parameters:	$x_max = -.48 \qquad x_min = -.49$
	$y_max = .18 \qquad y_min = .16$
Blowup parameter:	10000
Maximum number of iterations:	256

Position on page:	Bottom
Image type:	Julia set
Equation:	$f(z) = z^9 - cz^6 + cz^3 + c$
Complex constant:	$c = .116 - .698i$
Screen parameters:	$x_max = .4 \qquad x_min = 0$
	$y_max = -.3 \qquad y_min = -.7$
Blowup parameter:	10
Maximum number of iterations:	256

Page 3-15

Position on page: Top
Image type: Julia set
Equation: $f(z) = z^{10} + c$
Complex constant: $c = -.1089 - .8524i$
Screen parameters: $x_max = -.12$ $x_min = -.24$
 $y_max = .72$ $y_min = .60$
Blowup parameter: 10
Maximum number of iterations: 256

Position on page: Bottom
Image type: Julia set
Equation: $f(z) = z^{9} - cz^{6} + cz^{3} + c$
Complex constant: $c = .39 - .623i$
Screen parameters: $x_max = .5$ $x_min = .2$
 $y_max = .3$ $y_min = 0$
Blowup parameter: 10
Maximum number of iterations: 256

Page 3-16

Position on page: Top
Image type: Julia set
Equation: $f(z) = z^{12} - z^{11} - z^{10} + c$
Complex constant: $c = .124 - .7835i$
Screen parameters: $x_max = .74$ $x_min = .62$
 $y_max = .09$ $y_min = -.01$
Blowup parameter: 10
Maximum number of iterations: 256

Position on page: Bottom
Image type: Julia set
Equation: $f(z) = z^{12} + c$
Complex constant: $c = -.7738 - .1881i$
Screen parameters: $x_max = -.48$ $x_min = -.72$
 $y_max = -.36$ $y_min = -.60$
Blowup parameter: 10
Maximum number of iterations: 256

Page 3-17

Position on page: Top
Image type: Julia set
Equation: $f(z) = z^{10} + c$
Complex constant: $c = -.1028 - .8469i$
Screen parameters: $x_max = .48$ $x_min = .24$
 $y_max = -.60$ $y_min = -.84$
Blowup parameter: 10
Maximum number of iterations: 256

Page 3-17 (*continued*)

Position on page:	Bottom
Image type:	Julia set
Equation:	$f(z) = (z^3 - z^2)^2 + c$
Complex constant:	$c = .5225 + .5225i$
Screen parameters:	$x_max = 1.4 \qquad x_min = -.6$
	$y_max = 1.3 \qquad y_min = -1.3$
Blowup parameter:	1000000
Maximum number of iterations:	256

Page 3-18

Position on page:	Top
Image type:	Julia set
Equation:	$f(z) = z^{15} + c$
Complex constant:	$c = .107 + .8765i$
Screen parameters:	$x_max = 1.1 \qquad x_min = .7$
	$y_max = .05 \qquad y_min = -.28$
Blowup parameter:	10
Maximum number of iterations:	256

Position on page:	Bottom
Image type:	Julia set
Equation:	$f(z) = z^4 + cz^2 + c$
Complex constant:	$c = -.85 + .068i$
Screen parameters:	$x_max = .15 \qquad x_min = -.05$
	$y_max = .6 \qquad y_min = .4$
Blowup parameter:	10
Maximum number of iterations:	256

Page 3-19

Position on page:	Top
Image type:	Julia set
Equation:	$f(z) = z^{13} + c$
Complex constant:	$c = -.363515 - .75688i$
Screen parameters:	$x_max = 1 \qquad x_min = -1$
	$y_max = 1 \qquad y_min = -1$
Blowup parameter:	10
Maximum number of iterations:	256

Notice the highly unusual thirteen-fold symmetry in this fractal image (above).

Position on page:	Bottom
Image type:	Julia set
Equation:	$f(z) = z^{10} + c$
Complex constant:	$c = -.1089 - .8524i$
Screen parameters:	$x_max = 0 \qquad x_min = -.12$
	$y_max = -.36 \qquad y_min = -.48$
Blowup parameter:	10
Maximum number of iterations:	256

Page 3-20

Position on page:	Top
Image type:	Julia set
Equation:	$f(z) = z^{15} + c$
Complex constant:	$c = .121 - .8561i$
Screen parameters:	$x_max = 1.05$ $x_min = .7$
	$y_max = .1$ $y_min - .1$
Blowup parameter:	10
Maximum number of iterations:	256

Position on page:	Bottom
Image type:	Julia set
Equation:	$f(z) = (z^2 + c + 1)/(z^2 - c - 1)$
Complex constant:	$c = .37 - .26i$
Screen parameters:	$x_max = 2$ $x_min = -2$
	$y_max = 2$ $y_min = -2$
Blowup parameter:	10
Maximum number of iterations:	256

Page 3-21

Position on page:	Top left
Image type:	Julia set
Equation:	$f(z) = z^{16} + c$
Complex constant:	$c = .1498 - .9012i$
Screen parameters:	$x_max = .36$ $x_min = .12$
	$y_max = -.36$ $y_min = -.60$
Blowup parameter:	10
Maximum number of iterations:	256

Position on page:	Top right
Image type:	Julia set
Equation:	$f(z) = z^{16} + c$
Complex constant:	$c = .1498 - .9012i$
Screen parameters:	$x_max = .84$ $x_min = .60$
	$y_max = -.48$ $y_min = -.72$
Blowup parameter:	10
Maximum number of iterations:	256

Position on page:	Bottom left
Image type:	Mandelbrot set
Equation:	$f(z) = z^5 + c$
Screen parameters:	$x_max = .3406$ $x_min = .3361$
	$y_max = -.7017$ $y_min = -.7051$
Blowup parameter:	10
Maximum number of iterations:	128

Position on page: Bottom right
Image type: Mandelbrot set
Equation: $f(z) = (z^3 + 1)^{.5} + c$
Screen parameters: $x_max = -.3465$ $x_min = -.3475$
 $y_max = .293$ $y_min = .283$
Blowup parameter: 100000
Maximum number of iterations: 256

Page 3-22

Position on page: Top left
Image type: Mandelbrot set
Equation: $f(z) = z^2 + z^{1.5} + c$
Screen parameters: $x_max = .024$ $x_min = 0$
 $y_max = -.18$ $y_min = -.20$
Blowup parameter: 100000
Maximum number of iterations: 256

Position on page: Top right
Image type: Julia set
Equation: $f(z) = (z^3 + 1)^{.5} + c$
Complex constant: $c = -.347 + .291i$
Screen parameters: $x_max = -.4$ $x_min = -.8$
 $y_max = .4$ $y_min = 0$
Blowup parameter: 10
Maximum number of iterations: 256

Position on page: Bottom left
Image type: Mandelbrot set
Equation: $f(z) = z(z^2 + 1)/(z + c)$
Screen parameters: $x_max = 1.1$ $x_min = .6$
 $y_max = .3$ $y_min = -.3$
Blowup parameter: 10000
Maximum number of iterations: 256

Position on page: Bottom right
Image type: Mandelbrot set
Equation: $f(z) = z^3 - z^2 + z + c$
Screen parameters: $x_max = .1425$ $x_min = .14125$
 $y_max = .6725$ $y_min = .67125$
Blowup parameter: 10
Maximum number of iterations: 256

Position on page: Top left
Image type: Julia set
Equation: $f(z) = z^2(z^2 + 1)/(z + c)$
Complex constant: $c = -1.57 + .48i$
Screen parameters: $x_max = .8 \qquad x_min = -.8$
$y_max = .8 \qquad y_min = .8$
Blowup parameter: 10
Maximum number of iterations: 256

Position on page: Top right
Image type: Julia set
Equation: $f(z) = (z^3 + z^2 + z + c)/(z - c)$
Complex constant: $c = -1.07 + .48i$
Screen parameters: $x_max = .9 \qquad x_min = .7$
$y_max = -.6 \qquad y_min = -.8$
Blowup parameter: 10
Maximum number of iterations: 256

Position on page: Bottom left
Image type: Mandelbrot set
Equation: $f(z) = (z^4 + c)^{.5}$
Screen parameters: $x_max = .58 \qquad x_min = .5725$
$y_max = .396 \qquad y_min = .366$
Blowup parameter: 100
Maximum number of iterations: 256

Position on page: Bottom right
Image type: Julia set
Equation: $f(z) = (z^3 + 1)^{.5} + c$
Complex constant: $c = -.37 - .26i$
Screen parameters: $x_max = .6 \qquad x_min = -.2$
$y_max = 1.0 \qquad y_min = -.1$
Blowup parameter: 10
Maximum number of iterations: 256

Position on page: Top left
Image type: Julia set
Equation: $f(z) = z^{26} + c$
Complex constant: $c = -.00784 + .06395i$
Screen parameters: $x_max = .27 \qquad x_min = -.27$
$y_max = -.5 \qquad y_min = -1.04$
Blowup parameter: 10
Maximum number of iterations: 256

Position on page:	Top right
Image type:	Julia set
Equation:	$f(z) = (6z^7 + c)/7z^6$
Complex constant:	$c = .6633 - .2233i$
Screen parameters:	$x_max = 3$ $x_min = -3$
	$y_max = 6$ $y_min = -6$
Blowup parameter:	10
Maximum number of iterations:	256

Position on page:	Bottom left
Image type:	Julia set
Equation:	$f(z) = (z^2 + c + 1)/(z^2 - c - 1)$
Complex constant:	$c = .25 - .5i$
Screen parameters:	$x_max = 2.8$ $x_min = -2.8$
	$y_max = 2.8$ $y_min = -2.8$
Blowup parameter:	10
Maximum number of iterations:	256

Position on page:	Bottom right
Image type:	Julia set
Equation:	$f(z) = z^3/(1 + cz^2)$
Complex constant:	$c = .25 - i$
Screen parameters:	$x_max = 5$ $x_min = -5$
	$y_max = 5$ $y_min = -5$
Blowup parameter:	10
Maximum number of iterations:	256

Page 3-25

Position on page:	Top left
Image type:	Julia set
Equation:	$f(z) = z^\pi + \pi^c$
Complex constant:	$c = -.25 + .55i$
Screen parameters:	$x_max = .5$ $x_min = -.5$
	$y_max = .5$ $y_min = -.5$
Blowup parameter:	10
Maximum number of iterations:	256

Position on page:	Top right
Image type:	Julia set
Equation:	$f(z) = ((z^2(x - y^2))/(1 - z)) + c$
Complex constant:	$c = .61 - 1.11i$
Screen parameters:	$x_max = 1.2$ $x_min = -1.2$
	$y_max = 1.2$ $y_min = -1.2$
Blowup parameter:	10
Maximum number of iterations:	256

Page 3-25 (*continued*)

Position on page:	Bottom left
Image type:	Mandelbrot set
Equation:	$f(z) = z^6 + cz^4 + cz^2 + c$
Screen parameters:	x_max = $-.5950$ x_min = $-.5952$
	y_max = $.0122$ y_min = $.0120$
Blowup parameter:	10
Maximum number of iterations:	256

Position on page:	Bottom right
Image type:	Mandelbrot set
Equation:	$f(z) = z^6 + cz^4 + cz^2 + c$
Screen parameters:	x_max = $-.388$ x_min = $-.400$
	y_max = $-.724$ y_min = $-.736$
Blowup parameter:	10
Maximum number of iterations:	256

Page 3-26

Position on page:	Top left
Image type:	Julia set
Equation:	$f(z) = z^{26} + c$
Complex constant:	$c = .00215 - .90425i$
Screen parameters:	x_max = $-.77$ x_min = $-.88$
	y_max = $-.22$ y_min = $-.32$
Blowup parameter:	10
Maximum number of iterations:	256

Position on page:	Top right
Image type:	Julia set
Equation:	$f(z) = z^{26} + c$
Complex constant:	$c = .00215 - .90425i$
Screen parameters:	x_max = $.88$ x_min = $.44$
	y_max = $-.22$ y_min = $-.66$
Blowup parameter:	10
Maximum number of iterations:	256

Position on page:	Bottom left
Image type:	Julia set
Equation:	$f(z) = z^{25} + c$
Complex constant:	$c = .082445 - .939345i$
Screen parameters:	x_max = $.33$ x_min = $-.33$
	y_max = $-.34$ y_min = -1.04
Blowup parameter:	10
Maximum number of iterations:	256

Page 3-26 (*continued*)

Position on page:	Bottom right
Image type:	Julia set
Equation:	$f(z) = z^{24} + c$
Complex constant:	$c = -.154875 - .895375i$
Screen parameters:	$x_max = .375 \qquad x_min = -.375$
	$y_max = 1.0 \qquad y_min = .25$
Blowup parameter:	10
Maximum number of iterations:	256

Page 3-27

Position on page:	Top left
Image type:	Julia set
Equation:	$f(z) = z^3 + c$
Complex constant:	$c = .43 + .33i$
Screen parameters:	$x_max = .7 \qquad x_min = 0$
	$y_max = 1.0 \qquad y_min = .2$
Blowup parameter:	10
Maximum number of iterations:	256

Position on page:	Top right
Image type:	Julia set
Equation:	$f(z) = (z^4 + 1)^{.5} + c$
Complex constant:	$c = -.75 + .57i$
Screen parameters:	$x_max = 1 \qquad x_min = -1$
	$y_max = 1 \qquad y_min = -1$
Blowup parameter:	10
Maximum number of iterations:	256

Position on page:	Bottom left
Image type:	Julia set
Equation:	$f(z) = (z^4 + 1)^{.5} + c$
Complex constant:	$c = -.75 - .625i$
Screen parameters:	$x_max = 1.0 \qquad x_min = .7$
	$y_max = .2 \qquad y_min = -.4$
Blowup parameter:	10
Maximum number of iterations:	256

Position on page:	Bottom right
Image type:	Julia set
Equation:	$f(z) = (z^4 + c)^{.5}$
Complex constant:	$c = .19 - .67i$
Screen parameters:	$x_max = .55 \qquad x_min = .43$
	$y_max = .445 \qquad y_min = .345$
Blowup parameter:	10
Maximum number of iterations:	256

Page 3-28

Position on page: Top left
Image type: Julia set
Equation: $f(z) = (z^2 + c)^2 + z + c$
Complex constant: $c = -.05 + .2289i$
Screen parameters: $x_max = 1.0$ $x_min = -.3$
 $y_max = 0$ $y_min = -13$
Blowup parameter: 100
Maximum number of iterations: 192

Position on page: Top right
Image type: Julia set
Equation: $f(z) = z^7 + c$
Complex constant: $c = -.33 + .5016i$
Screen parameters: $x_max = .65$ $x_min = .60$
 $y_max = -.35$ $y_min = -.40$
Blowup parameter: 10
Maximum number of iterations: 256

Position on page: Bottom left
Image type: Julia set
Equation: $f(z) = z^{15} + c$
Complex constant: $c = .099 + .858i$
Screen parameters: $x_max = .9$ $x_min = .7$
 $y_max = .3$ $y_min = .1$
Blowup parameter: 10
Maximum number of iterations: 256

Position on page: Bottom right
Image type: Julia set
Equation: $f(z) = (z^3 + c)/z$
Complex constant: $c = .19 + .04i$
Screen parameters: $x_max = 1.2$ $x_min = -1.2$
 $y_max = 1.2$ $y_min = 1.2$
Blowup parameter: 10
Maximum number of iterations: 256

Page 3-29

Position on page: Top left
Image type: Julia set
Equation: $f(z) = [(2x - y^2 + a)/(2x^2 + y - b)] + i[(2x^2 + y - a)/(2x - y^2 + b)]$
Complex constant: $c = -.56332 + .55322i$
Screen parameters: $x_max = 2$ $x_min = -2$
 $y_max = 2$ $y_min = -2$
Blowup parameter: 10
Maximum number of iterations: 256

Position on page:	Top right
Image type:	Julia set
Equation:	$f(z) = (6z^7 + c)/7z^6$
Complex constant:	$c = -.123 - .123i$
Screen parameters:	$x_max = 2 \qquad x_min = -2$
	$y_max = 4 \qquad y_min = -4$
Blowup parameter:	10
Maximum number of iterations:	256

Position on page:	Bottom left
Image type:	Julia set
Equation:	$f(z) = (z^2 + c)^2 + z + c$
Complex constant:	$c = -.27 + .46i$
Screen parameters:	$x_max = 1.5 \qquad x_min = \quad 0$
	$y_max = 0 \qquad y_min = -1.5$
Blowup parameter:	10
Maximum number of iterations:	256

Position on page:	Bottom right
Image type:	Julia set
Equation:	$f(z) = z^7 + c$
Complex constant:	$c = -.33 + .5016i$
Screen parameters:	$x_max = \quad .75 \qquad x_min = \quad .45$
	$y_max = -.13 \qquad y_min = -.43$
Blowup parameter:	10
Maximum number of iterations:	256

Page 3-30

Position on page:	Top left
Image type:	Julia set
Equation:	$f(z) = z^7 + c$
Complex constant:	$c = .83733 + .180937i$
Screen parameters:	$x_max = \quad .2 \qquad x_min = -.2$
	$y_max = -.1 \qquad y_min = -.3$
Blowup parameter:	10
Maximum number of iterations:	256

Position on page:	Top right
Image type:	Julia set
Equation:	$f(z) = z^2 + z^{1.5} + c$
Complex constant:	$c = .12 + .12i$
Screen parameters:	$x_max = .102 \qquad x_min = .101$
	$y_max = .0805 \qquad y_min = .0795$
Blowup parameter:	10
Maximum number of iterations:	256

Page 3-30 (*continued*)

Position on page: Bottom left

Image type: Julia set

Equation: $f(z) = z^5 - z^3 + z + c$

Complex constant: $c = .2 + .4i$

Screen parameters: $x_max = .6$ $x_min = 0$

 $y_max - -.1$ $y_min = - 7$

Blowup parameter: 10

Maximum number of iterations: 256

Position on page: Bottom right

Image type: Julia set

Equation: $f(z) = cz^2 + c^2z$

Complex constant: $c = .98 - .3i$

Screen parameters: $x_max = .5$ $x_min = -.5$

 $y_max = .5$ $y_min = -.5$

Blowup parameter: 10

Maximum number of iterations: 256

Page 3-31

Position on page: Top left

Image type: Mandelbrot set

Equation: $f(z) = (z^9 + 1)^{.25} + c$

Screen parameters: $x_max = .3$ $x_min = -1.5$

 $y_max = 3.0$ $y_min = .6$

Blowup parameter: 10

Maximum number of iterations: 128

Position on page: Top right

Image type: Julia set

Equation: $f(z) = (z^7 + 1)^{(1/3)} + c$

Complex constant: $c = -.102 - .45i$

Screen parameters: $x_max = 1.2$ $x_min = -1.2$

 $y_max = 1.2$ $y_min = -1.2$

Blowup parameter: 10

Maximum number of iterations: 256

Position on page: Bottom left

Image type: Julia set

Equation: $f(z) = z^6 + cz^4 + cz^2 + c$

Complex constant: $c = -.39 - .72i$

Screen parameters: $x_max = -.03$ $x_min = -.33$

 $y_max = -.42$ $y_min = -.72$

Blowup parameter: 10

Maximum number of iterations: 256

Page 3-31 (*continued*)

Position on page: Bottom right
Image type: Mandelbrot set
Equation: $f(z) = (z - z^{.5})^2 + c$
Screen parameters: $x_max = 0$ $x_min = -2$
$y_max = 1$ $y_min = -1$
Blowup parameter: 10
Maximum number of iterations: 256

Page 3-32

Position on page: Top
Image type: Mandelbrot set
Equation: $f(z) = z^{24} + c$
Screen parameters: $x_max = .885$ $x_min = .873$
$y_max = -.105$ $y_min = -.127$
Blowup parameter: 10
Maximum number of iterations: 128

Position on page: Bottom
Image type: Julia set
Equation: $f(z) = z^4 + z + c$
Complex constant: $c = .2 + 0i$
Screen parameters: $x_max = 1$ $x_min = -1$
$y_max = 1$ $y_min = -1$
Blowup parameter: 10
Maximum number of iterations: 256

"Fractal Penetration"

Page 4-2

Position on page: Top
Image type: Julia set
Equation: $f(z) = z^2 e^z - z e^z + c$
Complex constant: $c = -.5 - .7i$
Screen parameters: $x_max = 0$ $x_min = -.5$
$y_max = 0$ $y_min = -.5$
Blowup parameter: 10
Maximum number of iterations: 256

Position on page: Bottom
Image type: Mandelbrot set
Equation: $f(z) = (z + cz - cz^2) * ((z + \sin z)^2 + c)$
Screen parameters: $x_max = -.4$ $x_min = -.6$
$y_max = -.27$ $y_min = -.36$
Blowup parameter: 10000
Maximum number of iterations: 128

Page 4-3

Position on page:	Top
Image type:	Julia set
Equation:	$f(z) = ce^z z^{.5}$
Complex constant:	$c = 2 + 1.5i$
Screen parameters:	$x_max = .3 \qquad x_min = -.3$
	$y_max = .3 \qquad y_min = -.3$
Blowup parameter:	10
Maximum number of iterations:	256

Position on page:	Bottom
Image type:	Julia set
Equation:	$f(z) = c * \cos z$
Complex constant:	$c = 1.27 - .37i$
Screen parameters:	$x_max = .05 \qquad x_min = -.05$
	$y_max = .05 \qquad y_min = -.05$
Blowup parameter:	10
Maximum number of iterations:	256

Page 4-4

Position on page:	Top
Image type:	Mandelbrot set
Equation:	$f(z) = z * \tan(\ln z) + c$
Screen parameters:	$x_max = \ \ 1.2 \qquad x_min = -1.2$
	$y_max = -1.5 \qquad y_min = -2.7$
Blowup parameter:	100
Maximum number of iterations:	64

Position on page:	Bottom
Image type:	Julia set
Equation:	$f(z) = z^2 \sin x \ \mid \ cz \cos y \ \mid c$
Complex constant:	$c = .672 + .37i$
Screen parameters:	$x_max = \ \ 1.5 \qquad x_min = \ \ 1.5$
	$y_max = 1.5 \qquad y_min = -1.5$
Blowup parameter:	10
Maximum number of iterations:	256

Page 4-5

Position on page:	Top
Image type:	Julia set
Equation:	$f(z) = c(\sin z + \cos z) * (z^3 + z + c)$
Complex constant:	$c = .3 + .5i$
Screen parameters:	$x_max = 1 \qquad x_min = -1$
	$y_max = 1 \qquad y_min = -1$
Blowup parameter:	1000
Maximum number of iterations:	256

Position on page:	Bottom
Image type:	Mandelbrot set
Equation:	$f(z) = z^2\sin x + cyz + z^2\cos x + cz \sin y + c$
Screen parameters:	$x_max = .3285 \qquad x_min = .3075$
	$y_max = -.3120 \qquad y_min = -.3520$
Blowup parameter:	10000
Maximum number of iterations:	128

Page 4-6

Position on page:	Top
Image type:	Julia set
Equation:	$f(z) = z^2 + ce^{-z}$
Complex constant:	$c = .255 - .34i$
Screen parameters:	$x_max = 1 \qquad x_min = -1$
	$y_max = 1 \qquad y_min = -1$
Blowup parameter:	10
Maximum number of iterations:	256

"Fractal Nixon"

Position on page:	Bottom
Image type:	Julia set
Equation:	$f(z) = z^{12}\cos x - z^{11}\sin y - z^{10}\tan y + c$
Complex constant:	$c = .84 - .135i$
Screen parameters:	$x_max = -.24 \qquad x_min = -.48$
	$y_max = -.48 \qquad y_min = -.72$
Blowup parameter:	10
Maximum number of iterations:	256

Page 4-7

Position on page:	Top
Image type:	Julia set
Equation:	$f(z) = z^2 + ce^{-z}$
Complex constant:	$c = -.6 + .2i$
Screen parameters:	$x_max = 2.7 \qquad x_min = -1.8$
	$y_max = 1.25 \qquad y_min = -1.25$
Blowup parameter:	10
Maximum number of iterations:	256

Position on page:	Bottom
Image type:	Julia set
Equation:	$f(z) = z^2\exp(z^2) + c$
Complex constant:	$c = -.235 - .85i$
Screen parameters:	$x_max = 2 \qquad x_min = -2$
	$y_max = 2 \qquad y_min = -2$
Blowup parameter:	10
Maximum number of iterations:	256

Page 4-8

Position on page:	Top
Image type:	Julia set
Equation:	$f(z) = z^2\sin x + cz\cos y + c$
Complex constant:	$c = .32 + .043i$
Screen parameters:	$x_max = 1 \qquad x_min = -1$
	$y_max = 1 \qquad y_min = 1$
Blowup parameter:	10
Maximum number of iterations:	256

Position on page:	Bottom
Image type:	Julia set
Equation:	$f(z) = z^2\sin x + cyz + z^2\cos x + cz\sin y + c$
Complex constant:	$c = .32375 - .326i$
Screen parameters:	$x_max = .12 \qquad x_min = 0$
	$y_max = -.38 \qquad y_min = -.50$
Blowup parameter:	10
Maximum number of iterations:	256

Page 4-9

Position on page:	Top left
Image type:	Mandelbrot set
Equation:	$f(z) = \exp(x^2/y^2) + y + c$
Screen parameters:	$x_max = 0 \qquad x_min = -2.0$
	$y_max = .75 \qquad y_min = -.75$
Blowup parameter:	10
Maximum number of iterations:	256

Position on page:	Top right
Image type:	Mandelbrot set
Equation:	$f(z) = z^2e^z - ze^z + c$
Screen parameters:	$x_max = -.455 \qquad x_min = -.46$
	$y_max = -.665 \qquad y_min = -.67$
Blowup parameter:	10
Maximum number of iterations:	256

Position on page:	Bottom left
Image type:	Julia set
Equation:	$f(z) = z^2e^z - ze^z + c$
Complex constant:	$c = -.5 - .7i$
Screen parameters:	$x_max = .5 \qquad x_min = -1.0$
	$y_max = .5 \qquad y_min = -1.0$
Blowup parameter:	10
Maximum number of iterations:	256

Page 4-9 (*continued*)

Position on page:	Bottom right
Image type:	Mandelbrot set
Equation:	$f(z) = c * \cos z$
Screen parameters:	$x_max = 1.278 \qquad x_min = 1.276$
	$y_max = -.373 \qquad y_min = -.374$
Blowup parameter:	10
Maximum number of iterations:	256

Page 4-10

Position on page:	Top left
Image type:	Mandelbrot set
Equation:	$f(z) = c * \cos z$
Screen parameters:	$x_max = 1.9 \qquad x_min = 1.8$
	$y_max = -.45 \qquad y_min = -.55$
Blowup parameter:	10
Maximum number of iterations:	256

Position on page:	Top right
Image type:	Mandelbrot set
Equation:	$f(z) = c * \cos z$
Screen parameters:	$x_max = 1.28 \qquad x_min = 1.26$
	$y_max = -.365 \qquad y_min = -.385$
Blowup parameter:	10
Maximum number of iterations:	128

Position on page:	Bottom left
Image type:	Julia set
Equation:	$f(z) = c * \sin z$
Complex constant:	$c = 0 - 1.5i$
Screen parameters:	$x_max = 1.5 \qquad x_min = -1.5$
	$y_max = 1.5 \qquad y_min = -1.5$
Blowup parameter:	10
Maximum number of iterations:	256

Position on page:	Bottom right
Image type:	Julia set
Equation:	$f(z) = ce^{cz}/(e^c - 1)$
Complex constant:	$c = 2.685 + 2.924i$
Screen parameters:	$x_max = 1.5 \qquad x_min = -1.5$
	$y_max = 1.5 \qquad y_min = -1.5$
Blowup parameter:	10
Maximum number of iterations:	256

Page 4-11

Position on page:	Top left
Image type:	Mandelbrot set
Equation:	$f(z) = z^2 + ce^{-z}$
Screen parameters:	$x_max = .055 \qquad x_min = .045$
	$y_max = .8125 \qquad y_min = .7875$
Blowup parameter:	10000
Maximum number of iterations:	256

Position on page:	Top right
Image type:	Julia set
Equation:	$f(z) = (z^3/(1 + cz^2)) + e^z - c$
Complex constant:	$c = .1 - 1.2i$
Screen parameters:	$x_max = 2 \qquad x_min = -2$
	$y_max = 2 \qquad y_min = -2$
Blowup parameter:	1000000
Maximum number of iterations:	256

Position on page:	Bottom left
Image type:	Julia set
Equation:	$f(z) = z * \tan(\ln z) + c$
Complex constant:	$c = .27 + .03i$
Screen parameters:	$x_max - -.1 \qquad x_min - -.4$
	$y_max = -.1 \qquad y_min = -.2$
Blowup parameter:	10
Maximum number of iterations:	256

Position on page:	Bottom right
Image type:	Julia set
Equation:	$f(z) = (z * \ln z)/e^c$
Complex constant:	$c = -.39 - .7i$
Screen parameters:	$x\ max = 2 \qquad x\ min = \quad .01$
	$y_max = 1 \qquad y_min = -1$
Blowup parameter:	10
Maximum number of iterations:	256

Page 4-12

Position on page:	Top left
Image type:	Julia set
Equation:	$f(z) = z^{12}\cos x - z^{11}\sin y - z^{10}\tan y + c$
Complex constant:	$c = .84 - .135i$
Screen parameters:	$x_max = -.24 \qquad x_min = -.48$
	$y_max = -.48 \qquad y_min = -.72$
Blowup parameter:	10
Maximum number of iterations:	256

Page 4-12 (*continued*)

Position on page: Top right
Image type: Julia set
Equation: $f(z) = c * (\sin z + \cos z)$
Complex constant: $c = .4232 - .564i$
Screen parameters: $x_max = 2$ $x_min = -2$
 $y_max = 2$ $y_min = -2$
Blowup parameter: 1000
Maximum number of iterations: 256

Position on page: Bottom left
Image type: Julia set
Equation: $f(z) = z^2\sin x + cz \cos y + c$
Complex constant: $c = .55 - .12i$
Screen parameters: $x_max = .7$ $x_min = - .5$
 $y_max = .2$ $y_min = -1$
Blowup parameter: 1000
Maximum number of iterations: 256

Position on page: Bottom right
Image type: Mandelbrot set
Equation: $f(z) = \exp(z^2)/(z + c)$
Screen parameters: $x_max = .6$ $x_min = - .6$
 $y_max = -.3$ $y_min = -1.5$
Blowup parameter: 10
Maximum number of iterations: 128

Page 4-13

Position on page: Top left
Image type: Julia set
Equation: $f(z) = e^{\cos(cz)}$
Complex constant: $c = .4876 - .644i$
Screen parameters: $x_max = 1$ $x_min = -1$
 $y_max = 1$ $y_min = -1$
Blowup parameter: 10000
Maximum number of iterations: 128

Position on page: Top right
Image type: Julia set
Equation: $f(z) = ce^z e^{\cos(cz)}$
Complex constant: $c = .5522 + .4477i$
Screen parameters: $x_max = 1.5$ $x_min = -1.5$
 $y_max = 1.5$ $y_min = -1.5$
Blowup parameter: 1000
Maximum number of iterations: 256

Position on page: Bottom left
Image type: Julia set
Equation: $f(z) = z^2\sin x + cyz + z^2\cos x + cz \sin y + c$
Complex constant: $c = .23 - .001i$
Screen parameters: $x_max = 1$ $x_min = -1$
 $y_max = 1$ $y_min = -1$
Blowup parameter: 1000
Maximum number of iterations: 256

Position on page: Bottom right
Image type: Julia set
Equation: $f(z) = (z^3/(1 + cz^2)) + e^z - c$
Complex constant: $c = .75 + .75i$
Screen parameters: $x_max = 1$ $x_min = -1$
 $y_max = 1$ $y_min = -1$
Blowup parameter: 1000
Maximum number of iterations: 256

Page 4-14

Position on page: Top left
Image type: Julia set
Equation: $f(z) = (z^3/(1 + cz^2)) + e^z - c$
Complex constant: $c = .1 - 1.3i$
Screen parameters: $x_max = 2$ $x_min = -2$
 $y_max = 2$ $y_min = -2$
Blowup parameter: 1000000
Maximum number of iterations: 256

Position on page: Top right
Image type: Mandelbrot set
Equation: $f(z) = (z + \sin z)^2 + z^{.5} + c$
Screen parameters: $x_max = 0$ $x_min = -3.5$
 $y_max = 1.5$ $y_min = -1.5$
Blowup parameter: 10000
Maximum number of iterations: 128

Position on page: Bottom left
Image type: Julia set
Equation: $f(z) = (e^z/\ln z) + c$
Complex constant: $c = -.61 + .01i$
Screen parameters: $x_max = .3$ $x_min = .1$
 $y_max = .2$ $y_min = 0$
Blowup parameter: 10
Maximum number of iterations: 256

Page 4-14 (*continued*)

Position on page:	Bottom right
Image type:	Julia set
Equation:	$f(z) = z^2\sin x + cyz + z^2\cos x + cz\sin y + c$
Complex constant:	$c = .3 + .2i$
Screen parameters:	$x_max = .4 \qquad x_min = -.3$
	$y_max = .6 \qquad y_min = -.1$
Blowup parameter:	10
Maximum number of iterations:	256

Page 4-15

Position on page:	Top left
Image type:	Julia set
Equation:	$f(z) = (1 + ic)\cos z$
Complex constant:	$c = 0 - .99i$
Screen parameters:	$x_max = 1 \qquad x_min = -1$
	$y_max = 1 \qquad y_min = -1$
Blowup parameter:	10
Maximum number of iterations:	256

Position on page:	Top right
Image type:	Julia set
Equation:	$f(z) = (1 + ic)\cos z$
Complex constant:	$c = .07 - .32i$
Screen parameters:	$x_max = 1 \qquad x_min = -1$
	$y_max = 1 \qquad y_min = -1$
Blowup parameter:	10
Maximum number of iterations:	256

Position on page:	Bottom left
Image type:	Julia set
Equation:	$f(z) = (1 + ic)\sin z$
Complex constant:	$c = 1.2 + .82i$
Screen parameters:	$x_max = 1.5 \qquad x_min = -1.5$
	$y_max = 1.5 \qquad y_min = -1.5$
Blowup parameter:	10
Maximum number of iterations:	256

Position on page:	Bottom right
Image type:	Julia set
Equation:	$f(z) = (z + \sin z)^2 + z^2 + ce^{-z} + c$
Complex constant:	$c = .08 + .08i$
Screen parameters:	$x_max = -.2 \qquad x_min = -.4$
	$y_max = .05 \qquad y_min = -.15$
Blowup parameter:	10
Maximum number of iterations:	256

Page 4-16

Position on page:	Top left
Image type:	Mandelbrot set
Equation:	$f(z) = (z + e^z + \ln z)^2 + c$
Screen parameters:	$x_max = -.4 \qquad x_min = -2.4$
	$y_max = 1 \qquad y_min = 0$
Blowup parameter:	10000000
Maximum number of iterations:	128

Position on page:	Top right
Image type:	Julia set
Equation:	$f(z) = z^{12}\cos x - z^{11}\sin y - z^{10}\tan y + c$
Complex constant:	$c = .84 - .135i$
Screen parameters:	$x_max = .87 \qquad x_min = .69$
	$y_max = -.06 \qquad y_min = -.24$
Blowup parameter:	10
Maximum number of iterations:	256

Position on page:	Bottom left
Image type:	Mandelbrot set
Equation:	$f(z) = (e^{cz} + c)^2$
Screen parameters:	$x_max = 5 \qquad x_min = -5$
	$y_max = 5 \qquad y_min = -5$
Blowup parameter:	10
Maximum number of iterations:	256

Position on page:	Bottom right
Image type:	Mandelbrot set
Equation:	$f(z) = (1 + ic)\cos z$
Screen parameters:	$x_max = .90 \qquad x_min = .88$
	$y_max = 1.18 \qquad y_min = 1.16$
Blowup parameter:	100
Maximum number of iterations:	256

Page 4-17

Position on page:	Top left
Image type:	Julia set
Equation:	$f(z) = cz - 1 + ce^{-z}$
Complex constant:	$c = -.194 + .6557i$
Screen parameters:	$x_max = 1.5 \qquad x_min = -1.5$
	$y_max = 1.5 \qquad y_min = -1.5$
Blowup parameter:	10
Maximum number of iterations:	256

Position on page: Top right
Image type: Mandelbrot set
Equation: $f(x) = (\ln x^2)^{.5} + y * \sin x + a$
 $f(y) = (\ln y^2)^{.5} - x * \cos y + b$

Screen parameters: $x_max = 3$ $x_min = -3$
 $y_max = 3$ $y_min = -3$

Blowup parameter: 10
Maximum number of iterations: 64

Position on page: Bottom left
Image type: Mandelbrot set
Equation: $f(z) = z^2 + ce^{-z}$
Screen parameters: $x_max = .075$ $x_min = .025$
 $y_max = .825$ $y_min = .775$

Blowup parameter: 10000
Maximum number of iterations: 256

Position on page: Bottom right
Image type: Julia set
Equation: $f(z) = (z + cz - cz^2) * ((z + \sin z)^2 + c)$
Complex constant: $c = -.465 - .3i$
Screen parameters: $x_max = -.7$ $x_min = -1$
 $y_max = -.25$ $y_min = -.45$

Blowup parameter: 10
Maximum number of iterations: 256

Page 4-18

Position on page: Top left
Image type: Julia set
Equation: $f(z) = z^2\sin x + cz \cos y + c$
Complex constant: $c = .51 + .16i$
Screen parameters: $x_max = 1.3$ $x_min = -1.1$
 $y_max = 1.9$ $y_min = -.3$

Blowup parameter: 10
Maximum number of iterations: 256

Position on page: Top right
Image type: Julia set
Equation: $f(z) = z * \tan(\ln z) + c$
Complex constant: $c = .05 + .11i$
Screen parameters: $x_max = 1$ $x_min = -1$
 $y_max = 1$ $y_min = -1$

Blowup parameter: 10
Maximum number of iterations: 256

Page 4-18 (*continued*)

Position on page:	Bottom left	
Image type:	Julia set	
Equation:	$f(z) = z^2\sin x + cz \cos y + c$	
Complex constant:	$c = .62 - .312i$	
Screen parameters:	$x_max = .15$	$x_min = -.35$
	$y_max = .15$	$y_min = .65$
Blowup parameter:	10	
Maximum number of iterations:	256	

Position on page:	Bottom right	
Image type:	Julia set	
Equation:	$f(z) = z^2\sin x + cz \cos y + c$	
Complex constant:	$c = .47 + .13i$	
Screen parameters:	$x_max = .7$	$x_min = .3$
	$y_max = 1.0$	$y_min = .6$
Blowup parameter:	1000	
Maximum number of iterations:	256	

Page 4-19

Position on page:	Top left	
Image type:	Julia set	
Equation:	$f(z) = z^{\exp(c)}$	
Complex constant:	$c = -.38 + 0i$	
Screen parameters:	$x_max = 1.2$	$x_min = -1.2$
	$y_max = 1.2$	$y_min = -1.2$
Blowup parameter:	10	
Maximum number of iterations:	256	

Position on page:	Top right	
Image type:	Julia set	
Equation:	$f(z) = z^2 e^z - z e^z + c$	
Complex constant:	$c = .5 + .5i$	
Screen parameters:	$x_max = .5$	$x_min = 0$
	$y_max = .5$	$y_min = 0$
Blowup parameter:	10	
Maximum number of iterations:	256	

Position on page:	Bottom left	
Image type:	Julia set	
Equation:	$f(z) = z^2 e^z - z e^z + c$	
Complex constant:	$c = -.5 - .7i$	
Screen parameters:	$x_max = 0$	$x_min = -.5$
	$y_max = 0$	$y_min = -.5$
Blowup parameter:	10	
Maximum number of iterations:	256	

Page 4-19 (*continued*)

Position on page: Bottom right
Image type: Julia set
Equation: $f(z) = c * \cos z$
Complex constant: $c = 1.2771 - .3736i$
Screen parameters: $x_max = .1 \qquad x_min = -.1$
 $y_max = .1 \qquad y_min = -.1$
Blowup parameter: 10
Maximum number of iterations: 256

Page 4-20

Position on page: Top left
Image type: Julia set
Equation: $f(z) = (z + cz - cz^2) * ((z + \sin z)^2 + c)$
Complex constant: $c = -.465 - .3i$
Screen parameters: $x_max = -.2 \qquad x_min = -1.2$
 $y_max = 0 \qquad y_min = -.6$
Blowup parameter: 10
Maximum number of iterations: 256

Position on page: Top right
Image type: Mandelbrot set
Equation: $f(z) = (z^2 + c)^2 + z + c$
Screen parameters: $x_max = 0 \qquad x_min = -.15$
 $y_max = .2625 \qquad y_min = 0$
Blowup parameter: 10000
Maximum number of iterations: 256

Position on page: Bottom left
Image type: Mandelbrot set
Equation: $f(x) = x^2\sin y + a$
 $f(y) = y^2\cos x + b$
Screen parameters: $x_max = -1.59 \qquad x_min = -1.99$
 $y_max = 1.0 \qquad y_min = .7$
Blowup parameter: 10
Maximum number of iterations: 256

Position on page: Bottom right
Image type: Mandelbrot set
Equation: $f(z) = z^2\sin x + cyz + z^2\cos x + cz \sin y + c$
Screen parameters: $x_max = .3285 \qquad x_min = .3075$
 $y_max = -.312 \qquad y_min = -.352$
Blowup parameter: 10000
Maximum number of iterations: 128

Pages 5-2 through 5-38

Image type: Composite

Page 6-2

Equation Study

Image type:	Julia and Mandelbrot sets
Equation:	$f(z) = z^3 + c$
Screen parameters:	Vary
Blowup parameter:	10/100
Maximum number of iterations:	256

Position on page:	Top left
Complex constant:	$c = .406775 + .227114i$

Position on page:	Top right
Complex constant:	$c = .406 + .227i$

Position on page:	Middle left
Complex constant:	Absent; this is a Mandelbrot set section

Position on page:	Middle right
Complex constant:	$c = .36 + .45i$

Position on page:	Bottom left
Complex constant:	$c = .2525 + .63i$

Position on page:	Bottom right
Complex constant:	$c = .2525 + .63i$

Page 6-3

Equation Study

Image type:	Julia sets
Equation:	$f(z) = z^9 - cz^6 + cz^3 + c$
Screen parameters:	Vary
Blowup parameter:	10
Maximum number of iterations:	256

Position on page:	Top left
Complex constant:	$c = .116 - .698i$

Position on page:	Top right
Complex constant:	$c = .39 - .623i$

Position on page:	Middle left
Complex constant:	$c = .3 - .735i$

Position on page:	Middle right
Complex constant:	$c = -.38 - .64i$

Position on page:	Bottom left
Complex constant:	$c = .39 - .623i$

Position on page:	Bottom right
Complex constant:	$c = .678 - .207i$

Page 6-4

Mandelbrot Set Study

Screen parameters:	$x_max = 1.5$	$x_min = -1.5$
	$y_max = 1.5$	$y_min = -1.5$

Blowup parameter: 10

Maximum number of iterations: 128

I have generated Mandelbrot sets up to the sixtieth order, that is, $f(z) = z^{60} + c$, but these somewhat lower order sets shown on this page exemplify those results sufficiently. As you can see, the dominant shape of these sets is circular, although a few perturbations appear here and there. As you would expect, there are an increasing number of lobes as the order increases, but it appears that the symmetry remains intact.

Page 6-5

Equation Study

Image type: Julia and Mandelbrot sets

Equation: $f(z) = ce^{cz}/(e^c - 1)$

Screen parameters: Vary

Blowup parameter: 10

Maximum number of iterations: 128/256

Position on page: Top left
Complex constant: Absent; this is a Mandelbrot set section

Position on page: Top right
Complex constant: $c = 2.685 + 2.924i$

Position on page: Middle left
Complex constant: $c = 2.5725 + 2.89i$

Position on page: Middle right
Complex constant: Absent; this is a Mandelbrot set section

Position on page: Bottom left
Complex constant: Absent; this is a Mandelbrot set section

Position on page: Bottom right
Complex constant: $c = 2.5725 + 2.89i$

Pages 6-6 and 6-7

Magnification Study

Image type:	Julia sets
Equation:	$f(z) = z^2 + c$
Complex constant:	$c = .3577911 + .0629241i$
Blowup parameter:	10
Maximum number of iterations:	256/512

On these two pages is a series of Julia set magnifications using the same set of 256 colors. The quality of self-similarity is clearly expressed within this study as the formations in the highest magnification are exactly like the original.

Just a reminder—
 1 million = 10^6 = 1,000,000
 1 billion = 10^9 = 1,000,000,000
 1 trillion = 10^{12} = a million millions (12 zeroes)
 1 quadrillion = 10^{15} = a billion millions (15 zeroes)
 1 quintillion = 10^{18} = a billion billions (18 zeroes)

Page 6-8

Equation Study

Image type:	Julia sets
Equation:	$f(z) = z^e + c$
Screen parameters:	Vary
Blowup parameter:	10
Maximum number of iterations:	256

Position on page:	Top left
Complex constant:	$c = -.24 + .64i$

Position on page:	Top right
Complex constant:	$c = .60 + .49i$

Position on page:	Middle left
Complex constant:	$c = .37 + .001i$

Position on page:	Middle right
Complex constant:	$c = .3615 + .001i$

Position on page:	Bottom left
Complex constant:	$c = -.72 + .36i$

Position on page:	Bottom right
Complex constant:	$c = .39 + .64i$

Page 6-9

Equation Study

Image type:	Julia sets
Equation:	$f(z) = z^2\sin x + cyz + z^2\cos x + cz \sin y + c$
Screen parameters:	Vary
Blowup parameter:	10
Maximum number of iterations:	256

Position on page:	Top left
Complex constant:	$c = .32375 - .326i$

Position on page:	Top right
Complex constant:	$c = .3382 - .31352i$

Position on page:	Middle left
Complex constant:	$c = .3373 - .3252i$

Position on page:	Middle right
Complex constant:	$c = .308095 - .21628i$

Position on page:	Bottom left
Complex constant:	$c = .310825 - .2188i$

Position on page:	Bottom right
Complex constant:	$c = .32375 - .326i$

Page 6-10

Equation Study

Image type:	Julia and Mandelbrot sets
Equation:	$f(z) = (z^7 + 1)^{(1/3)} + c$
Screen parameters:	Vary
Blowup parameter:	Varies
Maximum number of iterations:	Varies

Position on page:	Top left
Complex constant:	Absent; this is a Mandelbrot set section

Position on page:	Top right
Complex constant:	Absent; this is a Mandelbrot set section

Position on page:	Middle left
Complex constant:	Absent; this is a Mandelbrot set section

Position on page:	Middle right
Complex constant:	Absent; this is a Mandelbrot set section

Position on page:	Bottom left
Complex constant:	$c = -.32 - .857i$

Position on page:	Bottom right
Complex constant:	$c = -.32 - .857i$

Page 6-11

Equation Study

Image type:	Julia and Mandelbrot sets
Equation:	$f(z) - z^{24} + c$
Screen parameters:	Vary
Blowup parameter:	10
Maximum number of iterations:	64

Position on page:	Top left
Complex constant:	Absent; this is a Mandelbrot set section

Position on page:	Top right
Complex constant:	Absent; this is a Mandelbrot set section

Position on page:	Middle left
Complex constant:	Absent; this is a Mandelbrot set section

Position on page:	Middle right
Complex constant:	Absent; this is a Mandelbrot set section

Position on page:	Bottom left
Complex constant:	Absent; this is a Mandelbrot set section

Position on page:	Bottom right
Complex constant:	$c = -.1545 - .8965i$

Pages 6-12 and 6-13

Parameter Study

Image type:	Julia sets
Equation:	$f(z) = (1 + ic)\cos z$
Screen parameters:	$x_max = 1 \qquad x_min = -1$
	$y_max = 1 \qquad y_min = -1$
Blowup parameter:	10
Maximum number of iterations:	256

Notice how subtle changes in the complex constant parameter c affect the fractal image. The color map used goes from pure white (zero iterations) to pure blue (255 iterations). Black is for more than 256 iterations.

Page 6-14

Mandelbrot Set Study

Screen parameters:	Vary
Blowup parameter:	10 to 1000000
Maximum number of iterations:	64 to 256

Page 6-15

Mandelbrot Set Study

Screen parameters:	Vary
Blowup parameter:	10000
Maximum number of iterations:	128 or 256

INDEX BY EQUATION

$f(z) = z^4 + cz^2 + c$
 Found on page 3-18

$f(z) = z^5 - z^3 + z + c$
 Found on page 3-30

$f(z) = (z^2 + c)^2 + z + c$
 Found on pages 3-4, 3-28, 3-29, 4-20

$f(z) = cz^2 + c^2z$
 Found on pages 3-10, 3-30

$f(z) = e^{\cos(cz)}$
 Found on page 4-13

$f(z) = c * (\sin z + \cos z)$
 Found on page 4-12

$f(z) = c(\sin z + \cos z) * (z^3 + z + c)$
 Found on page 4-5

$f(z) = (z^2 + c)^2/(z - c)$
 Found on page 3-5
 Found in Mandelbrot Set Study on page 6-14

$f(z) = (z + \sin z)^2 + z^{.5} + c$
 Found on page 4-14

$f(z) = ce^z e^{\cos(cz)}$
 Found on page 4-13

$f(z) = (z + cz - cz^2) * ((z + \sin z)^2 + c)$
 Found on pages 4-2, 4-17, 4-20
 Found in Mandelbrot Set Study on page 6-14

$f(z) = z^2 + z^{1.5} + c$
 Found on pages 3-12, 3-22, 3-30

$f(z) = (z + \sin z)^2 + z^2 + ce^{-z} + c$
 Found on page 4-15

$f(z) = (z^3/(1 + cz^2)) + e^z - c$
 Found on pages 4-11, 4-13, 4-14

$f(z) = z^2\sin x + cyz + z^2\cos x + cz \sin y + c$
 Found on pages 4-5, 4-8, 4-13, 4-14, 4-20
 Found in Equation Study on page 6-9
 Found in Mandelbrot Set Study on page 6-15

$f(z) = (z^3 + c)/z$
 Found on pages 3-3, 3-28

$f(z) = ((z + 1)^2 + c)/z$
> Found on page 3-3

$f(z) = (z^3 - z^2)^2 + c$
> Found on page 3-17

$f(z) = (z - z^{.5})^2 + c$
> Found on page 3-31

$f(z) = z^2e^z - ze^z + c$
> Found on pages 4-2, 4-9, 4-19

$f(z) = (e^{cz} + c)^2$
> Found on page 4-16

$f(z) = \exp(x^2/y^2) + y + c$
> Found on page 4-9

$f(z) = [(2x - y^2 + a)/(2x^2 + y - b)] + i[(2x^2 + y - a)/(2x - y^2 + b)]$
> Found on page 3-29

$f(z) = z^5 + c$
> Found on page 3-21

$f(z) = z^7 + c$
> Found on pages 3-7, 3-28, 3-29, 3-30

$f(z) = z^6 + cz^4 + cz^2 + c$
> Found on pages 3-25, 3-31

$f(z) = z^9 + c$
> Found on page 3-9

$f(z) = z^9 - cz^6 + cz^3 + c$
> Found on pages 3-14, 3-15
> Found in Equation Study on page 6-3

$f(x) = x^2 + xy + a$
$f(y) = y^2 - xy + b$
> Found on page 3-5

$f(x) = x^2\sin y + a$
$f(y) = y^2\cos x + b$
> Found on page 4-20

$f(z) = c * \cos z$
> Found on pages 4-3, 4-9, 4-10, 4-19

$f(z) = c * \sin z$
> Found on page 4-10
> Found in Mandelbrot Set Study on page 6-14

$f(z) = c * \tan z$
Found in Mandelbrot Set Study on page 6-14

$f(z) = ce^{cz}/(e^c - 1)$
Found on page 4-10
Found in Equation Study on page 6-5

$f(z) = ce^z z^{.5}$
Found on page 4-3
Found in Mandelbrot Set Study on page 6-15

$f(z) = z^2(z^2 + 1)/(z + c)$
Found on page 3-23

$f(z) = z(z^2 + 1)/(z + c)$
Found on page 3-22
Found in Mandelbrot Set Study on page 6-15

$f(z) = (z^5 + c)/(z^3 + z^2 + z + 1)$
Found on page 3-14
Found in Mandelbrot Set Study on page 6-15

$f(z) = (z^3 + z^2 + z + c)/(z - c)$
Found on pages 3-2, 3-23

$f(z) = z^2\exp(z^2) + c$
Found on page 4-7

$f(z) = \exp(z^2)/(z + c)$
Found on page 4-12

$f(z) = (1 + ic)\sin z$
Found on page 4-15

$f(z) = (1 + ic)\cos z$
Found on pages 4-15, 4-16
Found in Parameter Study on pages 6-12 and 6-13

$f(z) = z * \tan(\ln z) + c$
Found on pages 4-4, 4-11, 4-18

$f(z) = (z^4 + c)^{.5}$
Found on pages 3-23, 3-27

$f(z) = (z^4 + 1)^{.5} + c$
Found on page 3-27

$f(z) = (z * \ln z)/e^c$
Found on page 4-11

$f(z) = (e^z/\ln z) + c$
Found on page 4-14

$f(z) = (z^3 + c)^{.5}$
\qquad Found in Mandelbrot Set Study on page 6-15

$f(z) = (z^3 + 1)^{.5} + c$
\qquad Found on pages 3-11, 3-21, 3-22, 3-23

$f(z) = (z + e^z + \ln z)^2 + c$
\qquad Found on page 4-16

$f(z) = z^{10} + c$
\qquad Found on pages 3-15, 3-17, 3-19

$f(z) = z^{11} + c$
\qquad Found on page 3-13

$f(z) = z^{12} + c$
\qquad Found on page 3-16

$f(z) = z^{13} + c$
\qquad Found on page 3-19

$f(z) = z^{15} + c$
\qquad Found on pages 3-18, 3-20, 3-28

$f(z) = z^{16} + c$
\qquad Found on page 3-21

$f(z) = z^{20} + c$
\qquad Found on page 3-8

$f(z) = z^{21} + c$
\qquad Found in Mandelbrot Set Study on page 6-4

$f(z) = z^{22} + c$
\qquad Found on page 3-10
\qquad Found in Mandelbrot Set Study on page 6-4

$f(z) = z^{23} + c$
\qquad Found in Mandelbrot Set Study on pages 6-4 and 6-14

$f(z) = z^{24} + c$
\qquad Found on pages 3-11, 3-12, 3-26, 3-32
\qquad Found in Mandelbrot Set Study on page 6-4
\qquad Found in Equation Study on page 6-11

$f(z) = z^{25} + c$
\qquad Found on page 3-26
\qquad Found in Mandelbrot Set Study on page 6-4

$f(z) = z^{26} + c$
\qquad Found on pages 3-24, 3-26

$f(z) = z^{27} + c$
> Found in Mandelbrot Set Study on page 6-4

$f(x) = (\ln x^2)^{.5} + y * \sin x + a$
$f(y) = (\ln y^2)^{.5} - x * \cos y + b$
> Found on page 4-17

$f(z) = z^{12}\cos x - z^{11}\sin y - z^{10}\tan y + c$
> Found on pages 4-6, 4-12, 4-16

$f(z) = z^{\pi} + \pi^c$
> Found on page 3-25

$f(z) = z^e + c$
> Found in Equation Study on page 6-8

$f(z) = z^{\exp(c)}$
> Found on page 4-19

$f(z) = (z^7 + 1)^{(1/3)} + c$
> Found on page 3-31
> Found in Equation Study on page 6-10

$f(z) = (z^9 + 1)^{.25} + c$
> Found on page 3-31

$f(z) = ((z^2(x - y^2))/(1 - z)) + c$
> Found on page 3-25

$f(z) = z^{12} - z^{11} - z^{10} + c$
> Found on page 3-16